Photography as a Tool

Other Publications:

PLANET EARTH
COLLECTOR'S LIBRARY OF THE CIVIL WAR
LIBRARY OF HEALTH
CLASSICS OF THE OLD WEST
THE EPIC OF FLIGHT
THE GOOD COOK
THE SEAFARERS
THE ENCYCLOPEDIA OF COLLECTIBLES
THE GREAT CITIES
WORLD WAR II
HOME REPAIR AND IMPROVEMENT
THE WORLD'S WILD PLACES
THE TIME-LIFE LIBRARY OF BOATING
HUMAN BEHAVIOR
THE ART OF SEWING
THE OLD WEST
THE EMERGENCE OF MAN
THE AMERICAN WILDERNESS
THE TIME-LIFE ENCYCLOPEDIA OF GARDENING
THIS FABULOUS CENTURY
FOODS OF THE WORLD
TIME-LIFE LIBRARY OF AMERICA
TIME-LIFE LIBRARY OF ART
GREAT AGES OF MAN
LIFE SCIENCE LIBRARY
THE LIFE HISTORY OF THE UNITED STATES
TIME READING PROGRAM
LIFE NATURE LIBRARY
LIFE WORLD LIBRARY
FAMILY LIBRARY:
 HOW THINGS WORK IN YOUR HOME
 THE TIME-LIFE BOOK OF THE FAMILY CAR
 THE TIME-LIFE FAMILY LEGAL GUIDE
 THE TIME-LIFE BOOK OF FAMILY FINANCE

*This volume is one of a series devoted to the art and technology
of photography. The books present pictures by outstanding
photographers of today and the past, relate the history
of photography and provide practical instruction in the use of
equipment and materials.*

LIFE LIBRARY OF PHOTOGRAPHY

Photography as a Tool
Revised Edition

BY THE EDITORS OF TIME-LIFE BOOKS

TIME-LIFE BOOKS, ALEXANDRIA, VIRGINIA

For information about any
Time-Life book, please write:
Reader Information, Time-Life Books,
541 North Fairbanks Court,
Chicago, Illinois 60611.

TIME-LIFE is a trademark of
Time Incorporated U.S.A.

Library of Congress Cataloguing in Publication Data
Main entry under title:
Photography as a tool.
 (Life library of photography)
 Bibliography: p.
 Includes index.
 1. Photography—Scientific applications. I. Time-
Life Books. II. Series.
TR692.P54 1982 778.3 82-3174
ISBN 0-8094-4410-0 AACR2
ISBN 0-8094-4408-9 (retail ed.)
ISBN 0-8094-4409-7 (lib. bdg.)

ON THE COVER: At left, a photograph
by Peter Parks of a tiny Daphnia
water flea, captured at the moment of
giving birth, reflects the recent strides
that photographers have made in
capturing even the liveliest microscopic
specimens in crisp and colorful
images. To achieve such pictures
photographers use equipment such as
the contemporary microscope at right,
photographed by Henry Groskinsky.

Contents

Time-Life Books Inc.
is a wholly owned subsidiary of
TIME INCORPORATED

FOUNDER: Henry R. Luce 1898-1967

Editor-in-Chief: Henry Anatole Grunwald
President: J. Richard Munro
Chairman of the Board: Ralph P. Davidson
Executive Vice President: Clifford J. Grum
Chairman, Executive Committee: James R. Shepley
Editorial Director: Ralph Graves
Group Vice President, Books: Joan D. Manley
Vice Chairman: Arthur Temple

TIME-LIFE BOOKS INC.
EDITOR: George Constable
Executive Editor: George Daniels
Board of Editors: Dale M. Brown, Thomas H.
Flaherty Jr., Martin Mann, Philip W. Payne, John Paul
Porter, Gerry Schremp, Gerald Simons, Nakanori
Tashiro, Kit van Tulleken
Art Director: Tom Suzuki
Assistant: Arnold C. Holeywell
Director of Administration: David L. Harrison
Director of Operations: Gennaro C. Esposito
Director of Research: Carolyn L. Sackett
Assistant: Phyllis K. Wise
Director of Photography: Dolores Allen Littles

President: Carl G. Jaeger
Executive Vice Presidents: John Steven Maxwell,
David J. Walsh
Vice Presidents: George Artandi, Stephen L. Bair,
Peter G. Barnes, Nicholas Benton, John L. Canova,
Beatrice T. Dobie, Carol Flaumenhaft, James L.
Mercer, Herbert Sorkin, Paul R. Stewart

LIFE LIBRARY OF PHOTOGRAPHY
EDITORIAL STAFF FOR
THE ORIGINAL EDITION OF
PHOTOGRAPHY AS A TOOL:
SERIES EDITOR:Richard L. Williams
Assistant to the Editor: Simone Daro Gossner
Text Editors: James A. Maxwell, Peter Chaitin
Picture Editor: Carole Kismaric
Designer: Raymond Ripper
Staff Writer: Peter Wood
Chief Researcher: Peggy Bushong
Researchers: Maureen Benziger,
Rosemary Conefrey, Monica O. Horne,
Sigrid MacRae, Shirley Miller, Don Nelson,
Kathryn Ritchell
Art Assistant: Jean Held

EDITORIAL STAFF FOR
THE REVISED EDITION OF
PHOTOGRAPHY AS A TOOL:
SENIOR EDITOR: Robert G. Mason
Designer: Sally Collins
Picture Editor: Neil Kagan
Text Editor: Roberta R. Conlan
Researchers: Patti H. Cass, Adrianne Goodman,
Charlotte Marine, Jean Strong
Assistant Designer: Kenneth E. Hancock
Copy Coordinator: Anne T. Connell
Picture Coordinator: Eric Godwin
Editorial Assistant: Jane H. Cody

Special Contributors:
Don Earnest, John Neary, Charles Smith (text);
Mel Ingber (technical research)

EDITORIAL OPERATIONS
Production Director: Feliciano Madrid
Assistants: Peter A. Inchauteguiz,
Karen A. Meyerson
Copy Processing: Gordon E. Buck
Quality Control Director: Robert L. Young
Assistant: James J. Cox
Associates: Daniel J. McSweeney,
Michael G. Wight
Art Coordinator: Anne B. Landry
Copy Room Director: Susan Galloway Goldberg
Assistants: Celia Beattie, Ricki Tarlow

CORRESPONDENTS
Elisabeth Kraemer (Bonn); Margot Hapgood,
Dorothy Bacon (London); Susan Jonas, Lucy T.
Voulgaris (New York); Maria Vincenza Aloisi,
Josephine du Brusle (Paris); Ann Natanson (Rome).
Valuable assistance was also provided by: Judy
Aspinall, Lesley Coleman (London); John Dunn
(Melbourne); Miriam Hsia (New York); Mary Johnson
(Stockholm); Eiko Fukuda, Katsuko Yamazaki
(Tokyo).

*The editors are indebted to the following individuals
of Time Inc.: George Karas, Chief, Time-Life Photo
Lab, New York City; Herbert Orth, Deputy Chief,
Time-Life Photo Lab, New York City; Photo
Equipment Supervisor, Albert Schneider; and Photo
Equipment Technician, Mike Miller.*

Ever since photography was invented, men have been pressing it into service as a tool, dreaming of new ways to make it do what human eyes cannot: of speeding up time or slowing it down to learn how things actually behave; of making visible the things that are too small or too distant or too faint for the unaided eye to see; of utilizing other light waves that, like ultraviolet, are totally invisible to human beings, but are there just the same to register on the eyes of certain insects and on photographic emulsions.

It was inevitable that as photography developed it would become invaluable to science and technology. This book introduces some of the wonders of scientific and industrial photography. But it does not limit itself to the purely professional side. There remain many areas combining the technical with the esthetic that can be explored by amateur photographers to the extent that patience, ingenuity and pocketbook permit.

This revised edition presents numerous examples of new kinds and qualities of photography the amateur can achieve by attaching his or her camera to a microscope or to a telescope, or by putting it inside a submersible waterproof housing. With a microscope, magnifications in the range of 330 times the size of the subject are now possible, even for the novice *(pages 58-59)*, and the more venturesome may want to follow the trend among some professionals to shoot live specimens under the microscope *(pages 70-75)*. Celestial pictures of great brilliance and clarity can also be made, using home telescopes fitted with sophisticated tracking devices *(pages 100-103)*. And thanks to new wide-angle lenses and strobes designed especially for use underwater *(pages 124-136)*, it is now possible for the amateur to bring back sharp, well-lighted pictures from murky zones that until recently were literally beyond his depth.

When published in 1973, *Photography as a Tool* introduced many scientific wonders. This edition adds even more stunning photographic accomplishments in a wide range of categories. Among them are David Mallin's color photographs of distant galaxies, which are thought by astronomers to be the most accurate color pictures of space yet made. Equally remarkable are the scanning electron microscope images by David Scharf, who has transformed the smallest of live insects into threatening or comedic beasts, shown in detail never before achieved.

Perhaps the most important change in this edition has been the addition of pictures made in hitherto impossible places and circumstances: Viking II close-ups of Saturn; PET-scan photographs that diagnose mental illnesses by recording different levels of metabolic activity in various parts of the brain; a view of a fusion explosion caught on film even though the duration of the event is only one billionth of a second; and color photographs of a live, two-month-old human embryo, seen inside its mother's womb and revealed right down to the precise shape of its newly formed fingernails. Full of mystery and the promise of more information still to come, these are pictures no photographer in the world could have made as recently as a generation ago.

The Editors

The Fast and Slow Revealed **1**

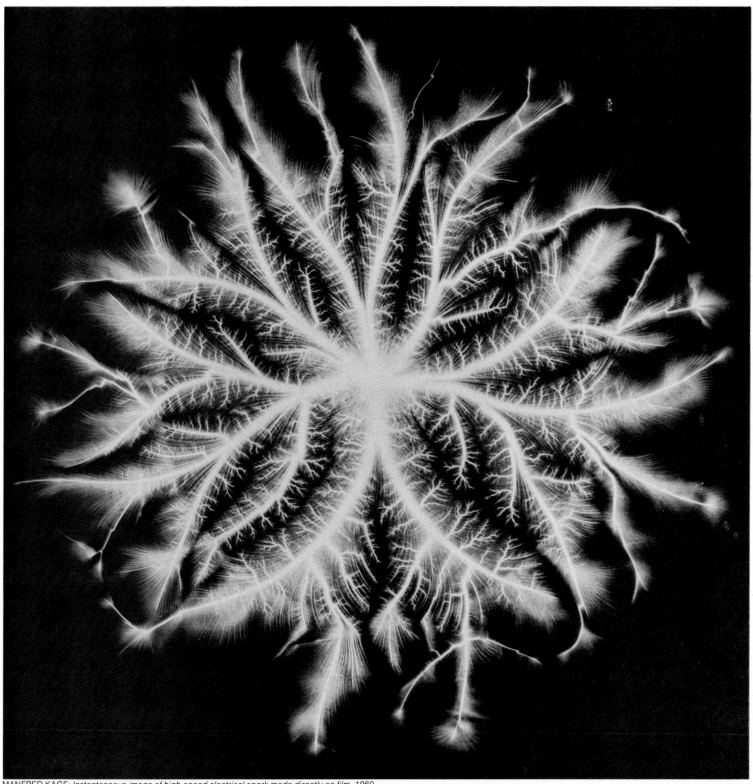

MANFRED KAGE: *Instantaneous image of high-speed electrical spark made directly on film*, 1960

The Camera at Work

The earliest cameras took pictures of familiar objects that the human eye could readily see: faces, landscapes, buildings. But photographers quickly realized they possessed a powerful instrument that could also perceive and record innumerable things to which the eye is blind. This made photography an essential tool of science and discovery. Through its magic eye has come a very large part of man's knowledge of the world.

Almost as soon as photography was invented, astronomers put it to work with their telescopes. They recognized that a photographic emulsion is cumulative in its recording of light. Film exposed over long periods—hours, or even days—gathers faint glimmers of light and thus builds up strong images of objects so far away and so dim that the eye gets no hint they exist. Even with the crude materials of the early days of photography, pictures of the heavens revealed many more stars than had ever been known before. Photographs have since provided much of what is known about the universe, bringing into view ever-more-distant parts of the cosmos.

Not only does photography reveal the most distant and biggest objects, stars, it also makes visible the smallest things in the world. Even close up, the eye can barely see objects that are 1/300 inch in diameter. Photography has no such limitation. An ordinary camera connected to an inexpensive microscope can explore the individual cells of living creatures, particles about 1/1000 inch across. Somewhat more complex equipment on more elaborate types of microscopes can penetrate a cell's inner workings and show the molecules of which it is made. In addition, cameras can easily go where eyes cannot, to the bottom of the ocean, for instance, and inside the human body. They can ride on small satellites and photograph the earth moving below. They record cloud formations for weather forecasters, count migrating animals for biologists, detect pollution for ecologists.

The eye can see only visible light—the rainbow colors from violet to red—but photography has much wider sensitivity. It can take pictures with the many other electromagnetic waves of the world—X-rays, ultraviolet, infrared—and even with beams of neutrons. All of these invisible rays gather knowledge inaccessible by ordinary light. (Examples are on pages 148-176.)

Some of the most useful—and beautiful—photographs are those that record not things but the passage of time in a way human vision cannot. Modern high-speed shutters and lamps can expand time, making possible the observation and study of actions that are so rapid the eye senses them only as blurs or misses them altogether. Modern photography can produce multiple pictures of events as inconceivably rapid as the first millionths of a second of a nuclear explosion. And photography can also contract time, speeding up extremely slow actions, such as the growth of plants, that proceed at such an imperceptible rate they cannot be detected by the human eye *(page 45)*.

The human eye can be described as a camera that takes about 10 pictures per second and telegraphs to the brain part of the information each picture contains. It cannot work much faster because the sensitive retina at the back of the eyeball that serves as its "film" needs an appreciable time to receive and transmit each impression and get ready for the next one. This repetition rate was fast enough for the primitive hunters for whom nature designed the eye. They may have noticed that certain fast-moving objects, such as the wings of flying insects, could be seen only as blurs, but such minor matters were not important to them. Their eyes kept up with the motions of edible animals and the approach of enemies. That was all they asked for or needed.

Modern civilization requires more. Nature is full of actions too fast for the eye to follow, and early in human history inquisitive individuals began to note the slowness of their eyes. How, they asked, do birds flap their wings? The eye tells something about the process but not enough to explain it. Is lightning really a broad path of fire? How do the muscles of an athlete change shape when he goes over a high jump? How does a falling cat manage to land on its feet? The unaided human eye is helpless to answer such questions, and with the advent of fast-moving machines, the number of unobservable actions increased enormously. Wheels, cranks and spindles turned into mysterious, sometimes dangerous blurs. As science and industry advanced, the slow-acting human eye fell further and further behind. It did not catch up until the development of modern high-speed photography.

The first true stop-action photographs were taken by a surprisingly modern method. In 1851 William Henry Fox Talbot of England, the inventor of the negative-positive system employed by modern photography, realized that even in sunlight, the strongest light then available, his shutters, lenses and emulsions could not stop the blurring caused by motion. Even if he could devise a very rapid shutter, his lenses admitted so little light and his emulsions were so insensitive that he would not be able to record an image with a brief exposure. Since he could not get a picture by using sunlight and a shutter, he decided to use another light source that went on and off very quickly. He set up a camera with an open shutter in a darkened room and illuminated his subject with a short flash of light, eliminating the need for a rapid shutter. The flash came from the spark produced by a linked series of Leyden jars.

Often used for classroom demonstrations of static electricity, a Leyden jar is merely a cylindrical glass container coated inside and outside with metal foil; the glass separates the two foil surfaces so that they act as a capacitor or electrical storage reservoir. When an electrostatic machine, a device that generates static electricity, is connected to one of the foil surfaces, it pumps into it an electric charge that attracts an equal charge from the other layer of foil. When sufficiently strong, a bright spark jumps

13

across the gap between electrodes connected to the foil surfaces. It gives quite a lot of light, enough to illuminate brightly a nearby surface, and lasts an extremely short time. Talbot probably did not realize how short the flash was (about 1/100,000 second) but he found it was short enough to "stop" almost any moving object that he could put in front of his camera. His most noted triumph, an apparent miracle at a time when a conventional photograph required a subject to hold rock-still for many minutes, was a picture of a page of the London *Times:* He pasted it to a rapidly rotating disk and got a readable photograph of it as it spun in front of his lens.

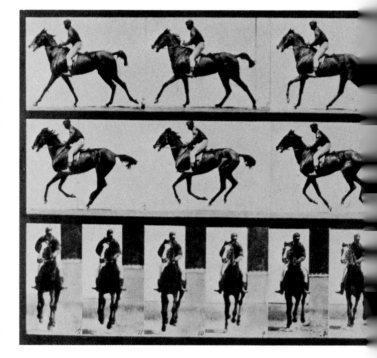

Talbot's success seems to have been forgotten for many years, but in the 1880s the Austrian physicist Ernst Mach (after whom the aerodynamic term denoting sonic speeds was named) built another powerful spark apparatus and took pictures of bullets leaving the muzzle of a gun. When the gun was fired, the bullet closed a circuit as it passed between the spark electrodes and the photographic plate. This action tripped the spark, which cast the bullet's shadow on the plate and clearly showed it in silhouette. The photographs also showed hot gases escaping from the muzzle and thin circular sound waves moving outward at mach 1, the speed of sound. These waves cast shadows because they are made of compressed air that bends light differently from ordinary air.

The idea of building up a powerful electrical charge in a capacitor and then suddenly releasing that charge to cause a brilliant flash is the basis of most modern high-speed photography—it is the principle of the electronic flash unit, or strobe light. But strobe photography did not get out of the laboratory until the 1930s. Meanwhile the gradual improvement of lenses, shutters and emulsions made it possible for cameras to take reasonably clear photographs of moving objects outdoors in full sunlight without artificial illumination. The most famous pioneer in this field was Edward James Muggeridge, an adventurous Englishman born in 1830 who began a very checkered career after he emigrated to the United States and upgraded his name to Eadweard Muybridge, which he claimed was the proper Anglo-Saxon form. How he learned photography is not known, but in the 1860s he showed up in California, where he was employed by the United States government to make a photographic survey of the Pacific Coast.

There, about 1872, he was hired by the railroad magnate Leland Stanford, former governor of California, founder of Stanford University and a great lover of horses. Stanford had had an argument with a man named Frederick MacCrellish about whether or not a trotting horse ever had all four of its hoofs off the ground at the same time; Stanford thought that it had. The story, which may be apocryphal, is that Stanford wagered $25,000 to back up his opinion and then engaged Muybridge to prove it for him by photography. The

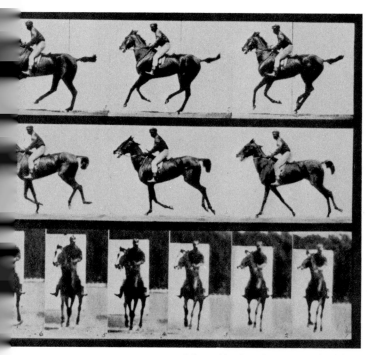

A thoroughbred racehorse canters through this series of stop-action pictures taken by Eadweard Muybridge at the University of Pennsylvania in the mid-1880s. The top two strips show the horse commencing and completing a single 9½-foot stride, beginning at upper right and finishing at far left in the second row (i.e., right to left instead of left to right). In the midst of the canter (second from left, second row) all four of the horse's feet are off the ground. The bottom strip shows a front view of the same stride. When taking pictures of animals moving as fast as this horse, Muybridge sometimes used shutter speeds of 1/2000 second, then extraordinarily swift.

first attempts were not successful ones because the exposure, 1/12 second, showed nothing but a blur.

The first successful pictures taken by Muybridge were of Stanford's racehorse Occident, which was endowed with a famously long stride, trotting in front of a white screen at 22½ miles per hour. This time Muybridge used an improved shutter that gave a much shorter exposure. The negatives were badly underexposed because of the slowness of his plates and lens but some of the pictures showed Occident with all four feet off the ground and thus settled the controversy.

Stanford was delighted but not satisfied. He wanted pictures of horses taken successively through their full stride, so he told Muybridge to go ahead and spend all the money he needed. Probably no photographer had ever had such an offer before. The result was a special track made of grooved rubber to eliminate dust. On one side was a "camera house" 40 feet long, complete with darkroom. On the other was a fence of white cotton cloth marked with numbered vertical lines. At its base was a board with horizontal lines four inches apart to show height above the ground. Twelve cameras (later increased to 24, set 12 inches apart) pointed across the track. Their shutters were tripped in sequence by an electrical system worked out by John D. Isaacs of the Central Pacific Railroad. The sequence started when the horse broke a stretched thread.

This elaborate set-up reputedly cost $40,000. The pictures it got were still underexposed but they were taken at something like 1/1000 second and clearly showed all the different gaits of horses. They were published widely, usually as line drawings based on Muybridge's indistinct pictures, and caused a painful controversy in artistic circles. Many of the famous painters of the time were forced to admit that they had been painting horses all wrong. Their favorite rocking-horse posture, with all four of the horse's feet extended, was demonstrated to be an absurdity.

Muybridge improved his techniques and used faster emulsions and lenses as they came along. Eventually, with the assistance of the University of Pennsylvania, he was able to get fairly good pictures of a great variety of moving animals, including such exotics as ostriches and baboons, and of men, women and children, usually naked and engaged in many activities, from fencing and pole vaulting to running and wrestling. He took 100,000 negatives in all, and in 1887 the university published 781 large plates, each of which showed 12 to 36 of his pictures. The price for the complete collection was $500 and as a result not many were sold. However, Muybridge offered smaller lots that found a wide market.

Most of Muybridge's pictures show rather slow motions, so he could use fairly long exposures and thereby get enough light into his camera to make

good negatives. When he took pictures of faster actions, such as those of running animals, he had to use shorter exposures and his pictures were indistinct because he could not provide sufficient light for the insensitive emulsions of the time. The much faster films that are available today have solved this problem, however, and with the modern mechanical shutters that are standard equipment on good cameras it is a simple matter to take unblurred pictures of many rapidly moving objects—children playing or athletes in action, for example.

While the standard mechanical shutters can stop many kinds of rapid action, they are not nearly fast enough to produce anything but a blur of such subjects as a golf club in mid-swing or a hovering bird flapping its wings. A new approach is necessary. It depends, as Talbot had so clearly foreseen long ago, on brief flashes of light.

Many attempts were made to increase the brightness of electric sparks. Among the most successful workers was Professor A. M. Worthington of Britain, whose spark pictures in 1900 revealed the intricate and beautiful splash shapes formed for fleeting instants by small objects falling into liquids. But his most powerful sparks were too dim for anything except miniature scenes.

The familiar flash bulb, introduced in 1929, was—and still is—excellent for supplying a lot of light for fairly brief exposures, but its burst of light lasts many thousandths of a second. It can be used for really high-speed photography only by teaming its flash with a high-speed shutter that takes a picture during just a small part of the time that the bulb's light lasts.

The big breakthrough in high-speed photography came in 1931 when Harold E. Edgerton, who was then a graduate student in electrical engineering at the Massachusetts Institute of Technology, became interested in observing the behavior of an electric motor subjected to varying loads. The motor rotated too fast to be detected by the human eye, and the available-light devices to make its motion seem to stop did not work well enough. So Edgerton set out to develop a better one. The result was the invaluable electronic strobe light that is so widely used today. It is now employed mainly as a convenient source of bright light, but in special forms it continues to serve its original purpose of stopping fast action.

One of the first photographers to use the strobe light in this way was Gjon Mili, who attended a Cambridge meeting of the Illumination Society with Edgerton in 1937. Edgerton recalls that Mili, then a lighting research engineer for Westinghouse Corporation, demonstrated a high-powered mercury arc lamp with such effect that it blew out the fuses in the building where the Society was in session. Edgerton had to wait in the dark until the fuses were replaced, but then he gave a successful demonstration of a two-lamp strobe with enough light output to be used in a studio. Mili was so impressed that he

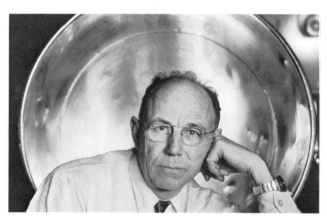

The man who made ultra-high-speed photography practical, Dr. Harold E. Edgerton, is framed by a large reflector used with his best-known invention, the strobe light. Edgerton is now a professor emeritus at the Massachusetts Institute of Technology, where he did much of his pioneering work in developing modern photographic lighting equipment, including some that is used in deep-sea exploration.

asked Edgerton to bring it to New York, where he worked, for practical trials. Out of this collaboration came a long series of striking high-speed pictures, many of which were published in *Life*. They showed dancers in action as clearly as if they were standing still, and golf balls and tennis balls crushed flat against the swing of club or racket. Some of their most startling photographs were made by firing the strobe repeatedly to take multiple pictures on the same film. This stroboscopic effect turned a golf player into an eerie pattern faintly reminiscent of a sea anemone, with his rapidly moving hands and club looking like tentacles arranged in a swirl around his comparatively motionless body *(page 36)*.

In his laboratory Edgerton used his magic lamp to dissect familiar, homely actions and revealed in them a wealth of unseen beauty and interest. Caught by the quick flash of his lamp, streams of water flowing from a faucet turned into shiny columns that slowly gathered into droplets resembling balls of glass. He caught cups of coffee or milk at the instant they smashed on a concrete floor, every spurt, drop and fragment immobilized.

As strobes developed they gave more and more light in less and less time and provided a marvelous new tool for analyzing the subtle actions of living creatures. Edgerton himself spent a great deal of time and ingenuity on one of the most mysterious and difficult of such subjects: bats. Since bats lead their active lives in darkness, the flying and hunting habits of most species were almost unknown before the development of strobe-light photography.

Edgerton was not the first to photograph bats, but they had never before been subjected to so much electronic expertise. He set up his apparatus inside the mouth of the Carlsbad Caverns in New Mexico, from which a tremendous horde of about 250,000 bats emerges every night to feed on flying insects. Farther inside the cave he erected a temporary tripod supporting a small, light-colored target about 10 feet from his camera. This was used only for setting up the system. A photoelectric cell pointed toward the target, which was illuminated by a spotlight. Then the cell was adjusted so that it was activated by light reflected from the target. Also pointed at the target was an array of three quick-acting strobe lights enclosed in a reflector to give a rather narrow beam with a flash duration of 70 millionths of a second.

After the apparatus had been tested, the tripod and target were removed and the camera's shutter opened. When a bat flew into the spotlight beam, light reflected from the creature triggered the photocell which in turn set off the brilliant flash of the strobe lights. The bat was caught on film as sharply as if it had been motionless.

Edgerton's photographs solved a problem that had long puzzled zoologists. The Mexican free-tailed bat that inhabits Carlsbad Caverns apparently lacks a membrane stretched between the hind legs that other bats use to

control their flight and to help them scoop their insect prey out of the air. But it has a long, thin tail that appeared to be a purposeless appendage.

Edgerton's detailed pictures of Mexican free-tailed bats in flight showed that when the bat becomes airborne it extends its legs rearward. A loose membrane slides out along the tail forming an efficient control surface. This clever way of furling the tail membrane probably helps conserve body heat and moisture when the bat is not in flight. No one had guessed the secret before Edgerton brought his strobes to the mouth of the bats' cave.

The most rigorous test of high-speed nature photography is to take razor-sharp pictures of hummingbirds, whose wings beat upwards of 60 times per second, in all their glory of iridescent color and flashing action. This was notably accomplished in 1953 by Crawford H. Greenewalt, at that time the president of the Du Pont Company, with the help of elaborate equipment that had been specially designed.

Greenewalt developed his system by trying it out on the ruby-throated hummingbird, the only species that inhabits the eastern part of the United States. Then he made expeditions to Brazil, Ecuador, Venezuela, Cuba, Jamaica, Panama, Arizona, California and Colorado in search of more exotic and brilliant subjects. Sometimes he photographed captive birds that had made themselves at home in large aviaries. Some rare species were captured specially for him. One was knocked gently out of the air by an Ecuadorian blowgunner, who used a pellet of soft clay that stunned the bird momentarily but did it no further harm. Many birds were photographed in their native habitats, usually at feeding stations to which they had been habituated by weeks of sugar doles.

Greenewalt's photographs of birds seemingly suspended in flight were beautiful as well as informative. But he was not content with still pictures, so he determined to make motion pictures of hummingbirds that would show how they fly, how fast they fly and how they perform their amazing acrobatics. There was available a high-speed motion-picture camera fast enough to do this, but it had the disadvantage of requiring a half second or so to get up to full speed. A second is a long time in the life of a hummingbird; by the time the camera got ready to photograph them, the birds, frightened by the camera's buzzing, would be far away.

So Greenewalt encouraged the development of a new, fast-starting camera. The chief cause of the sluggishness of the existing type was the inertia of its 100-foot reel of film, which resisted quick acceleration. The new model avoided this difficulty by discarding the reel and using film that was partly unwound, festooned loosely in a light-tight box. When the camera started into action it had to overcome only the inertia of a short length of film. In a few thousandths of a second it reached the picture-taking speed of 1,200

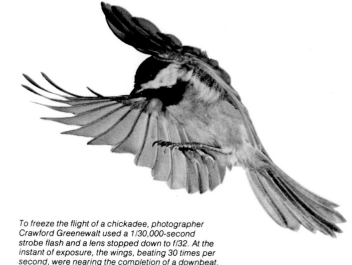

To freeze the flight of a chickadee, photographer Crawford Greenewalt used a 1/30,000-second strobe flash and a lens stopped down to f/32. At the instant of exposure, the wings, beating 30 times per second, were nearing the completion of a downbeat.

frames per second. No shutter was necessary because the film moved continuously and passed the lens so quickly that daylight made no impression. The camera took pictures only during the intermittent, brief flashes of powerful stroboscopic lamps.

Greenewalt enticed the ruby-throated hummingbirds at his home in Delaware to fly in front of his new camera by means of gifts of sugar water. The camera worked so fast that before a bird heard its buzz, many frames of its flight had been taken. The rest of the film often showed the extraordinary acrobatics of the creature's frightened getaway.

Greenewalt was still not satisfied; he wanted to find out how fast a hummingbird can fly and just how much each part of its wing cycle contributes to its support and forward motion during different kinds of flight. So he built an apparatus for the birds that his children called "Daddy's torture chamber": a fan driving a stream of air through an 18-inch pipe at speeds up to 30 miles per hour. The birds, he discovered, did not consider it a torture chamber. When he placed a sugar-bearing feeding station close to the outlet of the wind pipe, they quickly learned to come to it, and they continued to come after he put the fan in motion. Apparently by the time they had become accustomed to the fan's powerful roar they did not hear—or at least they were not alarmed by—the camera's buzz.

To reach their food the birds had to fly upwind to the feeder and keep flying while they sucked the sugar syrup out of it with their tubular tongues. Greenewalt could control and measure the speed of the air stream, so he could tell how fast each bird pictured was flying by how fast the air was moving. The top speed for a female ruby-throated hummingbird proved to be about 27 miles per hour.

With the facilities at his disposal, Greenewalt was able to develop and use strobes with greater speed than those that are normally used today by most amateur and even professional photographers. Most ordinary strobes are all right for taking photographs of people who are not doing anything too vigorous, but their flashes have a time span of several thousandths of a second, and during this time the wing of a bird, for example, moves so much that its outlines are blurred. Many an amateur has been disappointed by the poor nature pictures he gets with his new strobe. In most instances they are no better than photographs that have been taken in sunlight with the fastest speed of the shutter on his camera.

The chief cause of the slowness of ordinary strobes is their capacitors, which are conveniently small in size, weight and cost, but which do not give up their electric charge quickly enough. However, a number of strobes equipped to give high-speed flashes are available (pages 24-25). They are moderately expensive, but their flash durations can be as brief as 1/30,000 or

even 1/50,000 second, which is a speed fast enough to take photographs of small birds in flight, pictures of bursting balloons, of splashes, etc.

While an ordinary strobe's flash of one thousandth of a second is too slow for high-speed photography, it is still quite brief. And it is very brilliant. This makes a strobe light handy for the kind of photography that, instead of expanding time, contracts it. Many natural actions escape human observation not because they are too fast but because they are so slow that the eye does not see them happening, noticing only the cumulative effect after a considerable passage of time. Cameras are more patient and attentive. They can stare at a slow action for any desirable length of time, taking pictures of it periodically, one second, one hour or many days apart. When a series of such photographs is seen, the slow action comes to vivid life. Everyone knows, for instance, that a rose opens from a tight green bud, but the eye is unable to catch it in the act. The time-lapse camera using the brief flash of a strobe light has no difficulty at all.

Taking time-lapse pictures is not quite as simple as it sounds. The camera must look at the subject from exactly the same distance and angle during each shot. With indoor subjects, such as a flower opening in a vase, this is no great problem, but outdoor subjects must be protected from wind and other influences that might make them move in relation to the camera. Sometimes such sheltering care has unforeseen results. For instance, one photographer wanted to take a time-lapse sequence of a ripening apple. He built a small, glass-walled house around a branch of an apple tree and arranged his camera in front of a promising young apple. The apple grew all right, but it refused to turn red. Next season he tried another variety of apple, with no better results. Finally he discovered that the glass of the camera house was excluding the ultraviolet rays needed to make the apple turn color. The following year, instead of glass he used transparent plastic, which transmits ultraviolet and got lively pictures of the ripening of a red apple.

Lighting is always a problem with time-lapse pictures; if it varies, the changes due to the passage of time may be obscured. With indoor subjects, lighting can be kept constant by excluding natural light and always using the same number of artificial lights in the same positions. Even better is a strobe light so powerful that it conceals any variation of natural lighting.

Time-lapse pictures of nature require little special equipment, but scenes outdoors are high tests of a photographer's skill. If he wants to record the development of a thundercloud, he must take a picture every few seconds while keeping the camera adjusted to suit rapidly changing light conditions. When recording the blooming of a flower bed or flowering tree, he must try to avoid distracting effects such as shadows that appear in pictures taken when

the sun was shining but not when it was hidden behind clouds. Time-lapse photography is a fascinating activity, but not an easy one, and certainly not for an impatient photographer.

Time-lapse and high-speed photography of nature have attracted many serious amateurs, who have produced outstanding pictures. While special equipment may be required, it can be managed by nonprofessionals. This is not true of very high-speed photography. For stopping the fastest action, a great deal of complicated — and expensive — gear is needed. If the subject is not self-illuminating it must be photographed by means of light that falls upon it, and this is best accomplished by bright flashes that last so short a time that they eliminate the need of a fast-acting camera shutter.

Specially designed strobe lamps can be made to give flashes as brief as a millionth of a second. This is short enough to photograph bullets and more than short enough for such comparatively sluggish subjects as golf balls squashed against the club head. Faster actions require shorter flashes. Flashes as brief as 10 billionths of a second are possible with air-gap sparks, which are bright enough to take shadow pictures of high-velocity bullets passing directly between the spark and the film. These show not only the bullet but small specks that it has dislodged from material that it has passed through. The particles are traveling almost as fast as the bullet but their tiny shadows are as sharp as if they were motionless.

Short-exposure single pictures are easier to take than motion pictures whose individual frames follow in rapid succession. One difficulty is "holdover," the result of the fact that the gas-filled strobe tubes do not shut off instantaneously after the first surge of current has passed. The gas in them remains ionized and therefore conductive, so current that is intended to recharge the capacitor continues to flow through them, giving a steady and comparatively dim light that is useless for the purpose intended and eventually damages the lamp. The cure for holdover is some sort of rapidly acting switch that starts and stops the current at the desired rate. Probably the most effective switch is a kind of vacuum tube called a hydrogen thyratron, which can make a strobe light give as many as 10,000 flashes per second.

Even such brief flashes may not prevent blurring caused by rapid movement of the film through the camera. It must travel continuously, not stopping and starting for each picture, as in an ordinary movie camera. This problem can be solved by placing a rotating mirror or prism behind the camera lens to make the image it forms move along with the film. One model uses a square block of glass rotating in such a way that it keeps an image almost perfectly steady on each moving frame, then forms another moving image on the next frame. Such cameras take more than 10,000 pictures per second. When they are used in conjunction with a strobe light there must be some device to

make sure that the light flashes when the camera is prepared to take a picture. An ingenious device to synchronize camera and flash uses a small permanent magnet held near the sprocket wheel that moves the film. As each steel sprocket tooth passes the magnet, it affects the magnet's field and causes an electric pulse to be generated in a coil. The pulses keep step with the motion of the film and signal when it is in the correct position for the strobe light to fire and take a picture.

Some rapidly moving objects — including most explosions — produce a great deal of light of their own, so high-speed photographs of them can be taken without additional illumination. The problem here is to fit the camera with a shutter that stays open a millionth of a second or less. This is not easy; no ordinary mechanical shutter is fast enough. A shutter-like effect, however, can be provided by a rotating mirror that casts light successively on many small lenses arranged on the inside of a curved surface so that each acts like a separate camera. If the mirror turns fast enough (upwards of 10,000 revolutions per second) and the lenses are sufficiently numerous, such a camera can take pictures at the rate of 200 million per second, each picture exposed for 100 billionths of a second. The pictures, however, are not of very good quality, and for obvious reasons it is hard to start the picture series at the correct instant to catch the most interesting part of a brief explosive action.

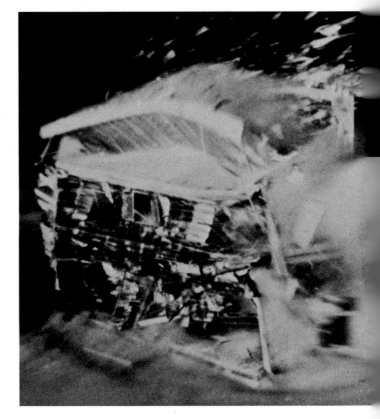

Another way to take ultrashort exposure pictures of brilliant objects is to use an electro-optical shutter with no mechanical moving parts to limit its speed. Such shutters depend on the fact that magnetic and electric fields can affect light that is passing through certain materials. Since the field can be applied in a few hundred billionths of a second, it can trigger a device that acts as an ultrafast shutter.

The best-known electro-optical shutter is the Kerr cell, named after the Scottish physicist John Kerr, who discovered in 1875 that when an electric field is applied to a substance, its molecules will align themselves in such a way that entering light waves will refract in two different directions.

This sounds like a small effect, but on it can be built a very effective quick-acting shutter. At one end, where the light enters, is a sheet of material that polarizes the light, altering the plane of vibration of its waves to, say, the horizontal. At the other end is another polarizing sheet turned at a 90° angle so as not to permit horizontally polarized waves to pass. Acting together, the two sheets block all light.

Between them, however, is a glass container holding a liquid such as nitrobenzene, with two metal electrodes at the container sides. When electric charges are imposed on the electrodes, the nitrobenzene changes the polarization of the light in a manner that permits a substantial portion of

Demonstrating the power of the camera to record events the eye could not otherwise see, a frame from a 35mm motion-picture film shows the roof of a wooden house peeling off, the façade falling in and the chimney about to collapse from the shock waves of an atomic-bomb blast. Part of a March 17, 1953, test at Yucca Flats, Nevada, the house was placed only 3,500 feet from ground zero. The ultra-high-speed movie camera, protected by a lead sheath, was trained on the house from a distance of 60 feet. This frame was made one and two-thirds seconds after detonation; the house was totally demolished instants later.

it to pass through the second polarizing sheet. The Kerr cell is now open for picture taking. Shutters using this principle— or a similar one that employs magnetic fields and glass elements instead of electric fields and nitrobenzene— can open and close in a few millionths of a second. Clear pictures of ultrarapid events, such as thin wires exploding when a heavy electric current is suddenly sent through them, have been taken at this exposure.

Perhaps the most spectacular pictures taken with an electro-optical shutter are of the early stages of nuclear test explosions in the open air. Many of them were taken for the Atomic Energy Commission by Edgerton, Germeshausen and Grier, Inc., a company founded by Professor Edgerton and two associates. There was no lack of light; in its early stages a nuclear fireball is many times brighter than the sun. The difficulty of photographing it came from the rapidity of its expansion. The fireball of even a comparatively weak explosion reaches 90 feet in diameter in 1/10,000 second, and the fastest growth is during the first millionths of a second.

To photograph a typical explosion where the bomb was in a small housing on top of a tower, the EG&G apparatus consisted of a cluster of cameras at the safe distance of 10 miles or more. They had mechanical capping shutters that opened one second before the bomb was scheduled to explode, and behind these were electro-optical shutters capable of opening and closing at ultrafast speeds. Controlled by circuits that took different times to act, each camera took its picture at a slightly different time. Then, since electro-optical shutters are not completely opaque, a second capping shutter went into operation to keep the flood of light from the fireball from spoiling the picture. It had to act very quickly, so it consisted of a glass plate covered with a network of thin lead wires, which vaporized when a pulse of electricity was sent through it. The vapor quickly coated the glass with an opaque layer of lead to obstruct the late-coming light.

The first picture, shot a millionth of a second after "Time Zero," shows the bomb enclosure looking like a little hut with a dim light in its window. The light is the first evidence of the cataclysmic event that is happening inside. In the next picture, millionths of a second later, the fireball is beginning to burst out of the hut. For a while it remains somewhat irregular, distorted by the inertia of heavy materials in the detonating mechanism, but a few millionths of a second afterward all such objects are vaporized, and the fireball forms a smooth expanding sphere that eats up the tower and turns it to vapor, too. Without the help of an ultrafast shutter, no human eye would ever have seen the first few moments of the youth of a nuclear fireball. □

Jonathan Norton Leonard

Flash Units for High-Speed Pictures

Not every strobe can shoot action pictures. Some models are designed only to serve as sources of bright light, and their flashes last too long to stop rapid motion. Most, however, provide flashes of 1/1000 second or shorter, enough to freeze most human motions, and some can achieve the very high speeds required for photographing fast-moving animals. Despite wide differences in operating capacity, all strobes are similar in construction. They consist of at least one xenon tube, a capacitor, a power source (usually a battery, although many units also operate on house current), a triggering unit that is activated by the camera's shutter mechanism, and a reflector.

The units shown opposite are representative of the types used by professionals and amateurs. They differ greatly in the brightness of the light they are capable of producing (indicated roughly by their power as measured in Beam Candle Power Seconds, or BCPS), their versatility, the time necessary to recharge between flashes, the duration of flashes and some of their special features.

A feature shared by all the units—except the ringlight (11), which is used for extreme close-ups—is the ability to provide flashes of varying duration. Those with electronic sensing devices (3-8, 10) can automatically adjust the duration of their flashes (and thus the amount of light released) as the distance from the subject changes. At close range, where only a small amount of light is needed and the flash can be brief, some can provide a flash as short as 1/50,000 second.

The high-power outfits that are used by professionals, the Speedotron (1, 2) and the Norman (9), provide their action-freezing flashes when set to function at a half or a quarter of their full power; this proportionately reduces the duration of the flash as well as the brightness. (All of the automatic units shown here can produce short-duration flashes in this manner, as well.) With the Speedotron, a single lamp containing four flash tubes (1) reduces the duration of the flash by three quarters while producing a higher brightness level than a normal single lamp. The unit can also be equipped with as many as six lamps (2) in order to light large areas such as sports arenas.

Professional units such as the Speedotron and the Norman always have separate power supplies to provide the high voltage levels needed for the rapid repeated shooting often required by photojournalists. When it is necessary, smaller units can be hooked up to a compatible external power unit like the Sunpak battery pack (12), which can shorten the recycling time. □

1 **Speedotron Universal Quad Light 104 with 2401A Power Supply: 46,225 BCPS; flash 1/420-1/1430 second**

2 **Speedotron Universal Light 102 with 2401A Power Supply: 46,225 BCPS; flash 1/220-1/910 second**

3 **Berkey Sunpak 611: 4000 BCPS; flash 1/400-1/50,000 second**

4 **Soligor MK-32A: 2250 BCPS; flash 1/3500-1/35,000 second**

5 **Vivitar 283: 2900 BCPS; flash 1/1000-1/30,000 second**

6 **Vivitar 3500: approximately 1300 BCPS; flash 1/2000-1/30,000 second**

7 **Berkey Sunpak 522: 2550 BCPS; flash 1/850-1/20,000 second**

8 **Nikon Speedlight SB-10: approximately 1300 BCPS; flash 1/1200-1/2000 second**

9 **Norman 200B: 4000 BCPS; flash 1/400-1/1600 second**

10 **Vivitar 3900: approximately 3000 BCPS; flash 1/800-1/30,000 second**

11 **Berkey Sunpak Ring Light GX8R: 120 BCPS; flash 1/100-1/200**

12 **Berkey Sunpak Powerpak for 510-Volt Battery**

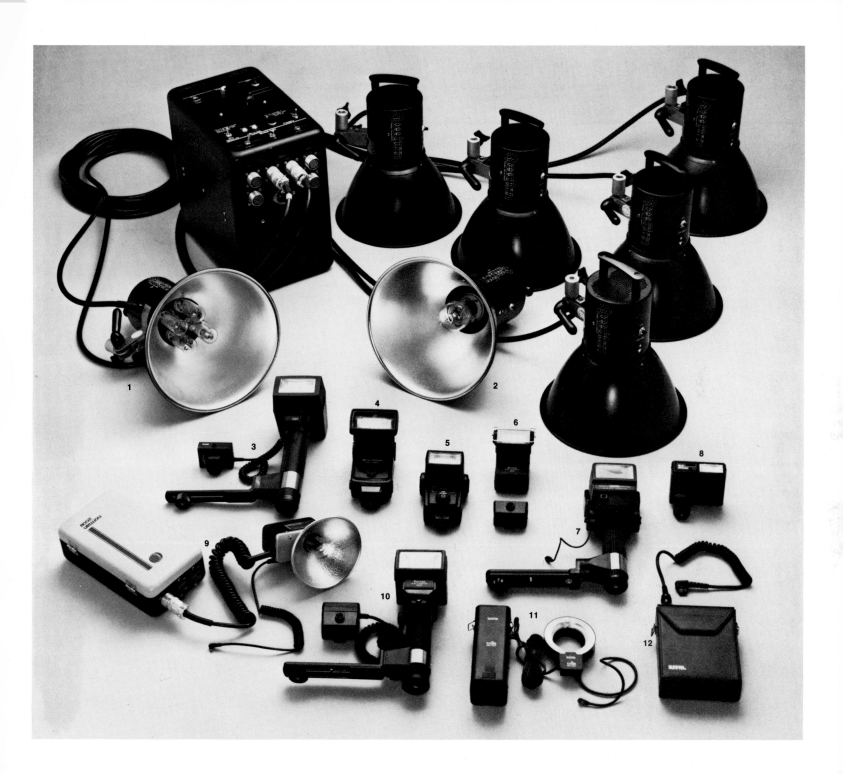

Using Photography to Manipulate Time

Much of the world is made of things in motion. But a great many of them are moving too fast for the eye to perceive or too slowly for their motion to be noticed—actions as swift as the wing beat of a hummingbird hovering to feed, or as intricately drawn out as the growth of petals when a bud unfolds.

But photography, expanding time by stopping fast action with brief exposures, or contracting it by compressing slow action with repeated exposures, has provided ways to capture images that exist for only millionths of a second and others that take months to materialize. Used in these ways the camera has proved itself a tool of almost inexhaustible application.

Engineers and scientists, ballet lovers and bird watchers, football coaches and golf pros have all gained new insights from high-speed photography, whether they make the pictures themselves or merely study them. Such photographs, beyond their practical importance, have also added a new and surprising dimension to our appreciation of the world, revealing beautiful patterns in events that are as brief as the splash of one drop of milk (opposite).

It is possible to stop fast action with an ordinary camera, using exposures of 1/1000 or 1/2000 second (normally the top speeds of mechanical shutters). But in such photographs, the finest details of a fast-moving subject may remain quite imperceptible. The extraordinary crown-like structure that is revealed in a milk drop by the pictures shown on the opposite page required special equipment, and the separate events in the detonation of an explosive can be caught only by complex, ultra-high-speed cameras capable of making exposures of billionths of a second. Most high-speed pictures are made with the help of strobe lights such as those shown on the preceding pages. A strobe can make exposures thousands of times faster than a mechanical shutter.

Stopping a single instant of action with a split-second flash of light from strobe lamps is only one of the techniques photographers use to manipulate time. Rapidly repeated flashes of light—from stroboscopic units—can be used to make multiple exposures that follow a moving subject over infinitesimal distances along its path. If the exposures are repeated at a slower rate, they reveal the most subtle changes in a subject that appears motionless. And long exposure of a moving light source—made by holding open the shutter—can result in equally remarkable photographs showing unseen patterns traced in time.

Each of these techniques presents a stimulating challenge to any photographer. High-speed strobes can be expensive, but there is no mystery about their use. Even without special equipment, the camera can be used in ways that transcend the limits of time. □

In an early investigation of the possibilities of high-speed stroboscopic photography, a drop of milk splashes into a shallow saucer (opposite, 1). Surface tension holding the drop together is shattered (2), and the drop breaks into droplets held together by surface tension of their own, forming a crown (3) and then a coronet pattern (4). The tips of the coronet separate (5) and finally fly free (6) as another drop falls to begin the sequence all over again. To obtain this historic series of pictures, taken in about 1938 at the Massachusetts Institute of Technology, Dr. Harold E. Edgerton used equipment that gave some 6,000 flashes per second, with each flash having a duration of approximately 1/1,000,000 second.

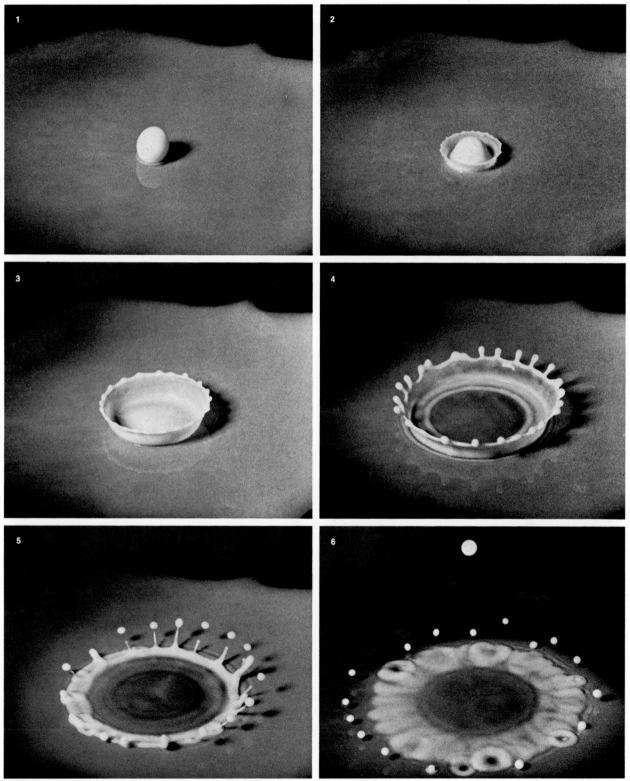

HAROLD E. EDGERTON: *Drop of Milk Splashing into a Saucer,* 1938

A Moment Frozen

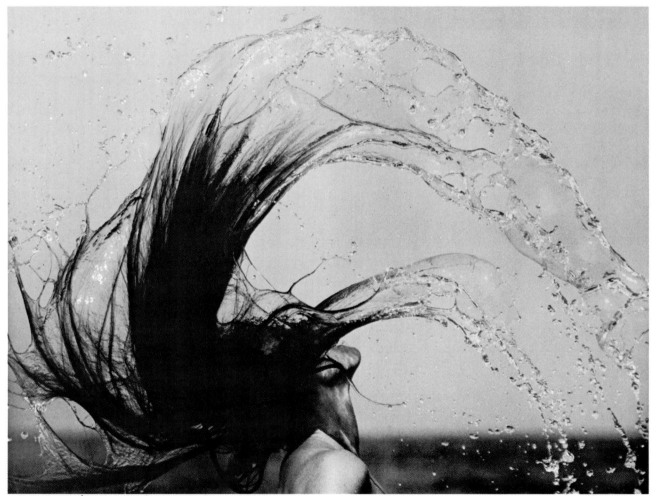

KRZYSZTOF KAMIŃSKI: *The Birth of Aphrodite*, 1964

Remarkable pictures can be created by using the top shutter speeds of an ordinary camera in order to freeze fast motion. An exposure of 1/1000 second preserved an arc of water droplets in the photograph above, and one of 1/2000 second captured the fine details of a fully expanded fireball in the image on the opposite page. In both cases, a bright, sunny setting assured that sufficient light would reach the film during the very brief period that the shutter was open.

Such stop-action pictures are a challenge to the ability of the mechanical shutter to freeze motion—and to the reflexes of the photographer. They require that he press the shutter release just before the moment he wishes to capture, in order to allow for his own 1/10-second reaction time and for the 1/20 second it takes for a mechanical shutter to open.

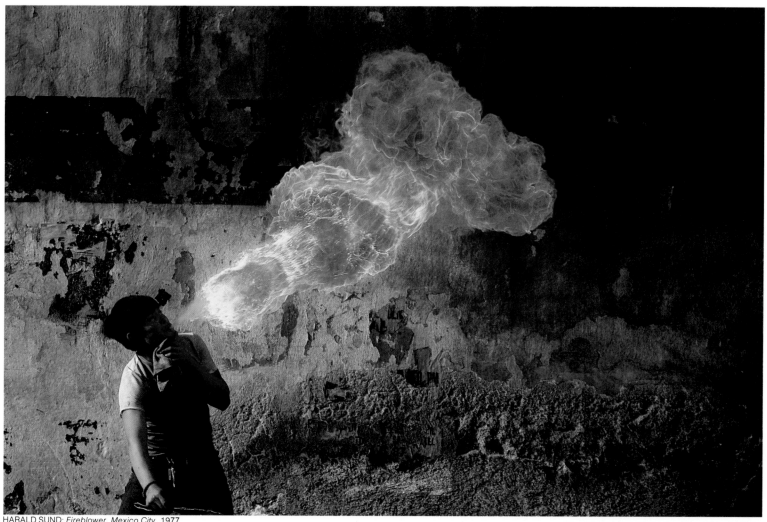

HARALD SUND: *Fireblower, Mexico City, 1977*

◄ *With a toss of her drenched hair, a swimmer at the Baltic seacoast town of Danzig, Poland, leaves a watery trail, stopped by the fast shutter of photographer Krzysztof Kamiński. Kamiński named his subject "Aphrodite" because the Greek goddess of love and beauty was, according to some legends, born of the sea.*

A street performer in Mexico creates a fiery eruption by spewing out and igniting a combustible liquid. The convolutions of the fire cloud were recorded with a shutter set for 1/2000 second—the top speed available on regular cameras. Even this speed was unable to freeze the movement nearest the fireblower's mouth where the velocity was greatest.

29

Actions Faster than the Shutter's Click

Tips on Stopping Action

Using a strobe to freeze movement is little different from using it simply as a handy source of bright light. The same methods are employed for calculating exposure from the guide number listed in the unit's instruction sheet, and the general principles of lighting a subject apply. However, the even illumination of bounce-lighting, with the flash aimed at ceiling or wall, may work for high-speed shots with some units but not with others (pages 30-31); certain types automatically lengthen the duration of their flashes as distance increases between the strobe and the first reflecting surface hit by the light rays—a bounced flash may turn out to be too long to stop fast motion. Some other points to bear in mind:

What action can be stopped. *The 1/1000-second or shorter flash provided by most units will freeze nearly any human activity—swimming, diving, prizefighting, dancing, jumping. To stop birds' wings, bursting balloons or splashing water, a flash shorter than 1/15,000 second is needed; many amateur units can also provide that. But it takes special equipment to catch a golf ball at the moment it is squashed by a club head (1/100,000 second) or to stop a bullet in flight (1/1,000,000 second).*

Adjusting flash duration. *The simplest way to get flashes of higher speed is to connect an additional number of lamps to the same basic unit (some units are manufactured to operate several lamps at once; others can be adapted to do so). This reduces the current available to each lamp tube, reducing its light output—and also the time it stays lit.*

The problem of ghosts. *The stopping ability of a strobe depends on the fact that the film is exposed only to the very brief flash of light from the lamp. If other light, on for a longer period of time, is also present, it too can create an image on the film—a blurred ghost of the frozen strobe image. This is seldom a difficulty when shooting staged pictures indoors—the room illumination can readily be kept so dim that it will not affect the film. But general illumination is obviously not so easy to control when taking pictures at sporting events and outdoors, and avoiding ghosts under those conditions requires special precautions that depend on the kind of camera shutter being used (see below).*

Avoiding ghosts with a leaf-type shutter. *The solution for cameras with leaf-type (between-the-lens) shutters, such as studio view cameras, twin-lens reflexes and many others, is very simple: Use a shutter speed of 1/500 second. This will block most of the general illumination but none of the strobe light.*

Avoiding ghosts with a focal-plane shutter. *This type of shutter is used on nearly all single-lens reflexes as well as some rangefinder cameras, and with such equipment there is no real solution, only dodges that may help under certain conditions. The reason is that most focal-plane shutters must be synchronized with flash at a shutter speed of 1/60 second or slower. (Because of the way such a shutter is made, only at these slow speeds can the entire negative be exposed at the same instant for flash illumination; higher speeds would leave parts of the film blank.) But 1/60 second is too slow to block much of the general illumination that causes ghosts. Closing down the lens aperture is little help; this blocks strobe illumination as much as it does general illumination. For black-and-white shots indoors where the illumination comes from incandescent lamps, a blue filter is effective; it blocks the red light that predominates in incandescent illumination, while having far less effect on the daylight-white light from a strobe. Another useful trick is to shoot action pictures in extremely dim light: Ask the tennis player to demonstrate his form for the camera at dusk.*

Automatic triggers. *With some practice, it is possible to learn to anticipate action and set off a strobe manually at the precise instant the action occurs. But automatic triggers are generally necessary. Only the strobe need be controlled for such pictures, since they are generally shot in a darkened room, the shutter being opened manually (as for a time exposure) before the action begins and then closed manually immediately after the strobe fires. The most popular automatic trigger consists of a photoelectric cell in an electronic switching circuit; when a moving object interrupts a beam of light aimed at the cell, the circuit instantly fires the strobe. The strobe is wired to the trigger circuit through the little plug that ordinarily connects the strobe to the camera shutter. Simpler automatic switches can also be rigged to the strobe's camera plug: Two strips of metal foil can be arranged so that they are forced into contact, completing the circuit, when a moving object strikes the strips.*

While many fast actions can be stopped with a shutter, the very brief flash of a high-speed strobe can give far sharper and more detailed pictures. It would be impossible for a mechanical shutter to close quickly enough to produce the extraordinary clarity in the photograph opposite, which stops a swimmer halfway through her perfect dive.

Using a strobe to make stop-action shots does involve certain cautions, however. With the focal-plane shutter used on most 35mm single-lens reflex cameras, for example, it is best to make such photographs in very dim light in order to avoid ghostly secondary images from existing light *(see box, left)*. Indoors, where illumination adequate to stop very high speed action might be difficult to provide, strobes are an invaluable aid.

Although the most powerful, professional strobe units can cost well over a thousand dollars, and are "portable" only with the help of a few assistants, a number of the simpler, lightweight units now available at moderate prices make strobe lighting a practical choice for any photographer interested in taking high-speed pictures.

To record the splash of a diver as she enters the water, Life photographer George Silk used a strobe that produced a flash of 1/4350 second. The picture was made from a window at water level, catching both the underwater turbulence and the symmetrical spray about the diver's legs. In order to adjust his timing to catch the action at precisely the right moment, Silk needed to see results as the shooting progressed. He solved the problem by using Polaroid Type 55 P/N film (ISO 50/18°), which gave an instant print for reference and also a permanent fine-grain negative for later enlargement.

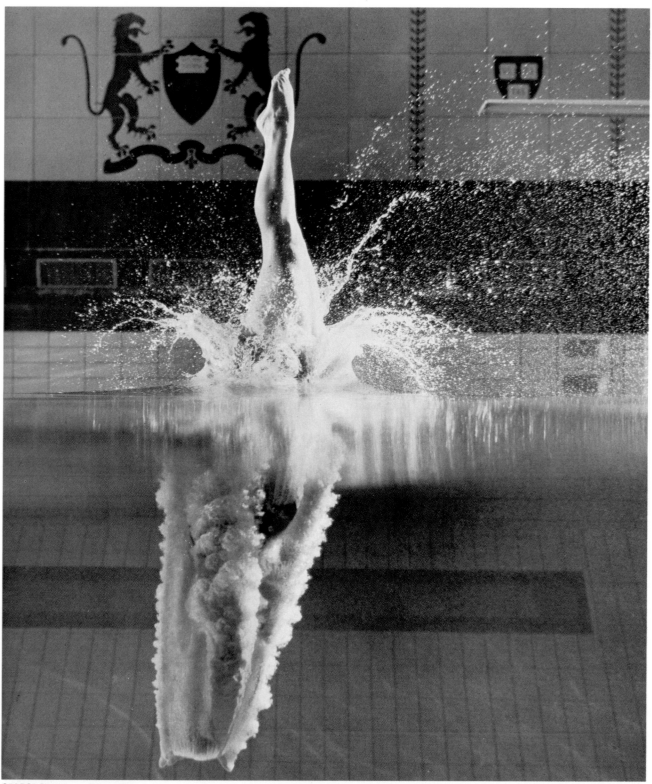

GEORGE SILK: *Young Diver*, 1962

Split-Second Studies of Nature

High-speed strobe shots of animals often provide revealing insights into their behavior. For example, Bianca Lavies' picture of a frog *(right)* superbly illustrates the manner in which the amphibian carries itself as it bounds through the air. Its forelegs are outstretched, poised to land, while its hindlegs are pulled up, ready to make another jump.

The photograph of the bat opposite yielded similar kinds of information, helping zoologist Merlin Tuttle understand the defense mechanisms of a particular frog-eating species that normally avoids poisonous toads by recognizing their distinctive mating call. To find out if the bat had a second line of defense when the toad was silent, Tuttle positioned a lone toad in total darkness. As the photograph shows, the bat was literally on the verge of biting into its prey, but in the next instant it flew away, leaving the toad unharmed. Tuttle concluded that the small protrusions around the bat's mouth are sense organs that detected the toxic secretion on the toad's skin.

Such moments are captured on a single frame of film by having these elusive subjects trigger the strobe themselves, since human reaction time is too slow. In both pictures shown here, the trigger was a photoelectric-cell device that fired the strobe when the subject passed through an infrared beam, used instead of visible light to avoid frightening the animal.

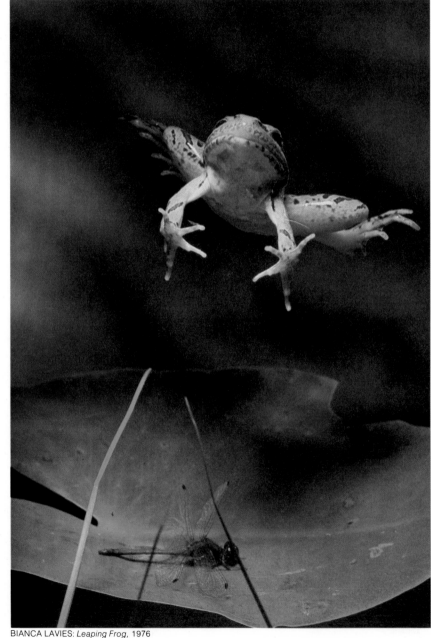

At the edge of a lake in Maryland, a common pickerel frog seems to hang suspended above a dragonfly on a lily pad. The agile amphibian took its own picture when it passed through an infrared beam and set off a 1/10,000-second flash from a strobe unit with three flash heads.

BIANCA LAVIES: *Leaping Frog,* 1976

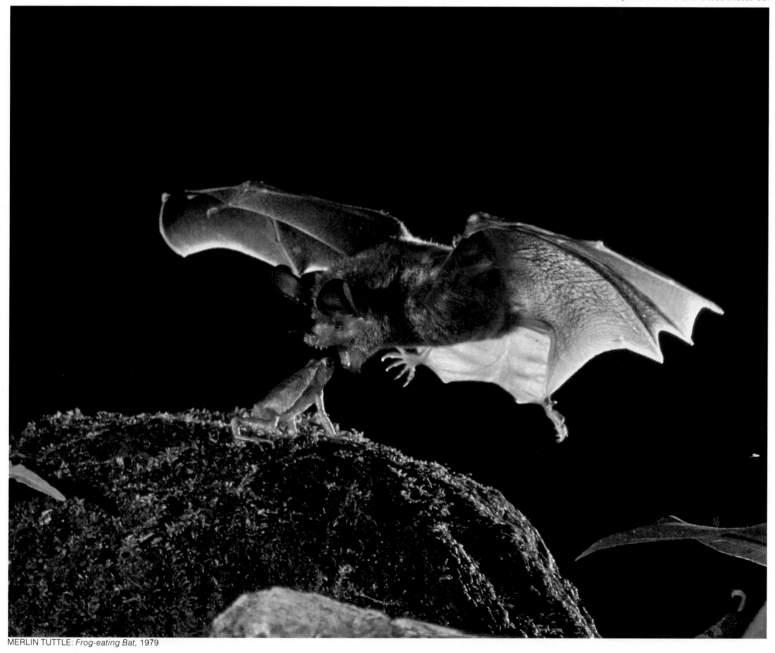

During an experiment in prey detection at a research station in Panama, a 1/30,000-second flash stops a frog-eating bat whose jaws are about to encompass the head of a toad. A fraction of a second later, the bat sensed that its would-be meal was poisonous and left the toad unscathed.

MERLIN TUTTLE: *Frog-eating Bat,* 1979

Stopping a Bullet in Mid-Air

Bullets moving as fast as 15,000 miles per hour have been stopped and examined in a great variety of photographic situations—bursting from gun barrels, shattering against metal plates, passing through light bulbs or even piercing balloons *(right)*. Such stop-action pictures are often the only way to study the characteristics of a bullet in flight, and some of the information gained has been completely unexpected.

When Harold Edgerton used a strobe-lamp exposure of a millionth of a second to photograph a .22-caliber bullet as it struck a steel block, the photograph revealed that the bullet liquefies for an instant, losing its shape as it compresses upon itself, much as in the pattern of the splashing milk drop shown on page 27. It then solidifies again into the fragments of the shattered bullet. Without the aid of high-speed photography, this discovery that a bullet "splashes" on impact might never have been made. □

A .22-caliber rifle bullet, traveling at a speed of 1,200 feet per second, is stopped (far right) after tearing through three balloons suspended from a string. The balloons are seen in successive stages of shredding. The exposure that captured this instant of action lasted 1/2,000,000 second.

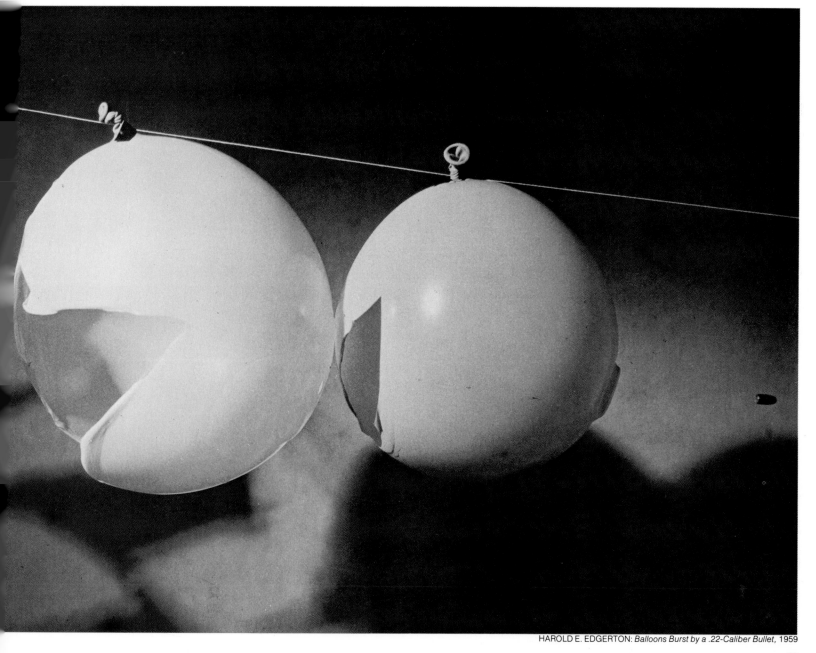

HAROLD E. EDGERTON: *Balloons Burst by a .22-Caliber Bullet,* 1959

Images of Motion Multiplied

Stop-action photography is more than a descriptive tool for revealing things the eye cannot see; it can also help analyze and measure them. While a single flash of a strobe lamp may stop a moving subject anywhere along its path, a rapid succession of such flashes can produce a multiple exposure that reveals many facts about how the subject was moving. Because the time between exposures is fixed and known, calculations of velocity, acceleration and distance can easily be made from such a photograph.

From the multiple exposure of a golfer's swing at right, for example, it is possible to determine not only the velocities of the club and the ball, but also such facts as how long the stroke took, the spin and angle of departure of the ball, and the twist of the club head after impact. Similar data can be derived from the multiple exposure of the gymnast on the opposite page.

Such photographs have found wide application in sports and other human endeavors in which technique and form play an important part. They also have become a valuable analytical instrument of science, providing a kind of visual calculus of motion. They have been used to settle many old disputes, for example whether a golfer's follow-through is important (it is not; the ball instantly takes off when struck), or whether the kick of a pistol affects the accuracy of a shot (it does not; the kick occurs when the bullet is several feet beyond the barrel).

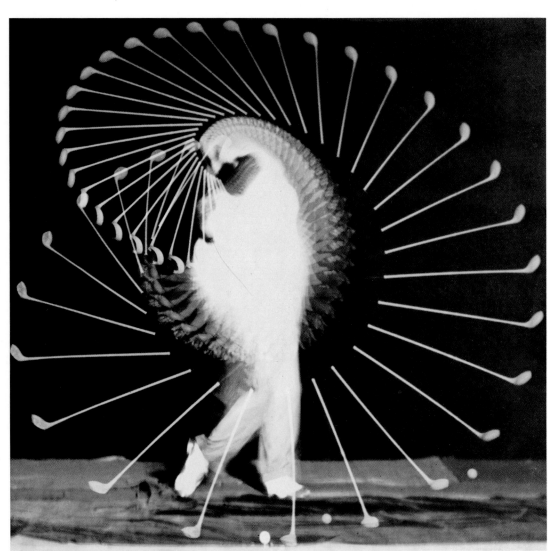

HAROLD E. EDGERTON: *Densmore Shute*, 1938

Analysis of this multiple exposure of the golf stroke of Densmore Shute, made with a 1/1,000,000-second flash every 1/100 second, reveals where the club is moving fastest: at the bottom of the swing, where the distance it covered between exposures is greatest.

In this photograph of gymnast Kurt Thomas ▶ performing the tricky Hecht dismount from the high bar, the overlapping of images at the high point of the sequence shows how he sustained his upward momentum long enough to adjust his position so as to land facing forward. The feat was recorded with a 1/1000-second strobe flash every 1/12 second.

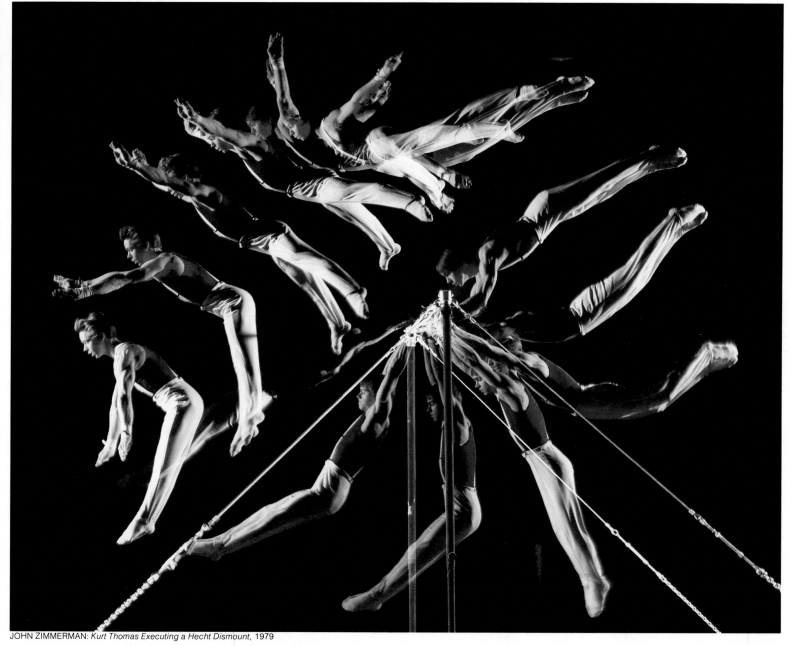

JOHN ZIMMERMAN: *Kurt Thomas Executing a Hecht Dismount,* 1979

Fleeting Images of Flight

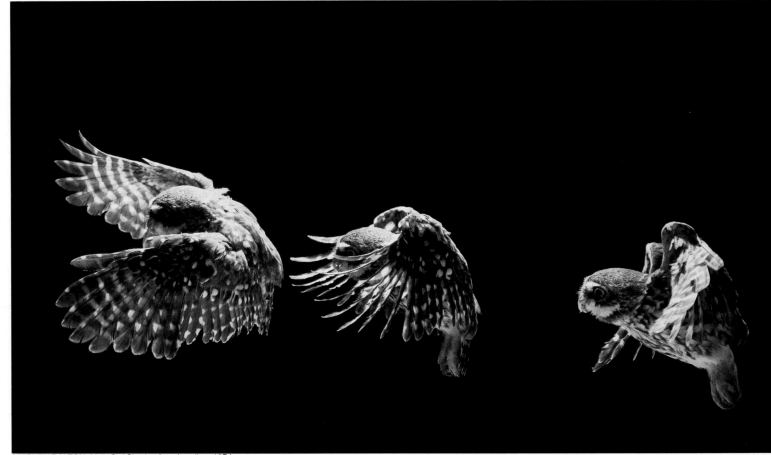

STEPHEN DALTON: *Little Owl Slowing for a Landing,* 1974

The extraordinary grace of birds in flight has been a perennial source of fascination to photographers as well as naturalists. High-speed strobe units have allowed the detailed examination of aerial maneuverings that otherwise could never have been detected, as illustrated by the remarkable sequence shown here of an owl slowing down for a landing.

The series of pictures was taken by the English naturalist and photographer Ste-

phen Dalton with a specially designed photographic apparatus that employs an electronic shutter that will open in 1/400 second—20 times faster than a mechanical shutter does.

At the heart of Dalton's complex system is a three-lamp strobe unit that emits flashes lasting only 1/25,000 second—a duration brief enough to still all but the most rapidly fluttering wings. The three strobe heads are fired one after the other

to freeze three images of the subject on one frame of 35mm film. Dalton shot the frame at right just as the owl was beginning to slow down. Then he repositioned the lights and camera so that the owl, on its second flight, would come into the camera's field of view as it completed its landing. Both the strobes and the shutter were triggered when the owl flew through a beam of light that was aimed at a photoelectric cell.

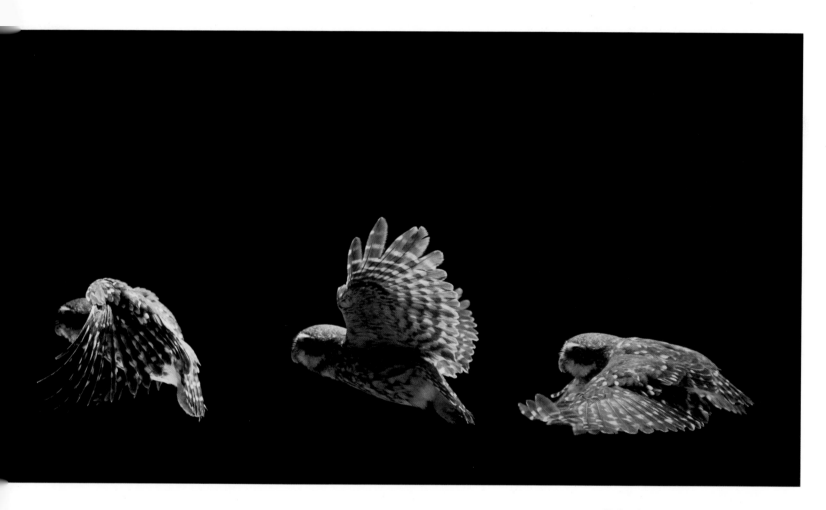

Six flash-frozen images on two frames of film trace in sharp detail the landing maneuvers of a little owl, as this small species is known. Changing from its normal mode of flight (far right), the owl slows down by dropping its tail and angling its body upward while simultaneously cupping its wings to create even more air resistance. The strobe unit was set to flash at intervals of 75 milliseconds.

Making High-Speed Multiple Exposures

Using a photoelectric cell, or electric eye, to set off a strobe flash is by now a common technique in high-speed photography when instant triggering of the strobe is critical. Human reaction time is often too slow, and so is a trigger activated by sound, as Harold Edgerton discovered while taking the picture on page 36. At first he tried to activate the strobe with a microphone placed to pick up the sound of the golf club striking the ball. But instead of capturing the moment of impact, his pictures showed the ball well on its way. Edgerton finally got the picture he wanted by using an electric eye to set off the flash.

In most instances, one photoelectric cell, receiving one beam of light, can be used to trick frogs, bats and bullets—as well as golf clubs—into taking their own pictures, without the intervention of the photographer's hand or eye. The result is either a single razor-sharp image, or a multiple exposure composed of several relatively distinct images.

On occasion, however, a more continuous record of a subject's movement may be desired. The photograph on the opposite page, a high-speed multiple exposure of a falling cup, was taken with a series of electric eyes that were placed in the path of the cup, setting off a strobe at fixed intervals, as shown in the diagram on this page. Each flash of the strobe lasted only 1/5000 second, and the shutter was held open throughout the one second it took the cup to fall and bounce off the foam-rubber pad. □

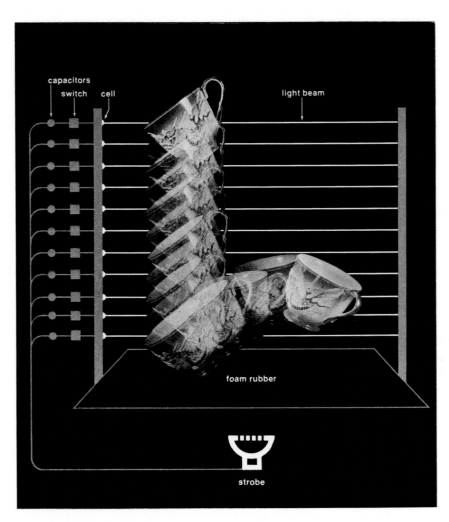

To produce a multiple image of a falling cup, photographer Lou Carrano set in place 11 photoelectric cells, spaced vertically at fixed intervals as shown above. Each cell received a narrow beam of light from a lamp opposite it and was connected to an electronic switch that would trigger a strobe when the beam to the cell was broken. After setting up a black velvet background and a foam-rubber mat at the bottom, Carrano darkened the room and dropped the cup past the battery of electric eyes. As the cup hit each line of light, it set off a strobe, producing the multiple exposure opposite.

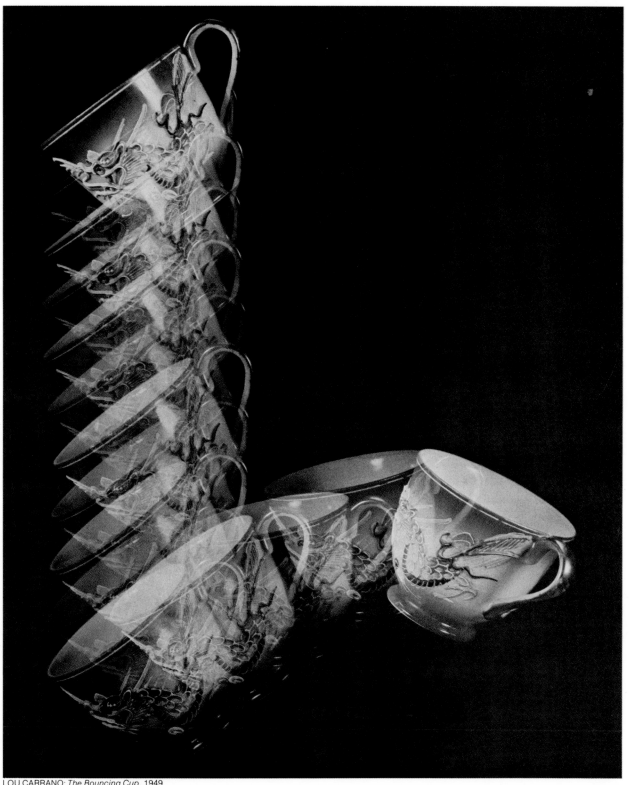

LOU CARRANO: *The Bouncing Cup,* 1949

Holding Patterns in Time

The time exposure is not a new photographic technique, nor does it require strobes or special equipment. When used to capture or compose images in motion, as in the photographs of moving light sources on these pages, long exposures become an important method of photographically manipulating time to record patterns the eye does not see in a single image.

Barbara Morgan, who made the photograph at right, began making her rhythmic "moving light designs" after devoting five years to photographing the modern dancer Martha Graham. "I started my flashlight swinging in my darkened studio," she recalls, "in front of an open shuttered camera, to build up images in time on a single negative." Dressed in a black gown and hood, so as not to record her own image on the film, she created the thicker lines by moving her flashlight slowly, the finer lines by moving it rapidly.

Naturally occurring patterns of light, captured in a long exposure, can produce equally fascinating and esthetic photographs. The streaked and stringy patterns of automobile lights on highways, for example, have been photographed with striking effect. Robert Mayer's montage of airport lights *(opposite)*, photographed from a landing plane, is a dramatic blend of movements that only the camera can hold together in a single pattern. □

A moving light design (right) was made by Barbara Morgan with a flashlight in front of an open shutter in a darkened studio. Morgan says the title refers to a state of being in Buddhist thought, reflecting a concept of wholeness and continuity. Total exposure time for the photograph was about three seconds.

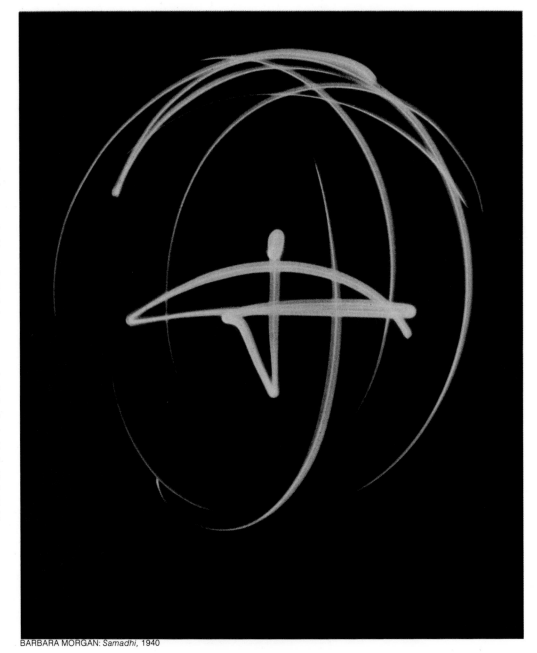

BARBARA MORGAN: *Samadhi,* 1940

A time exposure of 10 seconds captures the cumulative patterns of lights at LaGuardia airport in New York, as photographed from a landing plane. The blue wavy lines at bottom were traced by runway lights, the orange and yellow patterns by the lights of buildings, and by trucks shuttling about the runways.

ROBERT MAYER: *Aerial Abstract*, 1969

A Patient Recording of Change

Time-lapse photography is a technique for contracting time to record movements and capture images that pass too slowly for the human eye to discern. Astronomers, by focusing their cameras on a distant star at fixed intervals over many years, can detect wobbles in its path that reveal the number of satellites orbiting about it. Scientists have used the same technique in studying the growth of crystals under a microscope, or capturing in a single set of photographs all the stages in the life cycle of a plant or an insect. And because time-lapse photographs can provide a point of reference that ordinary observation does not, they reveal the slow, wayward migration of nerve cells in the living tissue of an animal's brain.

The rising and dipping of the midnight sun over Norway was recorded by Emil Schulthess and Emil Spühler in time-lapse photography at hourly intervals as it remained in the sky for a full 24 hours. To the human eye the sun would appear motionless at any point in this time sequence. But the time-lapse photographs provide a precise record of its path across the sky, following its movement from horizon to horizon.

In one of the more unusual applications of the technique, time-lapse photographs of a blossoming rose were used to settle a patent suit over a process for freeze-drying penicillin. The freeze-drying process required several hours, too long for it to be demonstrated in a courtroom. Photographer Henry Lester proposed to record the process in time-lapse photographs, but lawyers for the pharmaceutical firm involved in the litigation feared the court would not accept such pictures as an accurate representation. The exposures would seem too short, and the intervals between each frame too long, the lawyers feared, to establish the continuity of the process. So Lester set up his equipment before a rosebud. With a tripod-mounted camera and a strobe adjusted to flash every two minutes, he exposed 720 frames a day for six days while the rosebud filled out and burst into bloom. A sampling of the photographs *(opposite)* not only convinced the company's lawyers that the technique would provide an indisputable record of the process, but also persuaded the pharmaceutical firm's adversaries that their case would be lost if brought to trial. The suit was settled out of court, and Lester never had to photograph the freeze-drying process itself.

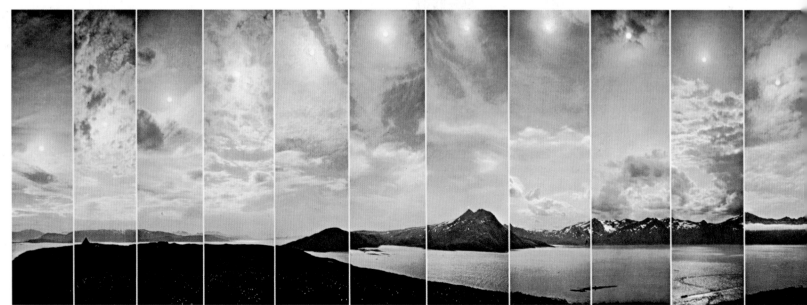

EMIL SCHULTHESS and EMIL SPÜHLER: *A Day of Never-setting Sun,* 1950

The transformation of a rose from bud to blossom is recorded in six time-lapse photographs, part of a considerably longer sequence of pictures. These exposures were made every two hours. A strobe light with a flash of 1/10,000 second provided illumination; ordinary floodlights turned on repeatedly might have harmed the flower with their heat.

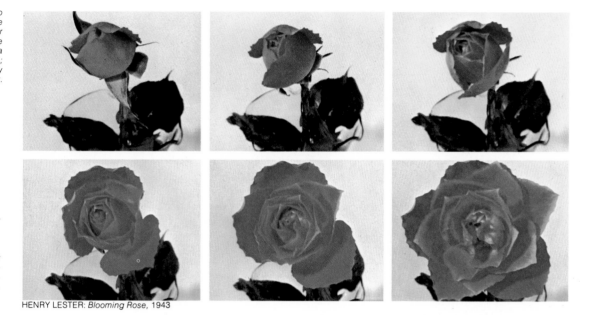

The spectacle of the midnight sun occurs every year in the sky over northern Scandinavia. These time-lapse photographs were made on a Norwegian island far above the Arctic Circle. Exposures ranged from 1/60 second at f/16 to 1/15 second at f/8, and the interval between exposures was precisely one hour. The sequence of exposures shows the sun in the sky for all 24 hours of the day and night.

HENRY LESTER: *Blooming Rose*, 1943

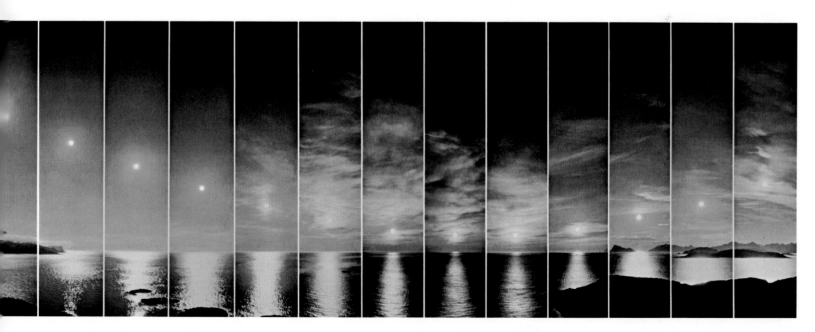

A portrait of the four seasons is revealed in these long-scale time-lapse photographs of a field in the Emmenthal Valley of Switzerland. The photograph at top left was made in April, at top right in August, at bottom left in October and at bottom right in February. In each case the camera was placed at precisely the same point (note the tree in the bottom left corner of each picture), at the same time of day—about two o'clock in the afternoon. With the exception of the October picture—shot at 1/60 second at f/18—the photographs were shot at the same exposure, 1/125 second at f/11. By its manipulation of time, the camera made visible at a single glance the slow sweep of a whole year in nature.

MAX MATHYS: *The Four Seasons*, 1968 and 1969

Pictures Bigger than Life **2**

ERWIN MÜLLER: *Field Ion Photomicrograph of Iridium Crystal,* 1969; magnified 350,000X, here enlarged to 2,000,000 times actual size

Photographing the Very Small

Photography gives microscopes a memory. It is the indispensable tool that enables scientists to make lasting records of the all-too-brief glimpses they get of the infinitesimal world before the microscope's lens. For the photographer, magnified pictures of this world of the very small offer subjects full of surprise and beauty. Photographs of ordinary objects can reveal unsuspected designs, shapes and colors: the symmetry of a weed's thorny seed pod; the complexities of a sliver of wood; the brightly hued markings of a moth. The methods can be simple *(pages 54-55 and 68-69)* and require only a moderate investment in special equipment.

To the scientist using elaborate microscopes and cameras, such magnified pictures serve a utilitarian purpose (though many of the scientists' photographs are strikingly beautiful as well). The world of the small can be fragile; tiny botanical specimens wither, living cells sandwiched in glass soon die, atoms are so elusive that they must be magnified millions of times to be pictured. Photographs provide a lasting record of these ephemeral phenomena before they disappear. A record is necessary also because such images can generally be seen in the microscope by only one person at a time. To be fully studied and understood, the images must be captured and disseminated among many scientists, teachers and students. Only through photography can accurate records be provided for protracted analysis and study.

Magnified pictures, whether taken by amateurs for pleasure or by scientists for study, are of two kinds: photomacrographs and photomicrographs. The boundaries of the two classifications, though they overlap a bit, are determined by the size of the object being photographed, by the kind of equipment needed to take the picture and by the intended purpose of the picture. These terms should not be confused with microphotography, which is the process for making very small pictures *(pages 184-185)*.

Photomacrographs *(pages 52-57)* are pictures of moderate enlargement, usually up to 10 to 30 times life size, of small objects that ordinarily would be viewed through a magnifying glass. A camera lens works like a magnifying glass and can be used to provide the same kinds of enlarged views—of the structure of a tiny seashell, for example. And for photomacrographs, the camera lens itself is generally used, aided perhaps by some simple attachments, but not connected to a microscope.

Photomicrographs *(pages 58-94)* are pictures of objects that have been magnified from about 10 times life size up into the millions—objects so small that they must be photographed through a microscope. In making photomicrographs the microscope takes the place of the camera lens, although it is possible in some instances to connect a camera to a microscope and get acceptable pictures without removing the camera lens.

Microscopes used for research photomicrography may be so large and

complex that a single one can take up much of a laboratory bench. Some employ unusual methods of manipulating light waves to create magnified views, while others do not work with light waves at all but create their images from beams of electrically charged atoms or atomic particles. Yet among the most interesting photomicrographs are those made with the small easy-to-use optical microscopes familiar to generations of high-school biology students. (Inexpensive versions of this instrument, available by mail order or in hobby shops, are somewhat less versatile and precise but are quite serviceable for occasional photomicroscopy at moderate magnifications.)

With most such instruments, the subject can be made to look quite dark against a white background — a bright-field view — or it can be made to look bright against a dark background — a dark-field view — and reveal completely new aspects of its structure. And if polarized light is used, startling color effects appear, particularly in certain minerals and biological specimens.

Magnified views of these kinds introduce a strange element of confusion. They seldom contain anything that indicates their true size. And photography has the unique and invaluable ability to depict the size of microscopic objects on two different scales of measurement at the same time. The first scale is the original magnification of the object into an image on film. But if a larger picture of the object is wanted, the image can be blown up by making an ordinary darkroom enlargement. This gives the object a secondary measurement: The original magnification remains the same but now the object is depicted proportionately larger. Thus a pinhead-sized sea creature photographed at a magnification of 100 times (100X in scientific shorthand) and then enlarged photographically 10 more times will be 1,000 times life size.

The ability to record the basic structure of things as they really are is photography's ultimate contribution to the science of microscopy. And it was this ability that led Robert Koch, the great German bacteriologist, to persuade his fellow scientists in the 1870s to forsake artists' drawings in favor of photomicrographs. "Drawings of microscopic objects are very seldom true to nature," said Koch. "They are always more beautiful than the original."

Koch was only half right. What photography has proved is that the original in nature is more beautiful than any microscopist had imagined. □

The Lens as Magnifier

A photomacrograph takes up where an extreme close-up leaves off. As in the 3-times-life-size view of a jimson weed seed pod opposite, it makes details big enough to be seen clearly—details that would otherwise have to be looked at through a magnifying glass. But the magnification is still small enough for the subject to be seen whole, without having to be cut into paper-thin slices to fit between microscope slides.

To make a photomacrograph, special lenses or lens attachments can be used, or, if the regular camera lens is removable, it will serve. The lens must be extended from the camera body—or more precisely, from the film inside the camera—by means of a tube or bellows. Extending the lens farther from the film has a magnifying effect, just as it would with an ordinary magnifying glass. This happens because the farther away the lens is moved from the film, the more space there is available for the image-forming light beam to spread out as it goes from the lens to the film.

Tube and bellows lens extensions are available as accessories for most cameras. The bellows permits adjustment of the lens extension to achieve various degrees of magnification; the tubes are rigid and each gives a predetermined degree of magnification, depending on its length, for a particular lens.

The focal length of the lens also plays a part in the magnification. A lens with a short focal length can be focused nearer to the subject. Therefore it gives a larger image than a lens with a longer focal length. (The reverse is true, of course, when the lenses are used in the normal way, without extensions.)

Besides a way to extend the lens, there is one other prerequisite for taking photomacrographs: a camera permitting a direct, through-the-lens view of the subject while focusing, that is, either a single-lens reflex or a view camera that has a ground-glass focusing screen. A direct view is essential because magnification of a subject reduces the camera's depth of field drastically. Focusing is therefore so critical that it cannot be done by measuring distances and must be checked by viewing the image itself.

The procedure for taking life-size or larger-than-life pictures is much like that in extreme close-up photography. Pictures can be taken outdoors; indeed, certain aspects of live subjects like insects are better photographed in a natural environment *(page 56)*. More often, however, it is desirable to collect specimens and then photograph them later indoors, where focusing, background and lighting can be more easily controlled. However, no elaborate studio is needed. The photomacrograph shown here was made by New York photographer Robert Weiss in his apartment. Weiss shot the seed pod using a vintage 4 x 5 studio view camera with a 6½-inch f/6.8 lens (a separate bellows attachment was not needed).

Most photographers will find it equally easy to adapt and use a 35mm single-lens reflex camera, as described in the do-it-yourself photomacrography instructions on the following pages.

RALPH WEISS: *Jimson Weed Seed Pod,* 1968; photographed life size, here enlarged to 3X

Taking Photomacrographs

A basic outfit for shooting life-sized and larger close-ups is shown at right, and the procedure is described in the steps that start below. The equipment centers on a bellows attachment (2) that fits between a 35mm SLR camera body and its normal 50mm lens (3). This combination can magnify up to 8½ times life size, depending on how far the bellows is extended. Adding a supplementary bellows (1) and a wide-angle lens (5) gives even greater magnifications.

Because split-image and microprism screens often misfunction with extended lenses, a ground-glass focusing screen (4) is a useful accompaniment, as are a double-ended cable release (7), to stop down the lens and trigger the shutter simultaneously, and a photoflood light (8). Reflectors (9) and backgrounds (10) can be improvised, but a sturdy tripod (12) with a flexible head (11) is vital, for magnification exaggerates camera shake. It is wise to bracket exposures by making extra shots at one stop above and one below the calculated reading.

1 **bellows extension**	7 **double cable release**
2 **bellows**	8 **clamp light with 200-watt photoflood**
3 **35mm camera with 50mm f/1.4 lens**	9 **white cardlike reflector paper**
4 **ground-glass focusing screen**	10 **background papers**
5 **20mm f/3.5 lens**	11 **double-tilt head**
6 **metric ruler**	12 **tripod**

1. A butterfly that is just under 36mm long is a good subject for life-sized reproduction on a 35mm frame, since its length is about the same as the long dimension (36mm) of the film.

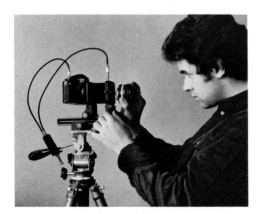

2. Mount the bellows unit on the tripod head and attach the camera body to the rear of the bellows. Hook up the double-ended cable release and attach the lens to the front of the bellows.

3. To determine bellows length, divide subject size into film size (36mm ÷ 36mm = 1), multiply by lens focal length (1 x 50mm = 50mm), and compress the bellows to the proper reading.

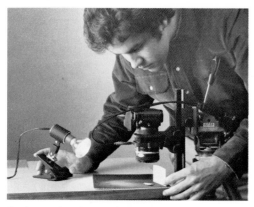

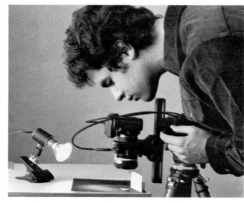

4. Arrange the subject on the desired background and position the camera over it. A photoflood set at an angle with a white card to act as a reflector is often sufficient lighting.

5. Set the lens's focusing ring on infinity, look through the viewfinder and bring the subject into focus by racking the camera-bellows unit up and down with the knob on the bellows railing.

Set against a black background to bring out its rich coloring, a butterfly specimen almost fills a frame of 35mm film. This life-sized (1X) magnification, taken with the compressed bellows as shown in Step 7, is presented here enlarged to about twice its actual size.

6. To increase depth of field, set the lens to a relatively small aperture, f/8 or f/11. Check the effect by pressing the preview control on the bellows that stops down the lens's iris.

7. Take a light reading with the camera's meter, using an 18 per cent gray card for a very light or dark subject. Set the shutter speed and make the shot with even pressure on the cable release.

One of the orange spots on the butterfly's wings was photographed with the 50mm lens and the bellows and extension, as shown in Step 9, to achieve a magnification of 8½ times life size. The image shown here is enlarged photographically to approximately twice that size.

8. Mounting the lens in reverse is a simple way to increase magnification, but it also fixes the focusing distance. Greater flexibility is possible if reverse mounting is used with a bellows, as shown.

9. Even greater magnifications can be obtained with a supplementary bellows set between the first bellows and the reversed lens. The total 438mm extension is shown here with a reversed 50mm lens.

Insect Studies Indoors and Out

With a living subject like an insect, the photomacrographer must decide whether to bring it indoors for shooting or to record it in its natural environment. There are advantages to each approach. Indoors, the photographer has much more control over both his equipment and an often unpredictable subject. In getting the picture of the tiger moth at right, Claude Nuridsany and Marie Péronnou were able to arrange lighting that not only made the moth's wings glow translucently but illuminated its face and body as well. They were also able to keep their bellows-equipped camera steady on a tripod while composing the tight shot. Moreover, the indoor photograph probably reveals more details of the insect's color pattern (the subject of the photographers' interest) than any picture taken in the field could.

By contrast, the shot opposite of a dragonfly minutes after it emerged from its nymphal exoskeleton would be difficult to re-create in a studio, because the metamorphosis is prompted by climatic conditions: It most often occurs the morning after a rain that ends an extended dry spell. Photographer Robert Noonan required preliminary field observations and patience—and then had to wade waist-deep in a pond on the designated morning—in order to capture the moment of the dragonfly's transformation.

The key to Noonan's success was the freedom of movement he gained by trying for a relatively modest magnification and keeping his gear simple. Extension devices make a camera hard to handle, so he used only macro lenses, limiting himself to magnifications from 1/2 to 2 times life size. A tripod was unnecessary, since he employed an electronic flash to freeze his subject. □

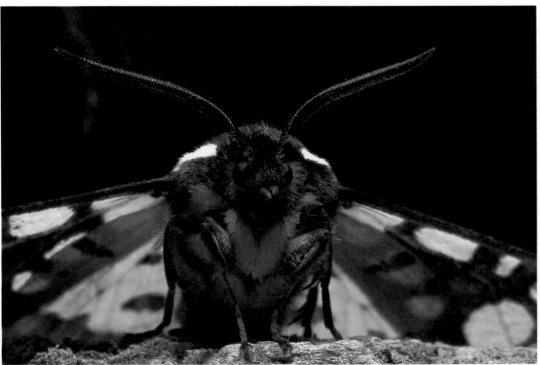

CLAUDE NURIDSANY AND MARIE PÉRONNOU: *Tiger Moth,* 1973

The red and yellow markings of a tiger moth are brilliantly displayed in this studio shot, taken with a flash positioned behind the subject and with reflectors set near the camera to bounce light onto the moth's front. The insect is in the stance it adopts when threatened, drawing its front wings forward to show off the colorful pattern of its rear wings, which helps to warn a predator that the moth is poisonous. Magnified 1.4 times, the moth is seen here enlarged to 7 times life size.

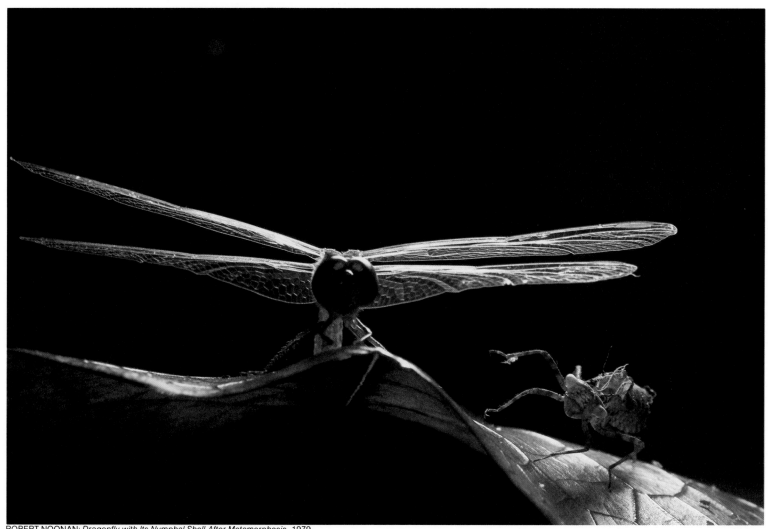

ROBERT NOONAN: *Dragonfly with Its Nymphal Shell After Metamorphosis*, 1979

*A dragonfly stretches and expands its wings
moments after breaking out of its nymphal shell
(right) in this photograph made in the field. To
simulate sunlight on the wings, the photographer
used a single electronic flash unit held at a
45-degree angle to the side. He had to work quickly
because it takes only about eight minutes for the
insect's wings to harden enough for it to fly. The
subject was magnified by half and is reproduced
here enlarged to 3 times life size.*

Photographing through the Microscope

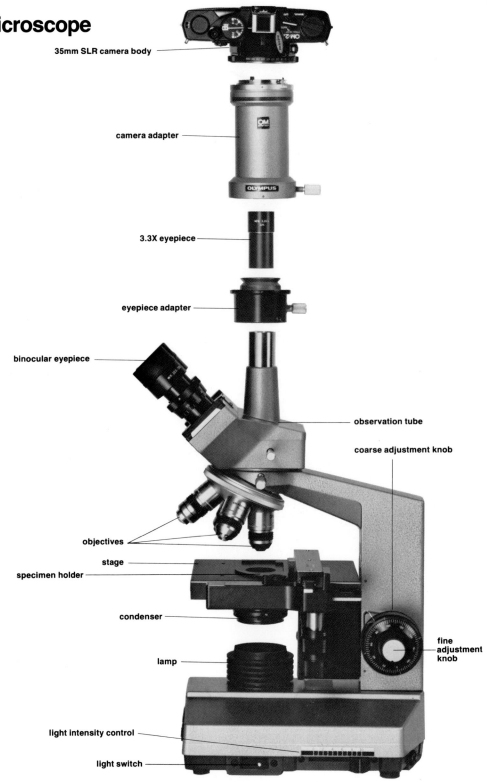

35mm SLR camera body

camera adapter

3.3X eyepiece

eyepiece adapter

binocular eyepiece

observation tube

coarse adjustment knob

objectives

stage

specimen holder

condenser

fine adjustment knob

lamp

light intensity control

light switch

Beyond the reach of the bellows and reversed lenses that enable a camera to make pictures several times life size is a world of images too small to be seen by the human eye—but easily reached by connecting the camera to a microscope. A typical modern college-laboratory microscope like the one at right may be quickly adapted for photography by attaching a special observation tube that provides a second view of the specimen in addition to the one through the microscope's regular binocular eyepieces.

An eyepiece is inserted into the tube using a special adapter, and a 35mm camera body with its lens removed is attached to the eyepiece by means of another adapter. The photographer is able to focus by looking through the camera's viewfinder as well as through the microscope's regular eyepieces, but the viewfinder must be consulted to check the camera's meter readings.

Total magnification is the product of the powers of the objective lens (the lens nearest the specimen) and the eyepiece: An image created with a 10X objective and a 5X eyepiece, for example, would thus have a 50X magnification. The objectives, which are mounted on a rotating turret, typically have magnifying powers ranging from four to 100 or more times life size, while eyepieces can magnify from one to 30 or more times.

Even a moderately good microscope requires a substantial investment if it is bought new. A good second-hand model, however, can often be purchased at a great savings and usually yields better-quality images than an inexpensive new one. If the microscope has no provision for a separate observation tube, its regular eyepiece can usually be adapted for picture taking.

4X objective

10X objective

40X objective

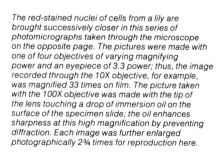
100X objective

The red-stained nuclei of cells from a lily are brought successively closer in this series of photomicrographs taken through the microscope on the opposite page. The pictures were made with one of four objectives of varying magnifying power and an eyepiece of 3.3 power; thus, the image recorded through the 10X objective, for example, was magnified 33 times on film. The picture taken with the 100X objective was made with the tip of the lens touching a drop of immersion oil on the surface of the specimen slide; the oil enhances sharpness at this high magnification by preventing diffraction. Each image was further enlarged photographically 2¾ times for reproduction here.

Details on a Light Background

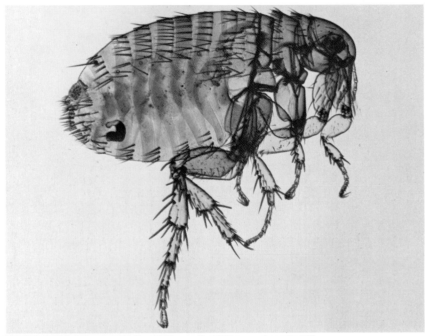

LEWIS W. KOSTER: *Egyptian Rat Flea,* 1967; magnified 27X, here enlarged to 50X

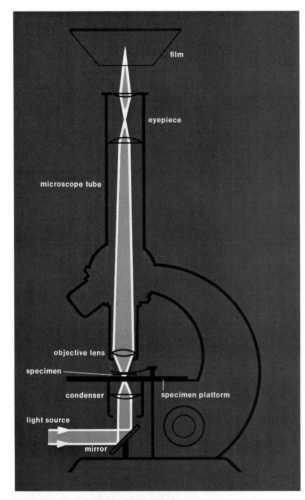

film

eyepiece

microscope tube

objective lens

specimen

condenser

specimen platform

light source

mirror

To photograph a specimen with the use of bright-field transmitted light, the light is directed into an angled mirror that is attached to the bottom of the microscope. This mirror deflects the light beam upward into a condenser lens. The condenser concentrates the beam and sends it through the specimen. Rays of light from all parts of the specimen now travel upward into the objective lens, which focuses the rays into a magnified image of the specimen within the microscope's eyepiece. The upper element of the eyepiece magnifies this image once again and transmits it to the film in the camera.

The clarity and detail of a photograph taken through a microscope depend to a large extent on how the specimen is illuminated. Different systems can be employed to control the direction and quality of the light, according to the specimen that is being viewed.

The most common system, illustrated on this and the opposite page, is bright-field illumination. With it, the subject is fully illuminated by direct beams of light that flood the specimen over the entire field of view. A key photographic advantage of bright-field illumination is that, in delivering the greatest amount of light to the subject and thence to the film, it keeps exposure times relatively brief. By contrast, other systems, described on the following pages, sacrifice some of the illumination coming from the microscope's light source in the process of achieving their special effects.

In bright-field illumination, the direction from which the light is aimed varies with the specimen. For semitransparent specimens, such as the insect shown above, the light is aimed upward and transmitted through the specimen *(diagram, right).* For specimens that are not transparent, such as metals, it is necessary to direct the light downward *(diagram and picture, opposite).* Such "incident" light is then reflected back to the microscope objective lens in order to create the image.

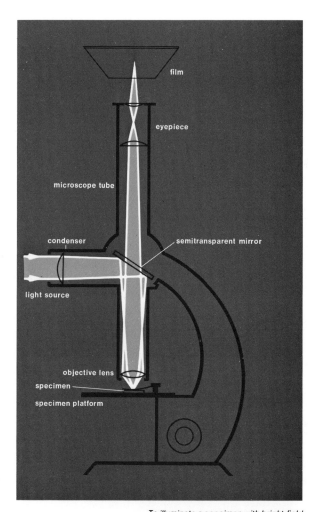

EUGENE S. ROBINSON: *Annealed and Etched Brass,* 1970; magnified 61.5X, here enlarged to 120X

To illuminate a specimen with bright-field incident light, the light beam goes through a condenser lens to a semitransparent mirror inside the microscope tube. The mirror deflects the light down to the specimen. Rays of light, reflected up from the specimen into the objective lens, are focused and sent on to the eyepiece and to the film in the same way as transmitted light. The size of the image recorded on the film, in both cases, is determined by the lenses used and by the distance between film and eyepiece: The greater this distance, the larger the image.

Details on a Dark Background

LEWIS W. KOSTER: *Egyptian Rat Flea,* 1967; magnified 27X, here enlarged to 50X

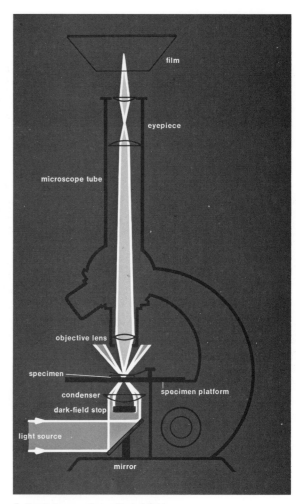

In photographs of many microscopic subjects, certain kinds of details can be emphasized and others defined more clearly if the specimen is not illuminated with a head-on beam of light but instead with oblique, glancing rays. Only the light that is sent back to the objective lens by the specimen itself forms the image. Everything around it looks dark; therefore, this system of lighting is called dark-field illumination.

As with bright-field photomicrography *(pages 60-61),* the light can come from in front of or behind the specimen, so that both opaque and transparent objects can be photographed. The pictures above, for example, show the insect and piece of metal that were previously photographed in bright-field.

But now they are seen in altogether different aspects. The nearly transparent insect shows up only in outline form, but its shape is more clearly profiled and the minute hairs on its surface are more visible because they catch the glancing rays of light produced by dark-field illumination. In the picture of annealed brass *(opposite),* regions that have different physical characteristics are seen in bold contrast because each reflects light differently.

Beyond its great scientific usefulness, dark-field illumination—with its dramatic emphasis on the extremes of highlight and shadow—offers excellent opportunities for adding esthetic value to photomicrographs, as these pictures amply demonstrate.

To illuminate a specimen with dark-field transmitted light, an opaque disk called a dark-field stop is placed in the path of the light beam just before it reaches the condenser lens. The stop prevents light from going through the center of the condenser, permitting only a cone of light to pass obliquely through the edges of the condenser lens. This portion of the light continues in an oblique path, missing the microscope's objective lens. Only those rays that bounce off features within the specimen itself and are deflected from their oblique path can be sent upward into the objective lens of the microscope to form the photographic image.

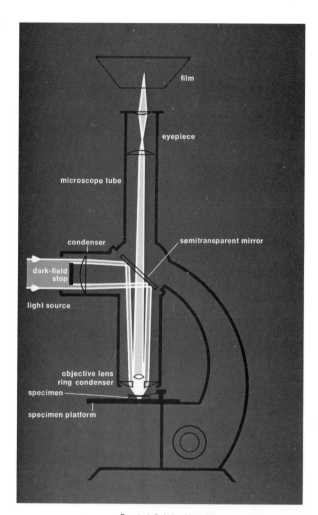

film

eyepiece

microscope tube

condenser

semitransparent mirror

dark-field stop

light source

objective lens
ring condenser

specimen

specimen platform

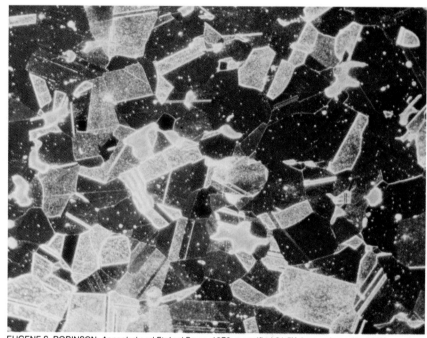

EUGENE S. ROBINSON: *Annealed and Etched Brass,* 1970; magnified 61.5X, here enlarged to 120X

*For dark-field incident light, an angled mirror that
is partially transparent is placed inside the
microscope tube opposite the light source. A
dark-field stop is placed in the path of the beam
before the rays get to the condenser and
mirror; this enables light to be reflected
downward toward the subject only from the edges
of the mirror. This light is angled by the mirror so
that it passes around the objective lens but goes
through the ring-shaped condenser to reach the
specimen. Some of the light rays bounce up
from the specimen, pass through the objective
lens and the center of the semitransparent mirror,
and finally enter the eyepiece to form the image.*

Filters That Create Color

Some of the most spectacular pictures taken through a microscope—and many of the most useful—are obtained by taking color photographs using polarized light. With this kind of illumination the specimen that has little color to start with can be made to exhibit many different shades and hues. This effect is demonstrated in the series of photographs *(opposite)* that *Life* photographer Fritz Goro made of a single moon rock, its colors changing from picture to picture to show structural details clearly. The polarized-light technique is also able to reveal the physical properties and composition of many objects, since these characteristics influence the manner in which the objects react to polarized light.

Polarized light is produced by putting special filters, both made of polarizing material but called the polarizer and the analyzer, in the path of the microscope's light beam *(diagram, right).* When rays of ordinary light, undulating in all directions, hit the polarizer, only those rays that are undulating in one particular plane pass through. These rays alone then penetrate the specimen, and if the specimen has polarizing properties, the ray is divided into two components, which travel at different speeds. These rays continue up the microscope, each traveling at a different angle, to the analyzer. Because one of the components travels slightly slower within the specimen, it arrives at

the analyzer behind the other component. As a result, the two components interact, canceling some wavelengths—colors—and reinforcing some others to create the hues that are seen.

Entirely new colors may be obtained, as Goro did with the moon rock, by moving the analyzer around until it passes rays that have traveled at a different angle and interacted differently to produce still another combination of wavelengths. (The light could be transmitted through the rock because the specimen had already been sliced to about a 1/1000-inch thickness for microscopic examination.)

Stronger and more brilliant colors can be obtained if a third optical element, called a retardation plate, is placed in the microscope between the objective lens and the analyzer. Its function is simply to slow the rays down more than the specimen alone would.

Microscopes that have built-in polarizing components are expensive, but polarized color photomicrographs can be produced by modifying any microscope. All that is needed are two small pieces of polarizing material, which can be obtained at almost any photographic supply store. Attach one piece of the material below the condenser, in the position that is shown in the diagram. Then remove the eyepiece and attach the other piece of polarizer to the bottom of the lower lens of the eyepiece.

To produce polarized light for brilliant color pictures with a microscope, a polarizer—a polarizing filter—is placed in the light beam below the condenser. The polarizer permits only rays that are undulating in a single plane to pass. These go through the condenser where they are concentrated and sent on through the specimen. The specimen itself alters the polarized beam and sends it up through the objective lens. The beam then passes through a retardation plate, which slows it down and enhances the color-creating process, and then through the analyzer that produces the colors seen in the image and recorded on film.

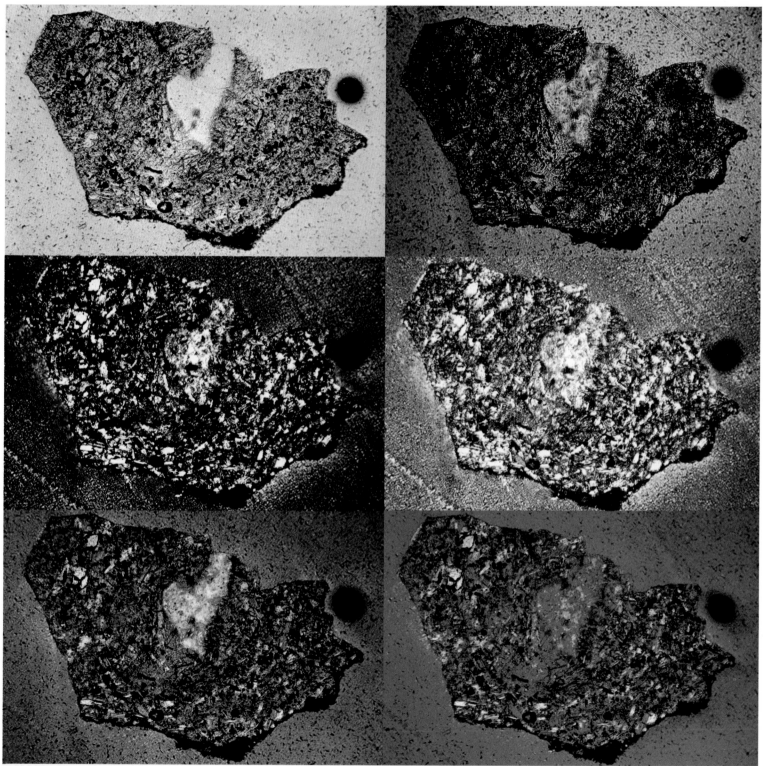

FRITZ GORO: *Polarized Pictures of Moon Rock,* 1969; magnified 16X, here enlarged to 45X

Prisms That Add Contrast

The complex instrument diagramed at right has an equally complex name— the Nomarski differential interference-contrast microscope (it was invented by the French optical expert G. Nomarski)—but it gives detail and form to specimens that would in most cases show up in photographs as vague and hazy. It does this by greatly increasing the contrast of things that have virtually none to begin with, making their features clear and often adding a three-dimensional effect. For example, the two planktonic fossils that are shown in Fritz Goro's pictures opposite are extremely thin and normally almost transparent. With the special lighting this microscope produces, the edges and internal structures of the specimens are transformed into what appear to be bas-reliefs, bringing out characteristics that could not be recorded with conventional instruments.

The Nomarski microscope has an optical system that is as complicated as its name. The way it works is fairly easy to follow, however. A beam of polarized light is sent through a double prism that splits the beam into two beams, altering their polarizations so that each is now polarized differently. These are then sent through the specimen, which makes some rays in each beam travel slower than equivalent rays in the other beam. After entering the objective lens of the microscope, the two beams are drawn together by the second double prism and the rays that had traveled at different speeds interact to give the image of the specimen more shadows and depth. Since the slowing effects depend on wavelength, the interaction of the waves emphasizes some colors, and this is made apparent by the second double prism and a second polarizing filter called the analyzer.

To illuminate a specimen for photography with the Nomarski interference-contrast microscope, light is directed from the side of the microscope to an angled mirror that sends the beam through a polarizer and a double prism. The prism splits the beam in two, each now of different polarization. These beams then pass through the condenser, which alters their paths so that their light rays become parallel and pass through the specimen side by side. The rays in each beam continue upward into the microscope's objective lens and pass through another double prism that draws them together again and, with the aid of the analyzer, reveals the colors.

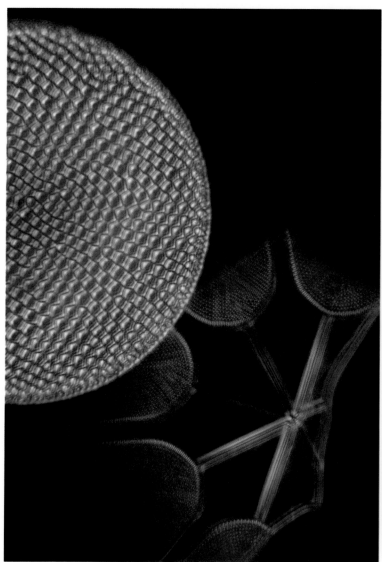

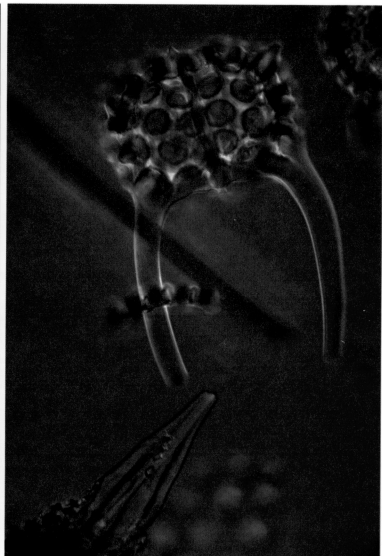

FRITZ GORO: *Diatom Fossils,* 1969; magnified 300X, here enlarged to 1,350X

FRITZ GORO: *Protozoa Fossils,* 1969; magnified 100X, here enlarged to 450X

The Amateur's Photomicrographs

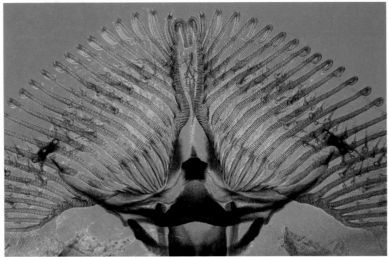

Mouth of Blowfly, 1967; magnified 25X, here enlarged to 70X

Oak Wood, 1969; magnified 50X, here enlarged to 145X

The picture-taking opportunities afforded by photomicrography are not limited to photographers with complicated instruments. Mortimer Abramowitz, a Great Neck, New York, school superintendent, took the beautiful photographs on these pages with quite inexpensive equipment: a 35mm SLR and a 1905 microscope he bought second-hand. The only exception is the picture at top left on the opposite page, which was made with an inexpensive camera with a nonremovable, fixed-focus lens, and a microscope of the type once used in elementary schools.

Given a choice, it is better to use a camera that has a removable lens since magnification and focusing are done with the microscope alone. An SLR or view camera, both of which permit a direct view of the microscope image, is preferable to a fixed-lens camera, which has two drawbacks: The lens may cause reflections or distortions in the image if the camera is not mounted just right, and the camera must be removed from the microscope each time a new image is focused.

Abramowitz suggests starting with everyday objects that are easily prepared on microscope glass slides. Dry objects like bits of wood *(lower left)* are shaved thin with a razor blade and placed in a drop of water between the slides. Liquid specimens need only be pressed between glass, and a drop can be photographed without covering.

To start with, Abramowitz recommends using black-and-white film and switching to color when the photographer is familiar with focusing the microscope and figuring exposure times. Eventually, in order to produce striking colors like the ones seen here, polarizing filters can be used *(pages 64-67).* □

Beach Grass, 1969; magnified 50X, here enlarged to 145X

Houseplant Fertilizer, 1969; magnified 50X, here enlarged to 145X

Menthol Crystals, 1966; magnified 50X, here enlarged to 145X

DDT Powder, 1970; magnified 50X, here enlarged to 145X

Pictures Bigger than Life
Portraits of Live Subjects

As researchers scrutinize the behavior of smaller and smaller life forms, microscopic specimens must increasingly be photographed while they are still alive and functioning. But taking a photograph of an agile—and almost invisibly transparent—subject is far more challenging than shooting a stained and mounted specimen. For Peter Parks, the naturalist-photographer who took the picture of a water flea at right, the solution was to use a special glass slide with a small, optically ground depression on its surface. This allowed him to confine the subject to a shallow puddle just under the objective lens. To make his transparent subject visible, Parks used dark-field illumination (page 62) and then froze its action with a brief flash—transmitted through heat-absorbing glass to protect the specimen.

Microbiologist Robert F. Smith adopted quite a different approach in getting the shot of the diminutive jellyfish opposite. He too set his subject against a dark field; but he gave detail-revealing color to his normally clear, colorless specimen by using a technique called fluorescence photomicrography. Instead of a regular light source, Smith's microscope has a black-light source that emits only ultraviolet (UV) wavelengths. This invisible radiation causes a responsive subject like the jellyfish to fluoresce—that is, to give off visible light, or glow in the dark. The light emanating from the subject is recorded on film while a filter keeps the ultraviolet from affecting the film.

Gleaming against a dark-field background, a Daphnia water flea was captured by Peter Parks as it gave birth to a clutch. In addition to the two offspring already out, others can be seen through the mother's glassy shell. A common pond dweller, the little crustacean was magnified 15 times and is shown here further enlarged to 85 times life size.

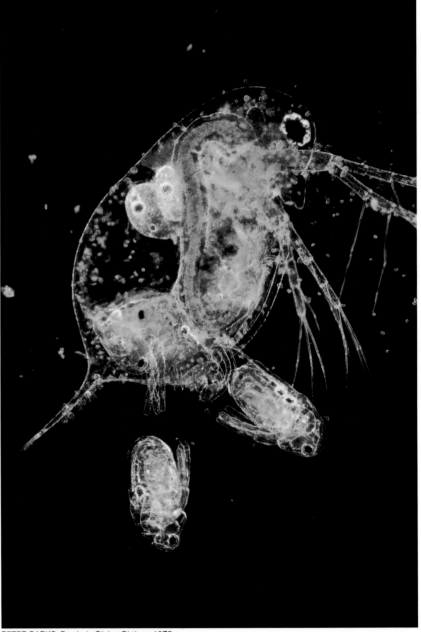

PETER PARKS: *Daphnia Giving Birth*, c. 1975

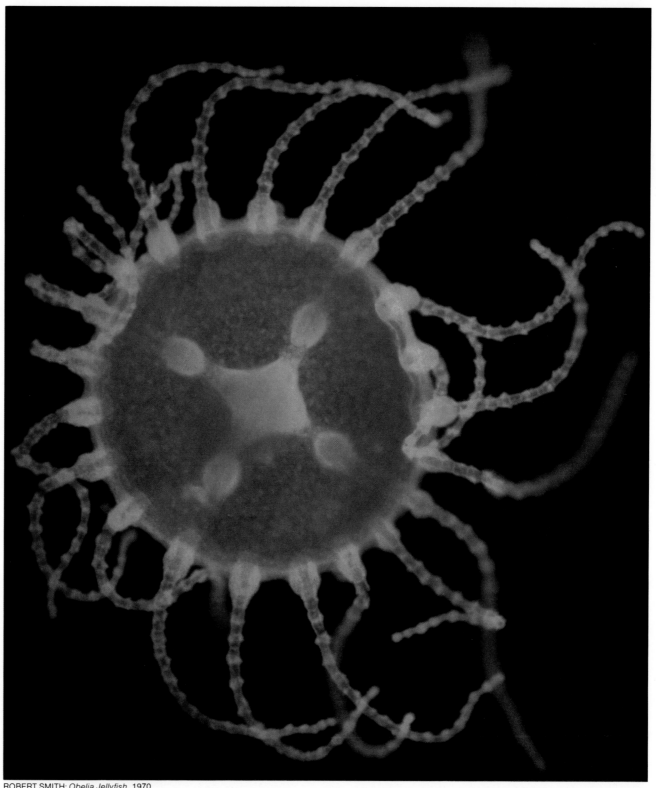

ROBERT SMITH: *Obelia Jellyfish,* 1970

The Dazzling Life in a Drop of Water

A single drop taken from the plankton-rich waters near Australia's Great Barrier Reef reveals an intriguing collection of jewel-like living microorganisms with sparkling shells of glassy silica. The spherical creatures radiating long needle-like spikes are minute animals called radiolarians, and the clear rectangular ones are a form of alga known as diatoms. A glass slide with a slight surface cavity held the drop while it was being photographed; dark-field illumination provided a background that set off the transparent shells. The specimens were magnified 75 times, and here they are shown enlarged to 675 times actual size.

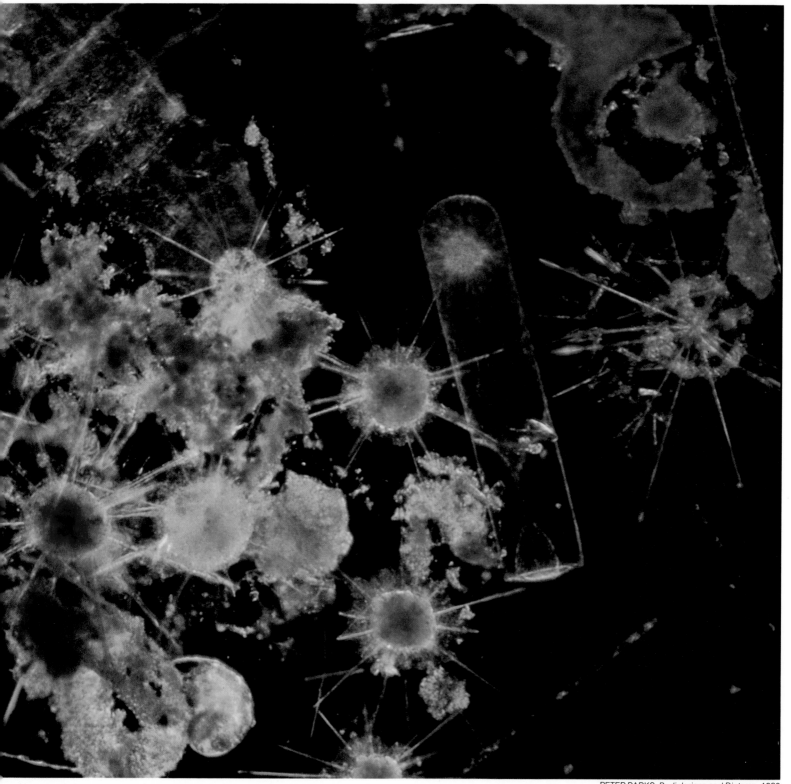

PETER PARKS: *Radiolarians and Diatoms*, 1980

An Unusual Embryo

Four photomicrographs trace the stages that occur when two mouse eggs join to create an embryo—a result normally achieved only when an egg is fertilized by a sperm. In this difficult and unusual technique, developed by medical researcher Pierre Soupart, two eggs with their outer membranes removed are brought together (right, top), and begin to fuse (bottom). After the merger is complete (top, opposite), the new cell begins to divide. Four and a half days later (bottom, opposite), it has grown into a blastocyst—the initial stage in embryonic development. Photographer Fritz Goro used the Nomarski differential interference-contrast technique in a research microscope (page 66) to optically stain the colorless cells. The cells were magnified 190 times and are shown here enlarged to nearly 1,000 times life size.

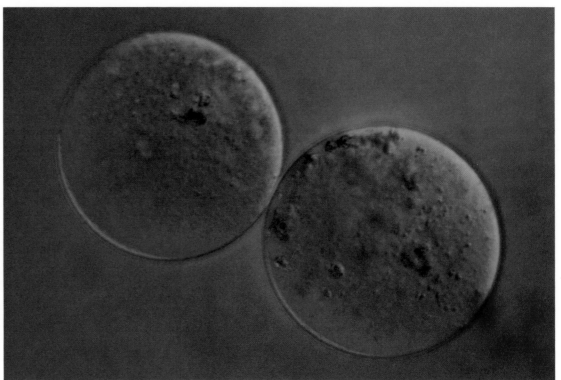

eggs placed together

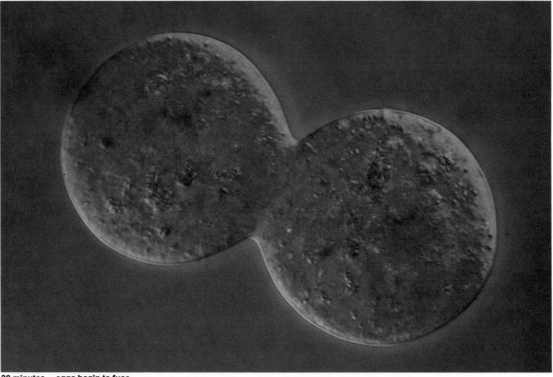

30 minutes—eggs begin to fuse

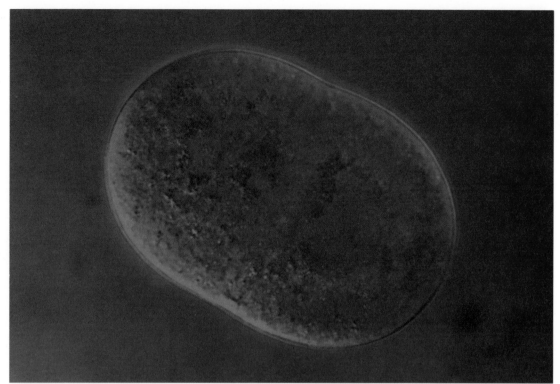

40 minutes—one cell is formed

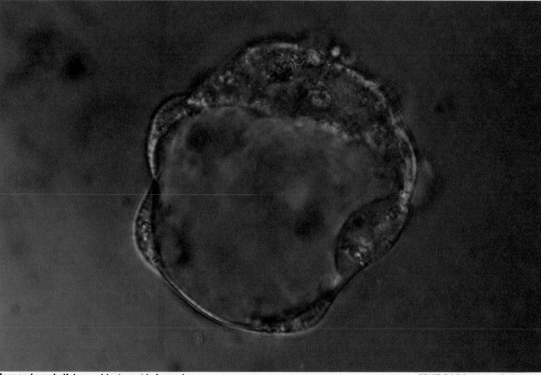

four and one-half days—blastocyst is formed

FRITZ GORO: *Mouse Cells*, 1980

Pictures Made by Electrons

Greatly enlarged photographs that show three-dimensional objects in much the same way as ordinary photographs can be made with a microscope that generates visible images from beams of electrons. Called the scanning electron microscope (SEM), it has an exceedingly wide magnifying range—from 5 times to 300,000 times life size—and a depth of field as many as 500 times greater than that of any optical microscope. In the skillful hands of David Scharf, who took the pictures here and on the following pages, its product can be visually stunning as well as scientifically informative.

A "gun" at the top of the SEM fires a fine stream of electrons down through the microscope toward the specimen, where it is focused by electromagnetic lenses. A scanning device causes the electrons to bombard the surface of the specimen, point by point, releasing the electrons already in the specimen. These are amplified and shown on a high-resolution TV-type screen. The screen is then photographed. In order to avoid interference by air molecules, the entire process must take place in a near-vacuum. The SEM is a more versatile instrument than the older transmission electron microscope, which produces two-dimensional images *(page 82)* by sending electrons through a specimen rather than by bouncing them off the surface of the subject.

DAVID SCHARF: *Salt Crystals*, 1977

Ordinary table-salt crystals assume a monumental presence when magnified by a scanning electron microscope. The crystals, coated with gold to improve the electrical conductivity of their surfaces, were magnified 55 times and are here reproduced 46 times life size.

Pointed hairs and the balloon-shaped resin nodules that contain the plant's psychoactive ingredient protrude from the surface of a new marijuana leaf. As with all live specimens, Scharf did not have to use a gold coating (the leaf's moisture provides enough conductivity); the plant's delicate details were thus recorded in their natural state. The leaf was magnified 350 times and is shown here 278 times life size.

DAVID SCHARF: *Marijuana Leaf,* 1974

A Gallery of Rogues

*The eight eyes of a jumping spider — so called ▶
because it pounces on its prey — form a dark circlet
on its brow. After a record 45 minutes in the
SEM's vacuum chamber, this hardy specimen lived
to scamper away. The spider was magnified to
21 times and is here enlarged to 25 times life size.*

*To make electron portraits of live subjects such
as this worker honeybee, Scharf applied the electron
beam with great care, using lower than normal
voltage and working quickly to avoid drying out the
insect in the SEM's vacuum chamber. Because
the beam focuses on only one point at a time, it takes
about a minute to make a complete image. But
this ability to refocus at each point produces
spectacular results: Each of the bee's pollen-
carrying hairs is seen clearly. The bee, magnified 13
times, is shown here 10 times life size.*

DAVID SCHARF: *Honeybee Portrait,* 1976

DAVID SCHARF: *Jumping Spider*, 1976

The whitefly, a tiny pest that infests plants and citrus fruit trees, seems to be encrusted with snow except for its multifaceted eyes. The powdery secretion protects the insect from weather and predators. Only one millimeter in total body length, the whitefly was magnified 225 times and is reproduced here enlarged to 279 times life size.

In this picture of a Braconid wasp, the insect's ▶ shell appears dark because the SEM's beam hit the surface head-on and few electrons were emitted. Areas where the beam's angle was oblique appear white because the glancing impact loosed a veritable shower of electrons. The wasp, magnified 75 times, is shown at the same magnification.

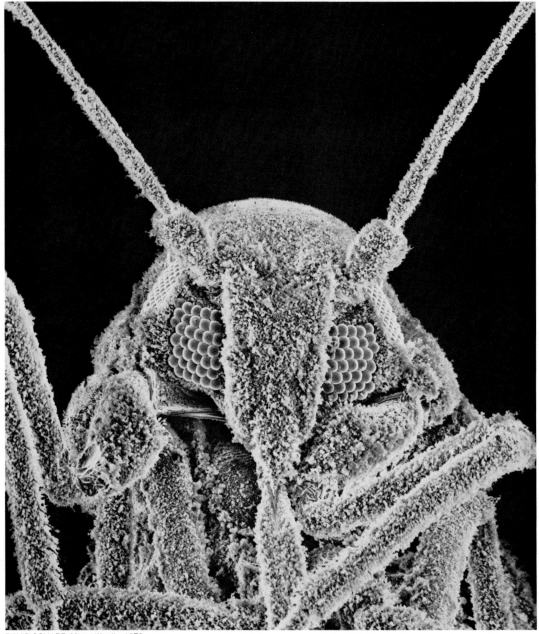

DAVID SCHARF: *Mister Woolly*, 1976

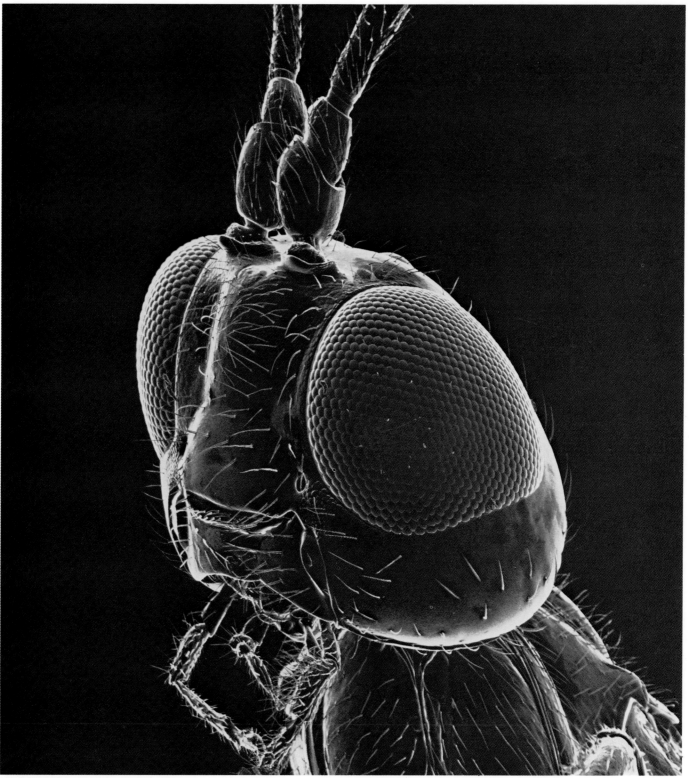

DAVID SCHARF: *Braconid Wasp Portrait,* 1976

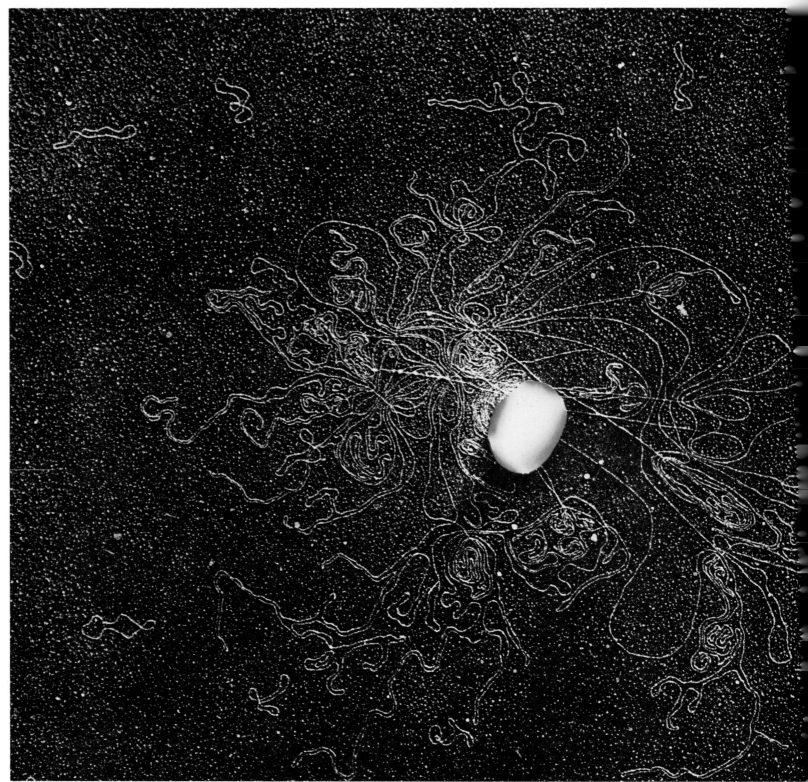

HUNTINGTON POTTER AND DAVID DRESSLER: *Bacterium with Threads of DNA,* 1980

Seeing the Threads of DNA

In a picture taken by molecular biologists to illustrate the complexity of gene splicing, a giant DNA molecule—a single chromosome containing some 3,000 genes—spills out of a one-celled E. coli bacterium that has been disrupted mechanically. The bacterium, which can be found in human intestines, also contains several much smaller rings of DNA called plasmids, auxiliary chromosomes like the three that can be seen in the upper left corner of the picture. In gene splicing, a segment of a foreign DNA molecule, from a plant or animal cell, is patched into a plasmid, which is then implanted into a living bacterium. This introduces a gene that can give the bacterium a new characteristic—for example, the ability to produce insulin or interferon. The unusually close view here—magnified 2,000 times and shown enlarged to 15,000 times life size—was taken with a transmission electron microscope (TEM), which works by beaming electrons through the specimen instead of scanning its surface like the SEM.

Pictures Made by Ions and X-rays

Nobody has ever seen an atom and no one ever can—light waves, unimaginably fine as they are, are too crude to pick one out for vision. But photographs can reveal images made by atoms, with the help of special instruments that do not use light; instead they employ X-rays and beams of the electrically charged atoms called ions.

The picture at right was made with a field ion microscope, which first provided a direct view of atoms. The specimen being studied, the tip of a platinum needle in this instance, is placed in an evacuated chamber and the chamber is filled with gas. When a high voltage is applied to the platinum tip, atoms of the platinum push ions of the gas against a fluorescent screen. The screen lights up when struck by the ions, revealing images of the platinum atoms that pushed the ions. These images are caught with a camera that was built by the microscope's inventor, Professor Erwin Müller of The Pennsylvania State University. Starting with an inexpensive 35mm camera body, Müller modified it to take a special f/.87 lens.

Photographs that disclose the atomic structure of crystals, like the picture opposite, are obtained by directing X-ray beams through the crystals onto film—no lens is needed. The X-rays' paths are affected by the lattice-like arrangement of the crystal's atoms, creating a pattern on film from which the structure's design can be figured. ☐

A field ion microscope picture records the actual locations of individual platinum atoms (right), arranged in clusters within the ringlike facets of one crystal of the metal. The atoms —the tiny white dots—were magnified 120,000 times on the negative and here are further enlarged to 450,000 times life size.

ERWIN MÜLLER: *Platinum Single Crystal Hemisphere,* 1965

An X-ray diffraction photograph of a crystal of beryl (right) reveals the symmetry of the crystal. The black spots in such a picture are not atoms, but a pattern created by the atoms in the crystal. Since the pattern depends on the arrangement of the atoms in the crystal, analysis of various X-ray diffraction pictures indicates the atomic structure of the crystals.

MAURICE VAN HORN: *Beryl Crystal*, 1957

The Small World of Manfred Kage

According to his own account, Manfred Kage *(right),* Europe's most prolific photographer of the Lilliputian world, never photographs anything larger than a hen's egg. Most of his subjects, as the following portfolio demonstrates, are a good deal smaller, requiring long bellows, optical microscopes or sometimes even a scanning electron microscope.

Though many of Kage's pictures look like the by-products of scientific projects, they are taken with esthetics, not technical recording, in mind. Most are commissioned by industrial firms engaged in basic research, but the pictures are used to advertise products rather than to illustrate technical reports, and Kage is free to interpret the subject as he sees fit.

In the process of this interpretation, Kage employs every trick in the photomicrographer's repertoire—filters, polarizers, prisms and light sources of various kinds. Kage works in a 30-room castle in the small German town of Weissenstein, south of Stuttgart, where he has several fully outfitted labs devoted to photomicrography and photomacrography.

A skilled optical craftsman, Kage constructs much of his own special equipment and frequently alters commercially made lenses to suit his purposes. When he became one of the few photographers to own a scanning electron microscope (SEM), even that formidable apparatus did not go unmodified. He devised a computer attachment that translates the intensity of the SEM's usual cold gray tones into subtle and more appealing shades *(page 94),* or translates shadows, middle tones and highlights into as many as three different colors. The results so intrigued scientists that Kage was asked to explain his technique to a congress of SEM specialists.

Taking a photomicrograph, Manfred Kage uses a 5 x 7-inch camera of his own design that is attached by a bellows to a laboratory microscope. Because the bellows is extended so far to produce a larger image on the film, Kage fine-focuses the microscope with his big toe while observing the image in the ground glass. At bottom center is a voltage regulator that prevents variations in the electric current from causing changes in the microscope illumination. At the left are lenses and extension bellows for making photomacrographs.

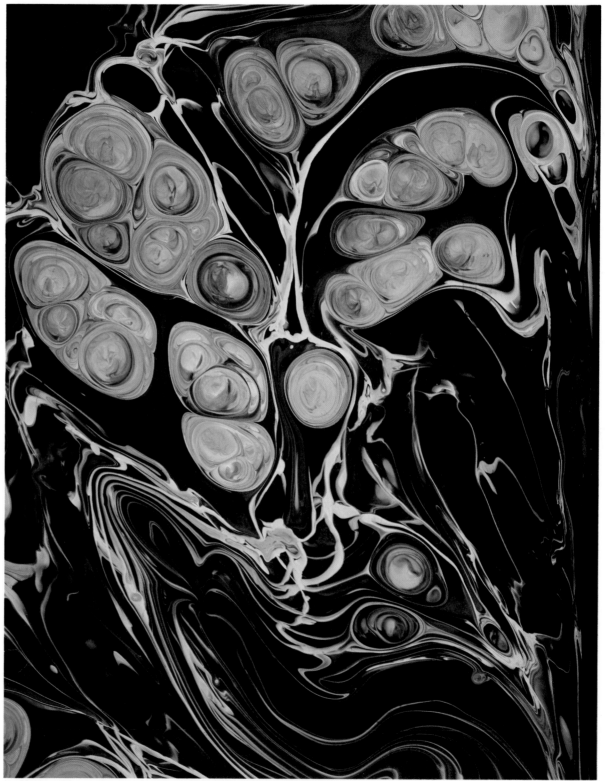

Liquid paint, 1978; magnified 10X with bellows, photomacrograph here enlarged to 13X

87

Cimetidine (ulcer medicine), 1977; magnified 100X, here enlarged to 125X

Paint hardening, 1976; magnified 160X, here enlarged to 205X

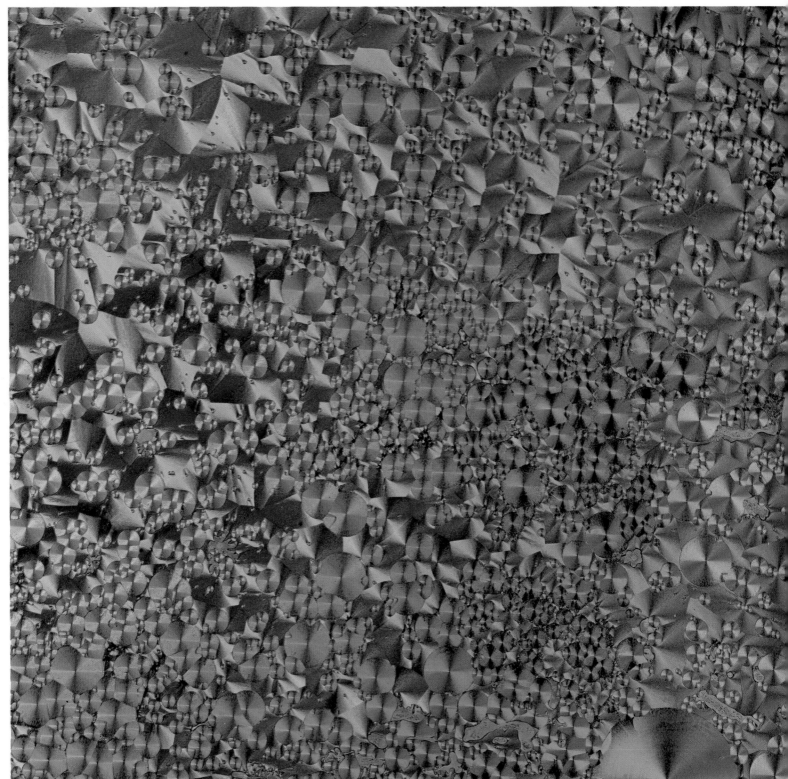

Ketone Crystal, 1968; magnified 21X, here enlarged to 35X

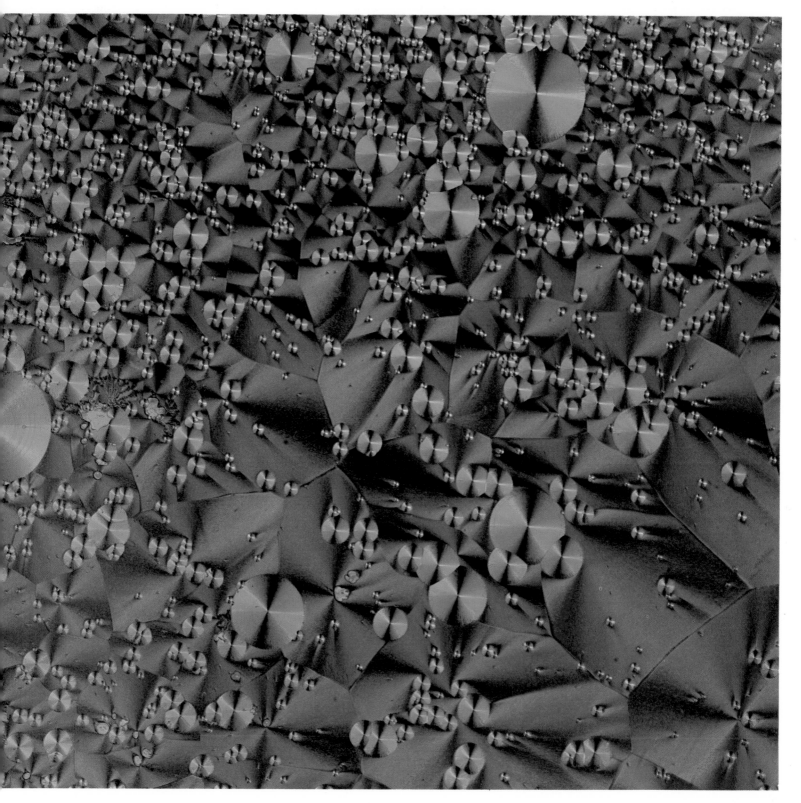

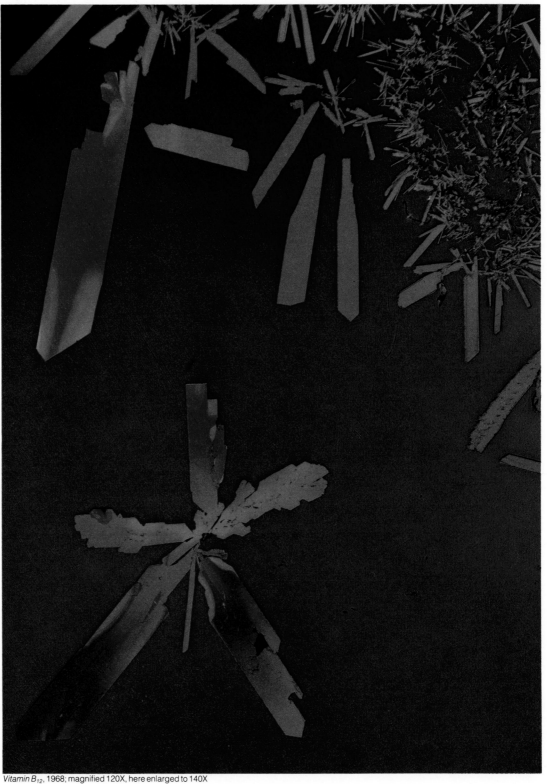

Vitamin B₁₂, 1968; magnified 120X, here enlarged to 140X

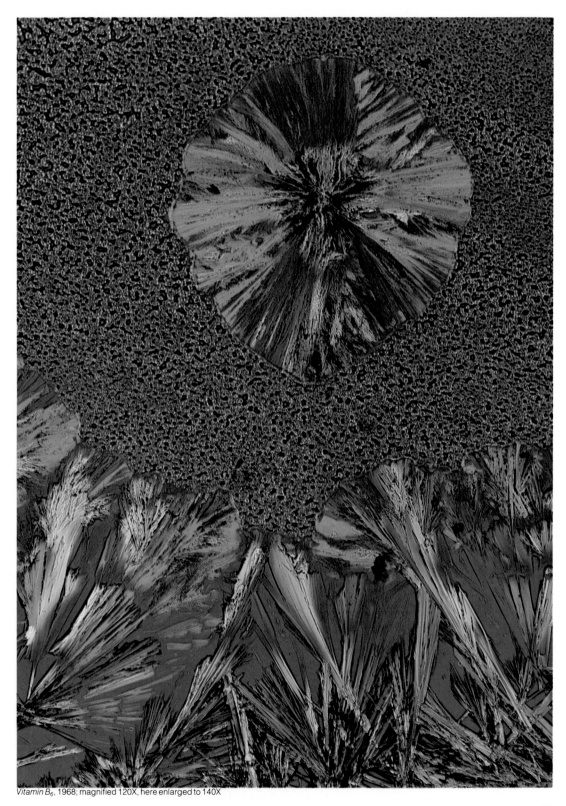

Vitamin B₆, 1968; magnified 120X, here enlarged to 140X

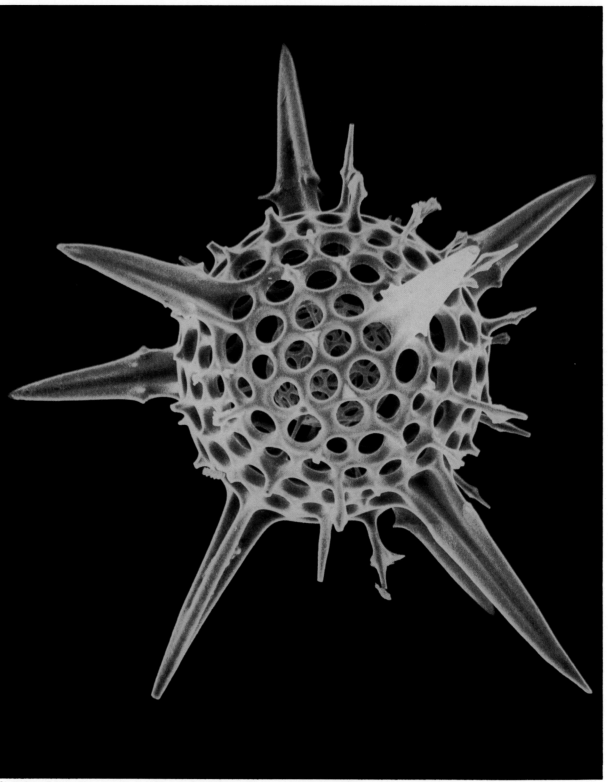

Shell of a radiolarian (tiny sea animal), 1979; magnified 600X with SEM, here enlarged to 1,920X

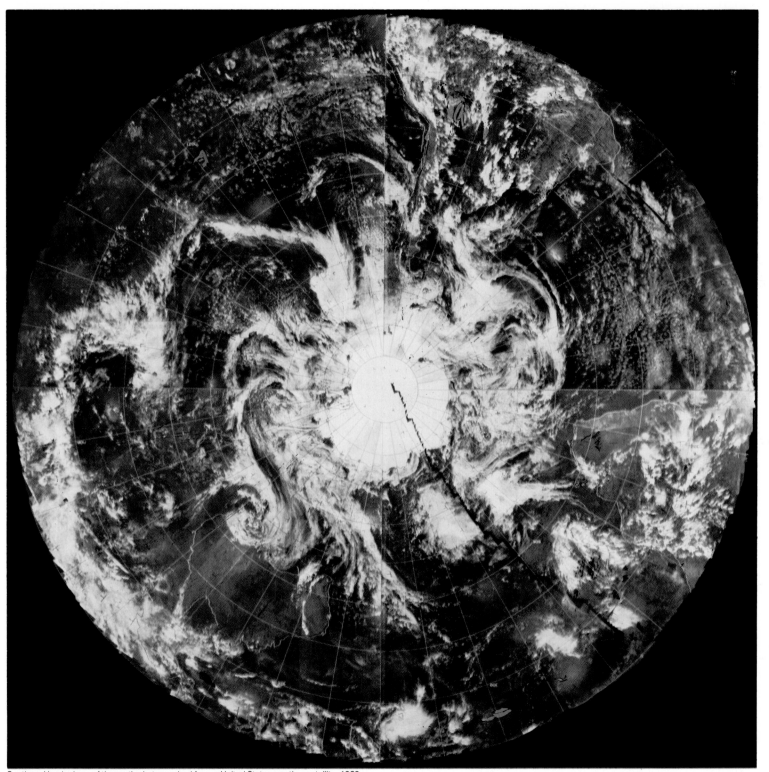

Southern Hemisphere of the earth photographed from a United States weather satellite, 1969

A View of Other Worlds

Whether in the depths of the ocean, high inside the earth's envelope of air or far out in space, photography affords us a far better appreciation of the complexities of our own planet, and the entire universe as well. Cameras have allayed the fears and superstitions that once lurked in tales of the sea by showing the underwater world to be an animated, curiously appealing kingdom of weird creatures and colorful forms. They have provided views of the earth from the air that, besides being esthetically pleasing, have hundreds of practical applications. And they have enabled us to discover distant celestial bodies whose existence we had not even suspected. In short, cameras afford a fresh view, one that is open to amateurs as well as professionals. Even with relatively uncomplicated equipment, good aerial, undersea and astronomical photographs can be made.

Telescopes were long the chief tool of astronomy, but the introduction of the camera to this science revealed entirely new categories of celestial bodies and unveiled startling new aspects of some—such as the rings of Saturn—that were already considered well-understood. Cameras became the cartographers of the moon's surface, yielding views so detailed that scientists in earth-bound laboratories could choose a safe landing spot for the first spacecraft as surely as if they had been piloting it. In the quest to push out even farther, cameras were sent speeding past the surface of the sun and across the solar system to probe the faces of Mars, Saturn, Jupiter and planets beyond—and to transmit back to earth the marvelous sights they beheld. Conversely, pictures of the earth taken by astronauts recorded our globe as a refreshingly beautiful oasis in the blackness of space.

Grand as the view of earth is from aloft, whether seen from a manned spaceship, an orbiting satellite or an airplane, such pictures are much more than ornamental. Ranchers use aerial photographs to count their livestock without bothering with a roundup. Geographers map unexplored territory from them, city planners plot redevelopment by studying overhead views of urban areas, and geologists spot hidden faults in the earth's structure that can provide clues to oil deposits. Some satellite photographs help meteorologists forecast the weather, while others—by recording the accumulation of snow in mountain ranges and tracing the courses of rivers—aid in the prediction of floods. Archeologists have used aerial photographs to rediscover lost cities and to locate mysterious artifacts from vanished cultures; they have become so dependent on information furnished by overhead views that one of them, the English scientist J. P. Williams-Freedman, remarked, "One ought to be a bird in order to be a field archeologist."

Aerial photographs have even influenced the course of world events. Photographs that were taken over Cuba by an American U-2 reconnaissance plane in 1962 revealed the presence of Russian-made missiles and precipitated the

Cuban Missile Crisis. War was averted when the Russians acceded to American demands and withdrew the missiles. But the Russian freighters that carried the missiles away from Cuba were photographed from above almost continuously, to be sure that the ships did not turn around in midocean and bring back their lethal cargo.

While much of aerial photography is the province of professionals — specialized ones at that — this is not altogether true of photography in the strange and alluring world beneath the seas. The rapid development of underwater cameras and equipment has made the marine world a new adventure land for thousands of fascinated photographers. Scenes once reserved for intrepid deep-sea divers are now the highlights of many a post-vacation slide show, because diving — and underwater photography — today are simple enough to be enjoyed by anyone.

Technology and professional skill of the highest order are required, however, to record the vistas that lie at the bottom of the world's oceans. A tubby little submersible named *Alvin* has helped open new chapters in marine science by enabling oceanographers and marine biologists — and their cameras — to work at greater depths than ever before. Scientists from the Woods Hole Oceanographic Institution, *Alvin's* home base, took the submarine to the floor of the Pacific, 8,000 feet below the surface, and brought back striking and unexpected images of strange cracks in the bottom of the sea. Huddled around these vents, where the pitch-black water was heated directly by the earth's magma, was an entirely new kind of life: marine organisms that lived by chemosynthesis, converting chemicals into energy for growth in much the same way that plants derive energy from photosynthesis. After studying the pictures — taken by hand-held camera from inside the craft and by remote-control cameras located above its viewing port and towed on a separate camera sled — scientists believe they have found the ground-zero points at which the earth generates new crust material, causing the ocean floor to spread inexorably apart at a rate of 17 centimeters per year. □

Bringing Home a Piece of the Sky

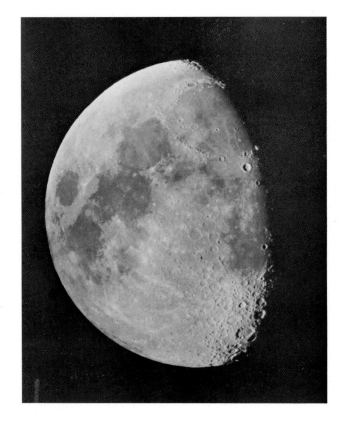

Relatively inexpensive telescopes of the kind used by many amateur astronomers, such as the 6-inch Dynascope reflector shown here, can be fitted to take a camera by an adapter that is slipped into the vertical eyepiece holder. Thus equipped, the telescope is capable of producing clearly detailed pictures of the moon (left).

Many amateur photographers also become enthusiastic amateur astronomers (or vice versa) because excellent photographs of the heavens can be made with just a little special equipment. Most cameras can be easily attached to the popular types of telescopes by inexpensive adapters that are usually available wherever telescopes and cameras are sold. Almost any camera will do, but the 35mm single-lens reflex is often preferred because it lets the photographer see what the telescope sees and is adaptable to many kinds of telescopes.

Both telescopes pictured here have mountings with electric tracking systems that follow the apparent movement of celestial objects caused by the earth's rotation. The system makes approximately one revolution in 24 hours, guiding the telescope—and camera—so the object remains in focus during exposure.

Focusing the telescope will bring the image into focus at the camera's film plane. Exposures depend on atmospheric conditions, the subject and its position in the heavens. The moon is a favorite subject, since it is close enough to show its details and is usually bright enough to make relatively short exposures practi-

cal. The planets Venus, Saturn and Jupiter also are frequent subjects because they, too, are bright.

Here are a few suggested times and settings, but remember that good photographs are achieved only by trial and error: For the full moon, shoot at f/11 and 1/100 second with film that is rated at ISO 32/16°; for a quarter moon use f/11 at about 5 seconds; for a crescent moon use f/11 at 10 seconds. To photograph the planets, try a film rated at ISO 125/22° and start at f/3.5 with an exposure time between ½ and 15 seconds, depending on the atmospheric conditions.

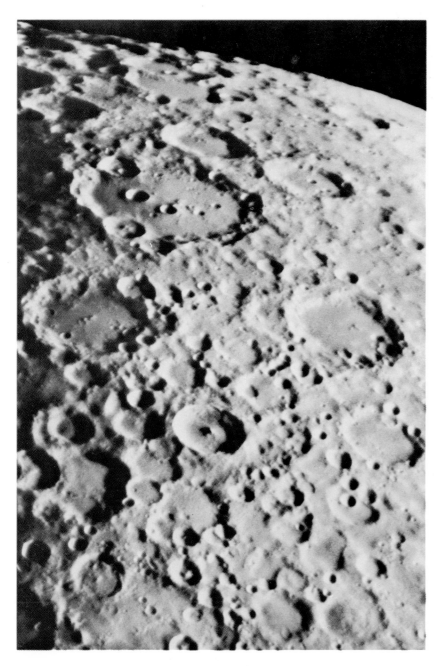

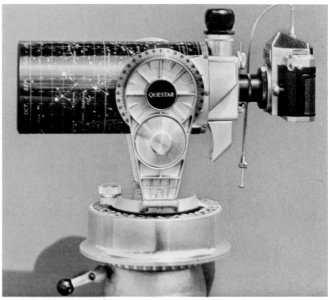

Cameras are easily attached to the compact, portable 3.5-inch Questar telescope—a high-precision (and fairly expensive) instrument—by a simple mechanism that is standard equipment. The picture at left, shot through the Questar with an exposure time of 10 to 15 seconds, shows the region around the largest crater of the moon, Clavius (near top).

Vivid Images by Amateurs

Some 1,600 light years from earth, the Great Nebula in the constellation Orion glows from light emitted by a cluster of very hot stars at its center. An off-axis guider helped keep the nebula in focus during the 20-minute exposure, allowing the camera to record perfect star images and the brilliant red too faint for the human eye to see.

For the serious amateur, the problems posed by more advanced astrophotography are both challenging and irresistible. Stunning photographs such as the ones shown here are well within reach of the amateur, given adequate amounts of patience and practice.

While all of these pictures were taken with 35mm film and an 8-inch telescope, some of them also require slightly more complicated equipment and techniques. When pictures of the sun are taken, for example, protective filters are vital to the safety of both the eyepiece of the telescope and the eye of the photographer.

With deep-sky photography, different problems arise. Telescope tracking systems are not precise enough to keep pinpoint focus throughout the lengthy exposures that are required to register the low brightness of distant stars. However, with an off-axis guiding system—which employs a separate eyepiece mounted between the camera and the telescope—a nearby guide star can be monitored during the exposure, and the telescope can be adjusted, thus keeping the primary object in focus.

Extended exposures to low light also can result in "reciprocity failure," a phenomenon in which color film reacts more slowly than normal. One popular solution is a so-called cold camera, in which dry ice is used to chill the film to –109° F. during exposure, permitting the dedicated amateur to record deep-sky objects that would not otherwise register on film.

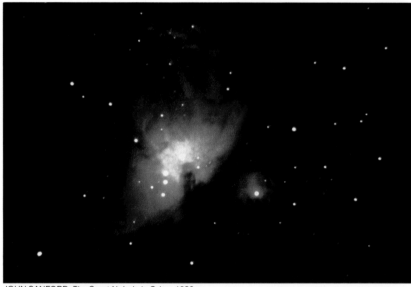

JOHN SANFORD: *The Great Nebula in Orion, 1980*

DENNIS DI CICCO: *Total Lunar Eclipse, 1975*

The southern limb of the eclipsed moon gleams brightly in this photograph, taken at six minutes past mid-totality by Dennis di Cicco, an editor of Sky and Telescope magazine. Di Cicco bracketed the exposure to ensure a good shot; this one was exposed at f/10 for 10 seconds.

JOHN SANFORD: *Arching Solar Prominence*, 1978

An arching "solar prominence"—in fact, an eruption of flaming hydrogen—billows away from the surface of the sun. Because such eruptions are visible only in a narrow band of the spectrum, a special filter—which must be kept at 135° F. during the exposure—is used to isolate the wavelengths of hydrogen light.

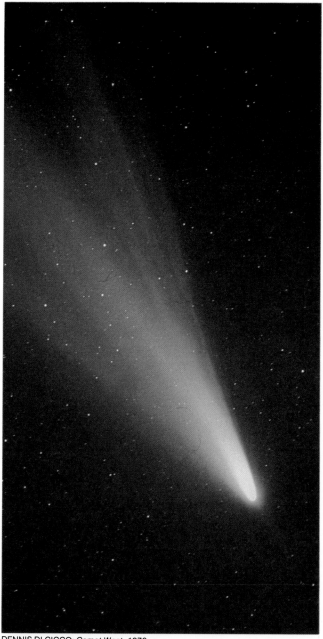

DENNIS DI CICCO: *Comet West*, 1976

Comet West, seen here near dawn from a Massachusetts beach, streaks tail-first back into space during its 1976 visit. One of the few comets to be visible in the daytime to the unaided eye, it will not return for one million years. Its bright nucleus and streaming tail were recorded by an exposure of f/1.5 at 1½ minutes.

How the Professionals Do It

In this bright-hued picture of the Helix Nebula, whose greenish center is composed of doubly ionized oxygen, an asteroid trail, seen as a tiny strip of color at upper left, reveals that the photographer made separate exposures with different color-sensitive plates—for the trail abruptly changes from green to blue as it moves. There is no red trail because the red plate was made a year earlier for another project, and the asteroid was not then present.

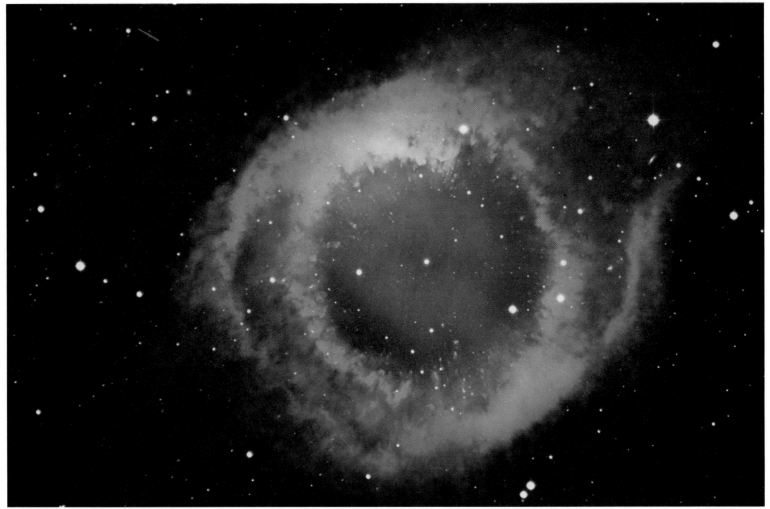

DAVID MALIN: *The Helix Nebula (NGC 7293),* 1979

While color photographs of deep-space objects can yield a wealth of scientific information unavailable from black-and-white pictures, conventional color materials are not designed for such long exposures. To make the images shown here, David Malin of the Anglo-Australian Observatory in New South Wales, Australia, employed both the oldest method of color photography—the additive system—and the latest techniques of boosting the sensitivity of photographic emulsions.

For each picture, Malin exposed three black-and-white plates, sensitive to blue, green and red light, respectively. Positive contact copies from each plate were projected through appropriate filters onto Cibachrome paper, producing a full-color print. But before the plates were used, they underwent a sensitizing process of baking, soaking and freezing in various chemicals. They then required exposure of only 20 or 30 minutes—one third the time needed for unsensitized plates.

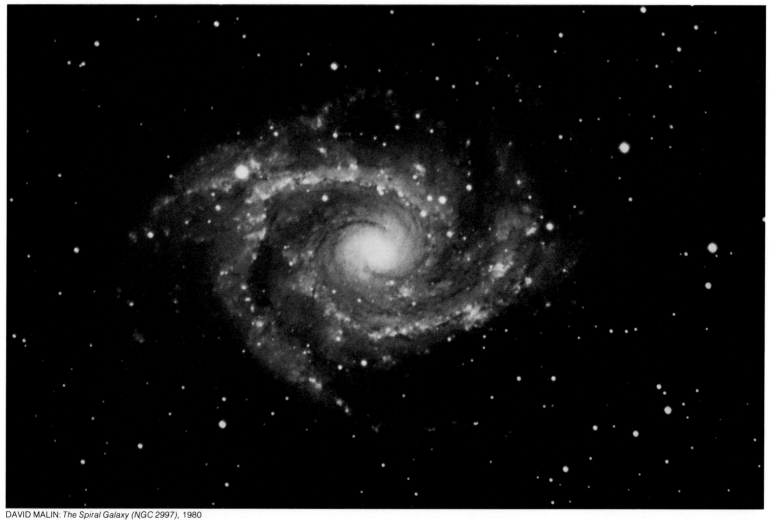

DAVID MALIN: *The Spiral Galaxy (NGC 2997), 1980*

Older yellow stars cluster in the nucleus of the spiral galaxy known as NGC 2997, and younger blue stars make up the radial arms, where red dots of ionized hydrogen gas indicate the birth of new stars. Located some 20 million light years from earth, the galaxy looks much as would our own Milky Way from a similar perspective. Malin shot this photograph and the one on the opposite page through a 3.9-meter telescope.

Using Computers to Color the Stars

Some objects in space are just too distant to be perceived as more than blurry splotches of light, even after the longest exposure made with the most sensitive films and the most powerful telescope. The longer the exposure, in fact, the blurrier the picture because of movements in the earth's atmosphere. However, the recent union of cameras and computers has produced techniques that coax the utmost information out of pictures that would otherwise be almost useless.

One such technique—the Interactive Picture Processing System (IPPS) developed at Kitt Peak National Observatory near Tucson, Arizona—can deliver such previously impracticable photographs as the two shown here. At right is the supergiant star Betelgeuse; on the opposite page, two galaxies tug at each other.

Betelgeuse, or Alpha Orionis, is 1,200 times larger than our sun, but because it is 650 light years from earth, photographing it is akin to taking a picture of a quarter from a distance of 50 miles. The IPPS accomplished this feat by using a massive 4-meter telescope and a number of high-technology accessories that ultimately funneled the image to an ordinary 35mm camera containing conventional high-speed black-and-white film. Dozens of short exposures were made, each lasting only 8/1000 second. Atmospheric turbulence broke up incoming light so that each shot was divided into 100 to 500 separate and slightly different images of the star.

The photographs were then analyzed by a microdensitometer, which assigned a numerical value to each gradation of density. A computer assigned a color to each value and then constructed a composite electronic portrait, which can appear on a color television monitor. □

KITT PEAK NATIONAL OBSERVATORY: *Alpha Orionis, 1974*

Varying temperatures on the surface of the star Betelgeuse in the constellation Orion are portrayed in arbitrarily assigned colors in this computer-enhanced photograph taken at Kitt Peak National Observatory. Orange designates the hotter areas, blue the cooler ones. Scientists believe that the hot spots may indicate violent eruption of gases from the star's interior.

Two galaxies, nicknamed The Mice by ▶ astronomers studying them at Kitt Peak National Observatory, pass so close to each other that the larger exerts enough gravitational pull on the smaller to pull out a "bridge" of stellar matter. The colors were assigned by computer to represent brightness levels in the original black-and-white negatives.

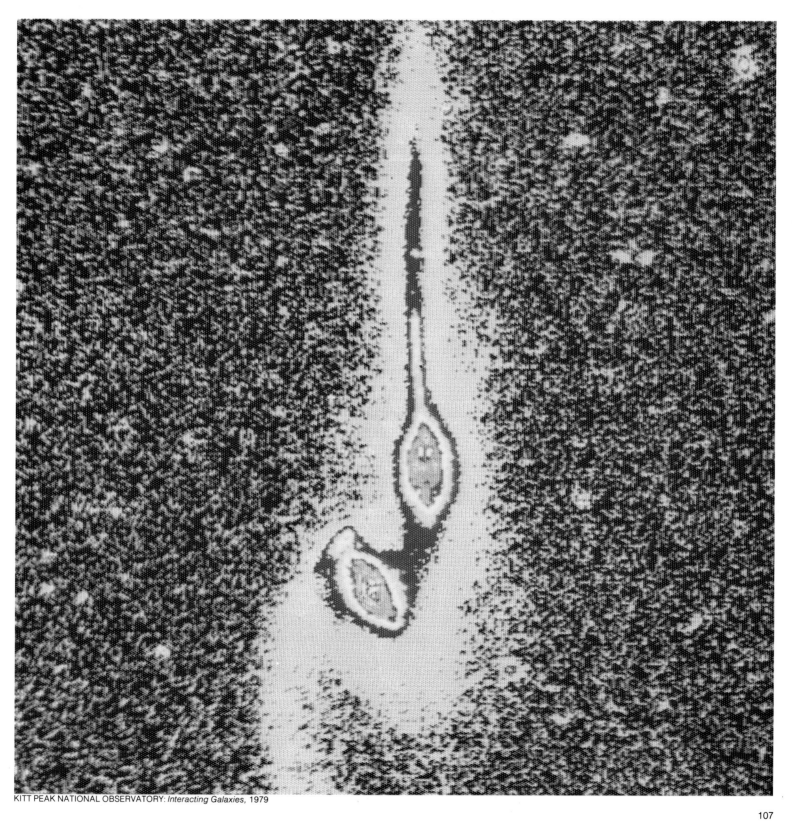

KITT PEAK NATIONAL OBSERVATORY: *Interacting Galaxies,* 1979

The Distant Made Near
The Heavens from Close Up

With the advent of space travel, photography was at last freed of the shrouding effect of the earth's atmosphere. Now, whether on journeys to distant reaches of the solar system or on short hops into earth orbit, the camera is able to record images in wavelengths that are largely or entirely blocked by our planet's atmospheric screen.

Long missions require that visual images be converted into radio signals for transmission back to earth *(pages 110-115),* but for tasks closer to home, such as the solar investigations that were conducted aboard the orbiting space laboratory named Skylab, more conventional —even though quite complex—photographic equipment was employed.

The spectacular image at right is a segment of a spectroheliogram made as part of one Skylab experiment. The sun's rays were directed into a specially designed concave grating, which reflected and dispersed them into a spectrum of the wavelengths within the range of extreme ultraviolet (XUV) light. These spectral lines—emitted by different gases at different temperatures—formed a series of overlapping monochromatic solar images on strips of XUV-sensitive film; the film was later developed and then printed on color paper.

The resulting false-color photographs yielded a harvest of data. For example, the sun's corona was revealed to be a boiling sea of energy, with temperatures reaching 2,000,000° C.

Layered images of the sun in this spectroheliogram taken by a Skylab camera are formed by adjacent spectral lines. The image at far right—in which an "elbow prominence" half a million miles above the sun's surface is most visible—was formed by light emitted by ionized helium; the shadows to the left of it come from weaker emissions of ionized iron.

SKYLAB: *Elbow Prominence*, 1973

Unveiling the Red Planet

In July and September of 1976, two robot explorers landed on the surface of Mars and began sending otherworldly postcards back across the 200 million miles to earth. Although they were 4,600 miles apart, the two Viking Landers recorded a Martian terrain of surprising homogeneity: The reddish landscape and salmon-colored sky in both places suggested that there is a wide distribution of iron compounds in the soil and of suspended dust particles in the atmosphere. Other photographs, sent from the Viking Orbiters, revealed sandy regions bearing the marks of a scouring wind, in addition to finger-like channels that may have been cut by ancient floods.

To take their remarkable surface photographs, each of the Viking Landers was equipped with two cameras weighing 15 pounds apiece. The cameras functioned as highly sophisticated light sensors; the film remained back on earth, in the Jet Propulsion Laboratory in Pasadena, California. Using a moving mirror and a system of photoelectric cells, these devices recorded light from the scene as hundreds of vertical lines. Each line was composed of 512 extremely small picture elements, or "pixels," which registered the light intensity in an angle of view about 1/120 the angle between the minute marks on a clock.

Converted into numbers and then into radio pulses, the pixels were sent back to earth, picked up by giant antennas and relayed to the Jet Propulsion Laboratory. There, the signals were decoded to produce photographs of vivid clarity and an odd familiarity—unveiling a distant and alien landscape strikingly reminiscent of the desert of the American Southwest.

The Utopian Plain near Mars's north pole stretches off to a rock-strewn horizon almost two miles away in this true-color photograph taken by Viking Lander 2. Three of the camera's 12 light sensors were filtered to record scans in red, green and blue light. Radioed back to earth, the brightness of each primary color was re-created with the help of a computer and a special multicolor laser. The laser beam was focused onto a sheet of film by means of a lens and a rotating mirror, building the image line by line, in vertical scans, exactly as it had been taken 200 million miles away.

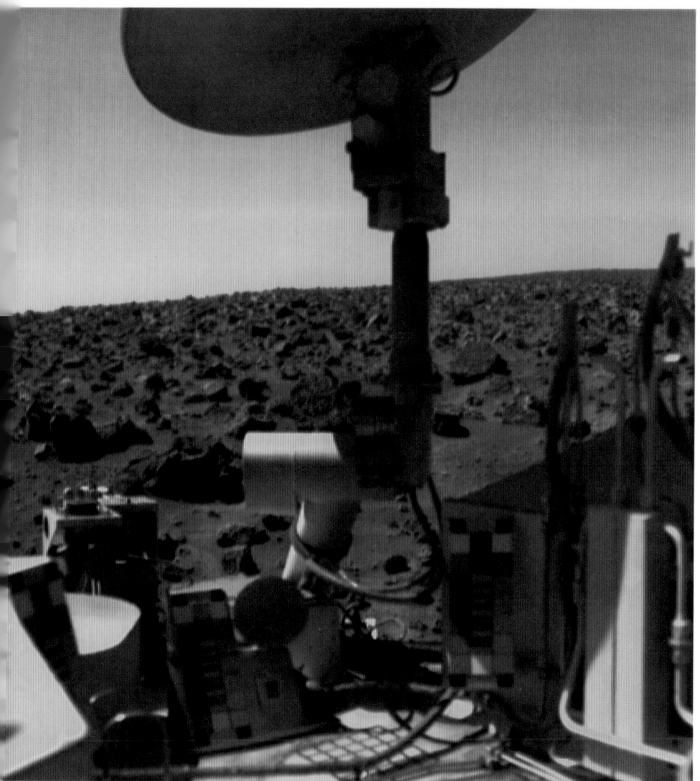

VIKING LANDER 2: *Mars's Utopian Plain*, 1976

Exploring a Mini-Solar System

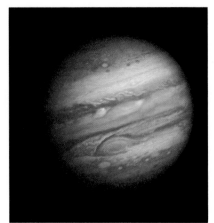

VOYAGER 1: *Jupiter,* 1979

Photographed from 20 million miles away by one of Voyager 1's slow-scanning cameras, Jupiter displays the permanent cloud cover that masks its surface of liquid hydrogen and helium. Scientists analyzing color reconstructions such as this one hope to learn more about the planet's weather patterns. Not as yet understood, for example, is the nature of two series of regularly spaced spots: dark ones in the northern hemisphere, white ones in the southern hemisphere.

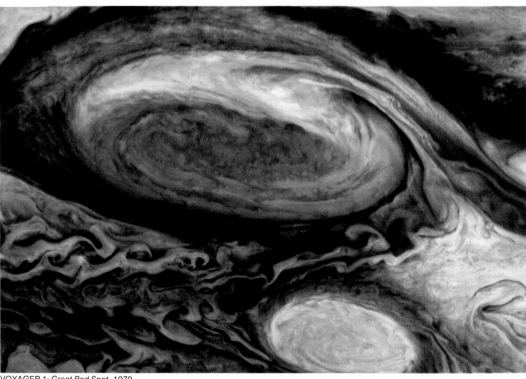

VOYAGER 1: *Great Red Spot,* 1979

For centuries, earth was the only body in the solar system known to be volcanically active. But in 1979, pictures from space announced the existence of volcanism elsewhere—on Io, the innermost large moon of Jupiter. Computer reconstructions, based on electronic images that had been taken by Voyagers 1 and 2, revealed no fewer than eight major Ionian volcanoes venting spectacularly into space *(opposite)*—the first extraterrestrial eruptions ever seen.

Other visual messages sent back by the Voyager space probes yielded some surprising information on the enormous planet that Io circles. For example, Jupiter *(above)* was found to have a Saturn-like ring, but whether the ring particles are the·debris from comets, from meteorites or from Io's volcanoes is not known. Jupiter's atmosphere, once believed to be smooth bands of clouds, was found instead to be seething with jet streams and turbulence. Lightning crackled constantly among the clouds of ammonia and ammonium hydrosulfide, which led scientists to speculate on the possible formation of chemical precursors to organic molecules. All in all, the electronic images were a challenge as well as a revelation, for they raised as many questions as they answered.

The Great Red Spot—a spiral storm system large enough to accommodate two earths—looks like an abstract painting in this color-enhanced reconstruction. Exaggeration of red and blue brings out the details of the spot and its adjacent turbulence. While astronomers have known about this feature of Jupiter's face for more than three centuries, the large oval to the south of it is a cloud system that formed about 40 years ago.

A volcano named Loki Patera, after a mythological Norse fire god, erupts in a plume 174 miles high on the surface of Io, the innermost of the four moons of Jupiter first seen by Galileo in 1610. Separate images taken in ultraviolet, blue, green and orange light were combined by computer, enabling scientists to study changes in the plume's composition from its dense center (yellow) to the larger area of finer particles (blue). The discovery of volcanism on Io confirmed it as having the youngest known surface in the solar system.

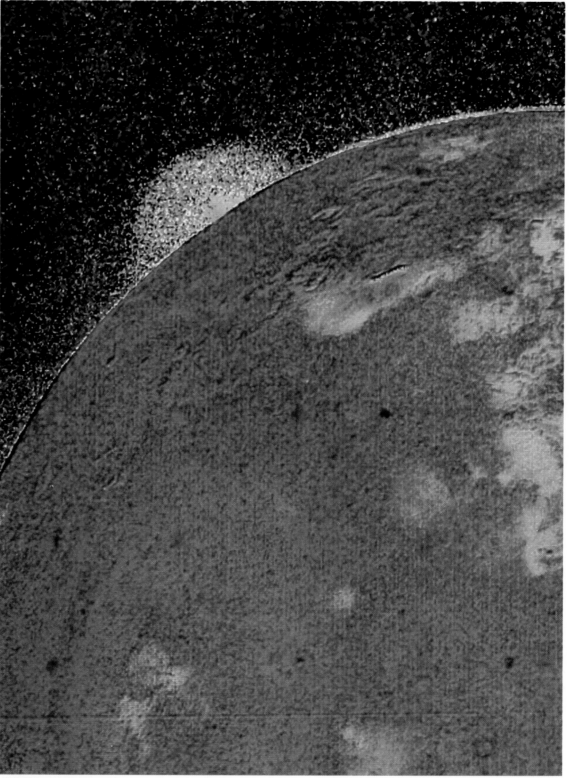

VOYAGER 1: *Loki Patera,* 1979

The Riddle of the Rings

Galileo, an early beholder of the rings of Saturn, was baffled by them: The silhouette that was revealed in his telescope was so dim that Saturn appeared, he said, to have "ears." Later astronomers, with better telescopes, saw three bands of rings around the planet, streams believed to be composed of ice and rock. But as the electronic signals from various space probes began to arrive back at earth, the notion of a few broad bands went the way of Galileo's ears. In 1979, Pioneer 11 spotted a new ring, named F ring, that appeared to be braided— a phenomenon that defied the laws of Newtonian physics. Two years later, pictures from Voyager 2 showed that F ring was made of as many as five parallel rings rather than three braided ones, and Saturn was revealed to have not 10—or even 100—but up to 100,000 ringlets.

No analysis of the rings of Saturn can ignore their relationship with the planet's many moons, and the photographs from Voyager helped here as well. F ring, for example, appears to maintain its narrow band—60 miles across, compared with the 30,000-mile width of B ring—with the aid of two very tiny moons, one on either side, whose gravitational pull shepherds stray bits of ice and rock back into line.

Analysis of the rings' colors may give clues to their origins, enabling scientists to determine whether they are made of material left over from the formation of the solar system or of the wreckage of moons that once orbited the planet. □

Viewed from a distance of 27 million miles, Saturn and its gaudy belt of rings glow brightly in light from the sun. The striations of the northern hemisphere indicate the planet's tumultuous weather patterns, in which alternating bands of easterly and westerly jet streams shear past each other at more than 1,000 miles per hour. This color-enhanced photograph, taken by Voyager 2 in July, 1981, is a composite of three images made through ultraviolet, violet and green filters.

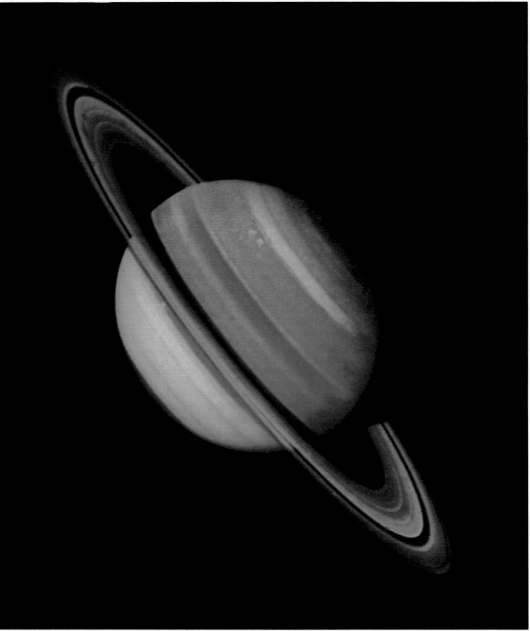

VOYAGER 2: *Saturn, 1981*

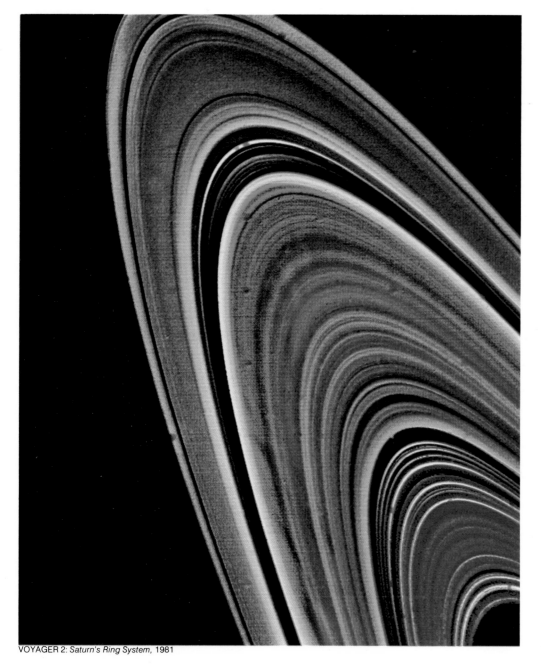

Possible chemical differences among Saturn's ring systems are seen as variations in color in this detailed view taken by Voyager 2 from 5.5 million miles away. Shot through clear, orange and ultraviolet filters, the composite image revealed for the first time differences between the inner and outer regions of B ring (orange and green). B ring is separated from the outermost A ring by the so-called Cassini Division (blue), which actually contains more than 50 faint ringlets.

VOYAGER 2: *Saturn's Ring System*, 1981

Payoff from a Bird's-Eye View

To look at the earth from on high, adventurers scaled mountains, ascended in leaky, gas-filled balloons and took off in the first rickety airplanes. Today the modern airplane enables millions of people to see the bird's-eye view with their own eyes—or better, with a camera's. For it is the aerial photograph that has provided such revealing—and haunting—glimpses of earth as the one at right.

In the hands of professionals, the airborne camera serves naturalists and archeologists, city planners and map makers; many amateurs seize the opportunity of an airline trip to make their own aerial photographs—a relatively simple procedure. Good pictures can also be taken from a small private plane. It can fly to specific locations at fairly low altitude, providing clear detailed photographs of points of interest more readily than a high-flying jet.

The photographer in a small airplane also experiences some unexpected sensations. To take an unencumbered picture, the door of the plane should be open. When the pilot banks to circle the area to be photographed, the photographer will suddenly be facing downward through the open door. For a moment, it will seem as though the plane is level while the ground tilts upward at a 45-degree angle. There is no danger of falling out, because centrifugal force will keep the photographer in place, but a tight seat belt may be reassuring.

A simple camera can produce good photographs from the air, but the high shutter speeds of more advanced types are an advantage; they prevent blurring that could be caused not only by the mo- tion of the camera in relation to its subject, but also by the vibration of the airplane. A fast lens helps make up for high shutter speeds. Focusing is no problem; the subject is always at infinity. Many amateurs who do more than occasional aerial photography search for old World War II Army Air Forces aerial cameras, particularly the K-20. It has an 8½-inch-focal-length lens that makes very sharp negatives in a 4 x 5-inch size; in addition, it allows the photographer to make many shots without reloading—each roll of film takes 50 pictures.

The aerial cameras that are used for large-scale professional work are quite different from the hand-held K-20. For its surveying and map making, the United States Coast and Geodetic Survey commissioned a hulking monster of a camera, a nine-lens, 600-pounder that takes 100 pictures on a roll of film 24 inches wide. From an altitude of 13,750 feet, each frame covers an area measuring 120 square miles.

However, the advent of satellite-borne "remote sensing" photography, in which electronic images are beamed earthward and reconstructed by computers, makes possible what amounts to an up-to-the-minute (and even a by-the-minute) portrait of the earth's face. Satellites like Landsat can scan the surface of the earth every 18 days from an altitude of 570 miles, covering 13,000 square miles at a glance. Today scientists can map areas that were only guessed at before, and they are able to document and predict flood damage, chart urban growth, detect fault lines that indicate earthquake zones, and sniff out water polluters.

"The Burning Tree"—a view of the Colorado River Delta at the Gulf of California taken from 14,000 feet—reveals the unexpected visual treasures inherent in aerial photographs. The river is at bottom, its water fanning out into a spreading network of limbs and branches. Through the years the silt deposits have filled the channels causing the river to branch again and again. The light areas are sand bars; the dark dots bushes and trees that have rooted on them. From the aerial perspective, the delta looks like a giant tree that is being consumed by billows of flame.

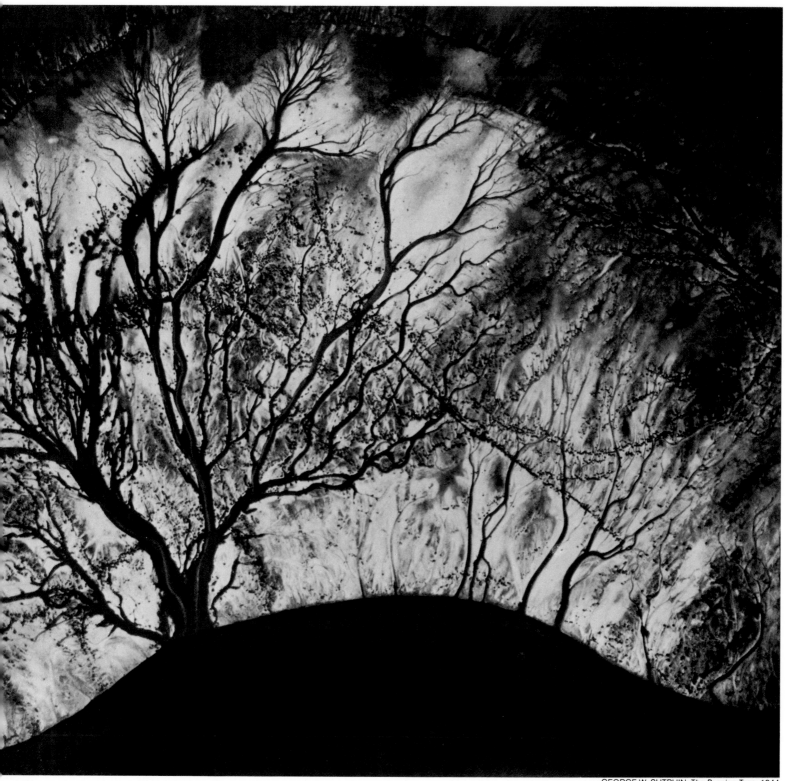

GEORGE W. SUTPHIN: *The Burning Tree*, 1944

WILLIAM A. GARNETT: *Los Angeles Sprawl,* 1969

Portrait of a Megalopolis

The spread of urban sprawl that makes up much of Los Angeles can be seen—house by house—stretching out to the mountains in the background. In the foreground is the Hawthorne district; the old core city with its high-rise buildings is at the center rear. Planners use comprehensive pictures like these to see where a city is going—and where it has been.

The extent of the urban sprawl that surrounds most American cities is told with numbing force through aerial photography. On the ground each house and plot of land is an entity with a separate existence of its own. Yet, when they are seen from the air, the individual houses merge with one another like oversized grains of sand, their numbers forming a virtual beach of habitations.

Such views do more than startle, they also serve city planners. Experts use aerial photographs of urban areas to help them decide how to lay out the right-of-way for a new highway or how to improve or extend an existing one. Aerial photographs also tell planners about the topography of uncharted land in areas where new cities are going to be built. When Brazil decided to locate its new capital city, Brasilia, in the wild jungle interior of that gigantic country, aerial photographs were the basis for planning. Some 20,000 square miles were photographed and from this huge area 80 square miles were chosen as the site of the city. The entire job, from photographing through analysis and selection of the site took less than a year—a fraction of the time a land survey would have required.

Sighting Traces of the Past

From the air the camera recaptures messages and memories of the past that are often invisible on the ground. The California Indian pictographs, or ancient drawings, at right, were unknown until seen from the air, while the picture of the site of Fort Union, New Mexico, not only shows the plan of its old fortress but even the impressions wagons left on the Sante Fe Trail.

The pictographs are located on the bluffs above the Colorado River in remote but not inaccessible areas. Yet these giant figures—the human form measures 170 feet from head to foot and 158 feet from hand to hand—were never noticed until 1932, when they were spotted by George Palmer, a local aviator, while he was cruising at 5,000 feet. Suspecting his eyes might have been deceiving him, Palmer returned to the scene with a box camera to take some aerial snapshots. Archeologists have since speculated that the human form is probably an Indian goddess; both pictographs are now believed to have been made some time after 1540 —the figure of the horse must have been drawn after the introduction of the animal to the New World by the Spanish explorers in that year. The exact reason for the huge pictographs may never be known. There are no nearby hills or promontories from which the artisans could admire their work.

The airborne camera gave the world its first look at these gigantic Indian figures—a human form and a horse—scratched into the gravel in Southern California. The figures were made by Indians scraping away the top gravel to expose the lighter soil beneath. The larger form is believed a goddess; quartzite stones indicate her eyes, nose, mouth and breasts.

UNITED STATES AIR FORCE: *Indian Pictographs,* 1932

The crisscross tracks left a century ago by pioneers' wagons can still be picked out in this aerial picture of the old star-shaped fortress at Fort Union, New Mexico, once a haven for settlers heading west along the Santa Fe Trail. The trail itself, its ruts so blurred by erosion that it is barely noticeable on the ground, is clearly visible winding out of the east (top left corner). The adobe brick buildings of the fort are still in use but hardly more prominent from the air than the remains of the old fortress.

WILLIAM A. GARNETT: *Fort Union,* 1969

A Watch on Wildlife

By studying aerial photographs, natu-
ralists gain valuable information on
such animal habits as the state of feed-
ing grounds, the size of the herds and
even on the work of poachers. The pic-
tures are so detailed that scientists
can often add up individual creatures
—even small ones—for a census that is
impossible to carry out on the ground.
It is not even necessary to tally each
one separately—the number showing
in one square of picture area is counted
and then multiplied by the area covered
to get a total. By knowing how many
wild animals exist in a certain territory
and where they are, the authorities can
establish hunting seasons and set bag
limits, which are regularly adjusted to
fit the size of the herds. □

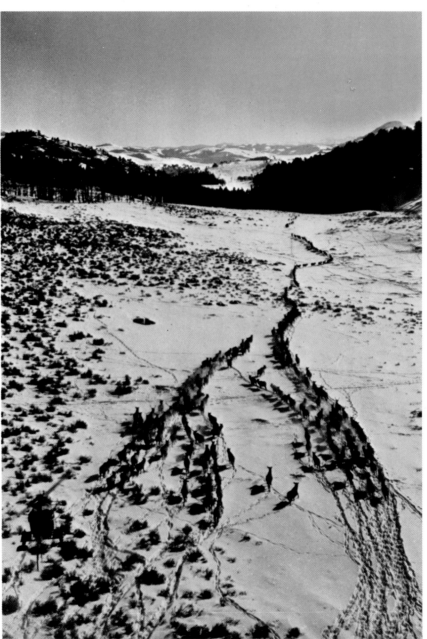

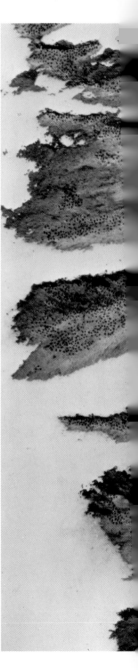

*Mountain elk follow the leader, displaying their
inherent herd instinct for single-file walking,
as a helicopter drives them over the snowy slopes
of the Rocky Mountains in Yellowstone National
Park to a corral. They were rounded up for
tagging in a study of the extent of their range.*

U.S. NATIONAL PARK SERVICE: *Elk Herd,* 1968

Each black dot is the shadow of a penguin — or a pair of penguins — at the rookery at Cape Crozier in Antarctica. This picture shows but a small section of the area, but by analyzing many of these pictures zoologists have estimated that some 300,000 Adelie penguins occupy the Cape rookery each summer.

J. J. PARKER, U.S. NAVY FOR THE U.S. GEOLOGICAL SURVEY: *Cape Crozier, Antarctica,* 1964

Bizarre Scenes from Underwater

The ability to record the unusual features and creatures of the sea has come from two diving inventions — scuba gear for deep waters and the snorkel for shallow — plus the development of watertight housings for cameras.

The scuba (self-contained underwater breathing apparatus) quite literally set the diver free to take pictures. Its components are a tank of compressed air that is strapped on the diver's back, a regulator and an air hose leading to the mouth. The diver also wears a transparent face mask, rubber fins for the feet and perhaps a rubber suit for protection against the cold, or against cuts and scratches.

The snorkel is simpler: It consists of a breathing tube with a mouthpiece at one end and a valve at the other. When on the surface, the swimmer breathes through the snorkel while observing the underwater world through a face mask. To explore, he simply holds his breath and dives; the valve shuts the breathing tube.

A wide range of camera equipment for underwater photography is readily available, from housings to fit all kinds of cameras to special electronic flashes *(pages 134-136),* but a wide-angle lens is a must. In the dimmer conditions underwater, the photographer should always be as close to the subject as possible. The short focal length of a wide-angle lens allows both close-in focusing and a generous field of view, as well as greater depth of field than a long lens.

On one of the Palau Islands east of the Philippines a scuba diver swims through a cloud of jellyfish that cluster near the surface of a landlocked saltwater lake fed by underground ocean streams. In the slanting light of late afternoon, photographer David Doubilet used a supplemental strobe and a fill-in slave unit to increase detail in the foreground. He took the picture from two feet away, using a 16mm lens and an exposure setting of f/8 at 1/60 second.

DAVID DOUBILET: *Jellyfish Universe*, 1981

The supple branches of sea whips were photographed in fairly shallow waters — 30 feet deep — in the Southwestern Pacific with a Rolleiflex set at f/22 and 1/250 second; a flash provided illumination. The whips are soft coral that gather in colonies on the firm bottom of the ocean. Around its mouth cavity, each whip has poisonous tentacles, with which it can sting and daze the microscopic zoöplankton it engulfs. To get the picture opposite of a graceful sea anemone, photographer Douglas Faulkner dived to a depth of 120 feet in Pacific waters off New Caledonia. He used his Rolleiflex with a flash, setting the shutter for 1/250 second and the lens aperture between f/16 and f/22.

DOUGLAS FAULKNER: *Sea Whips*, 1965

DOUGLAS FAULKNER: *Cerianthus Anemone*, 1965

DAVID DOUBILET: *Clownfish in Sea Anemones,* 1979

To get this crisp image of clownfish dodging among the stinging tentacles of sea anemones, David Doubilet attached a strobe and a fill-in slave unit at oblique angles to the top of his camera. He shot the picture from 11 inches away, using a 55mm lens and an exposure setting of f/16 at 1/60 second.

DAVID DOUBILET: *Octopus,* 1979

For this graphic portrait of an octopus in the clear
winter waters near Victoria, British Columbia,
Doubilet shot from below, without a flash, silhouetting
the creature against the sun. Using a 15mm lens with
an optical viewfinder, he made the picture from four
feet away, at a setting of f/11 at 1/125 second.

DAVID DOUBILET: *Dancing Sea Lions,* 1977

A pride of Galápagos Islands sea lions cavorts just beneath the surface near black volcanic rocks in this photograph, taken at midday with a 16mm lens. Because the dark rocks absorbed quite a bit of ambient light, the photographer used an exposure setting of f/5.6 at 1/125 second.

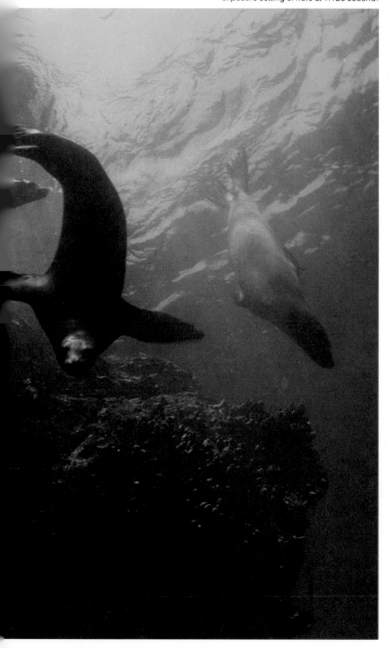

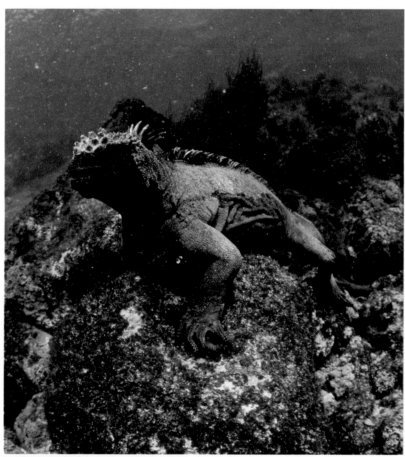

DAVID DOUBILET: *Grazing Marine Iguana, 1977*

On Punta Espinzoa Island in the Galápagos, a marine iguana, found nowhere else in the world, holds its breath while it grazes on algae growing on a submerged volcanic rock. The photograph was taken in extremely murky water from about six inches away with a fill-in strobe and an exposure of f/5.6 at 1/60 second. A 16mm lens allowed both the close-range focusing and enough depth of field to include details of the underwater scene.

AL GIDDINGS: *Hidden Depths*, 1975
132

Sixty feet beneath the surface of Truk Lagoon in Micronesia, silver bait fish flutter through the bridge of the Japanese aircraft transport Fujikawa Maru, one of some 60 ships sunk there by American bombs on February 17, 1944. The largest assembly of man-made reefs on earth, these ghostly vessels enable scientists to obtain precisely dated evidence on growth rates of coral, sponges and algae. The photograph was taken with a 20mm lens and a fill-strobe in early afternoon light.

Tools to Take below the Surface

The deep-sea realm of the scuba diver is one of motion and dimness—characteristics that introduce more difficulties for the photographer than the obvious challenge of protecting equipment against water. But with compact, versatile gear like that shown on the opposite page, even a beginner can make pictures to rival that of the billowing sea fan at right.

This easy-to-use equipment includes a separate underwater SLR camera (1), lenses of varied focal lengths (3,4,5), an optical viewfinder (2) for the 15mm lens, and a waterproof strobe (8) with mounts (9,12,14) that make camera and strobe one handy unit. Also included are a waterproof hand-held light meter (10) and a color-correcting filter (6). A less expensive option would be to use underwater housings for a 35mm camera (11) and a strobe (13).

A strobe unit and light meter are generally used by scuba photographers because there is little natural light at depths below about 30 feet, and estimated exposure values are apt to be wrong. Also, because of the way water refracts light, everything seems at least one third closer than it really is, both to the human eye and to the camera. This restricts the area covered by the picture. Pictures that are taken from more than 10 feet are generally murky because of tiny particles of sand and plant life suspended in sea water. The best solution is to use a lens of short focal length—some diver-photographers favor the 15mm fisheye lens that covers a 94° view of the scene.

Even more than on land, practice is important. With experience comes the ability to step back mentally, ponder all the variables posed by the submarine environment—and then use them to capture its very special beauty.

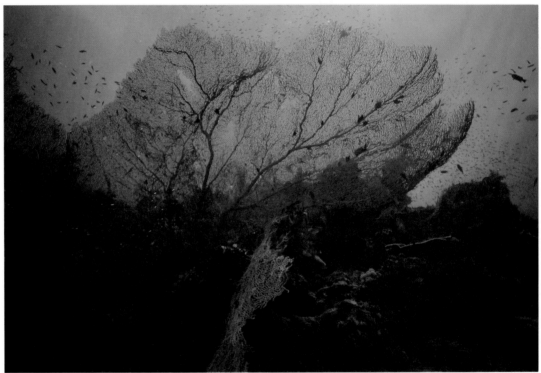

FLIP NICKLIN: *Sea Fan*, 1979

Ten fathoms below the surface of the Red Sea, the branches of a sea fan extend in a lacework above the rocky coral on the sea floor, sheltering a golden swarm of fish. Photographer Flip Nicklin used a Nikonos camera fitted with a 15mm lens that enabled him to shoot from within a few feet of the plant and still include all of it in the frame, along with some of the ocean floor. To augment the dim light at that depth, Nicklin used a strobe to fill in foreground detail, enhancing the picture's color balance and allowing him to use a smaller f-stop—f/8—to provide greater depth of field.

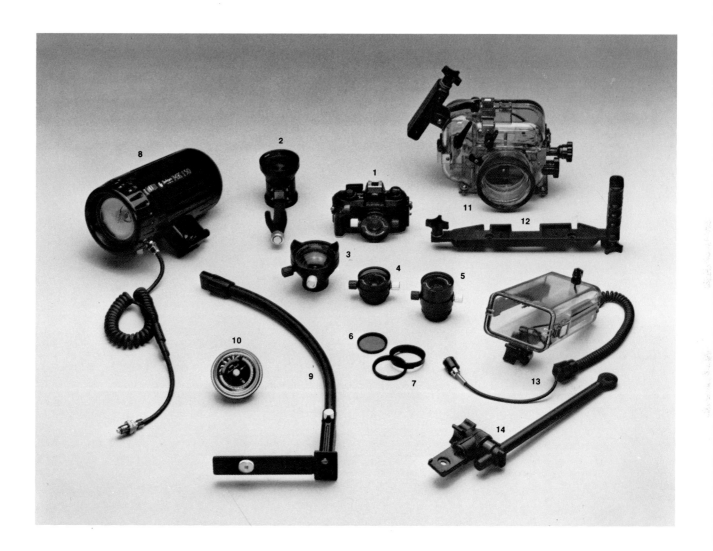

1 **Nikonos IV with 35mm lens** 8 **waterproof wide-angle strobe light**

2 **optical viewfinder for 15mm lens** 9 **flexible strobe arm**

3 **15mm lens** 10 **underwater light meter**

4 **28mm lens** 11 **underwater camera housing**

5 **80mm lens** 12 **strobe housing tray**

6 **color-correcting filter** 13 **underwater strobe housing**

7 **lens hood and adapter** 14 **flash bar**

Accessories for Getting Close-Ups

waterproof close-up strobe light

Nikonas IV with 35mm lens

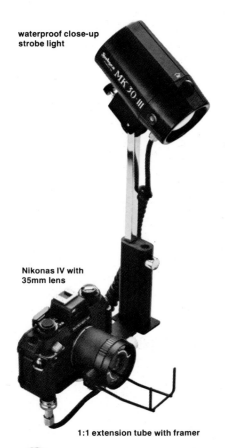

1:1 extension tube with framer

1:2 extension tube with framer

1:3 extension tube with framer

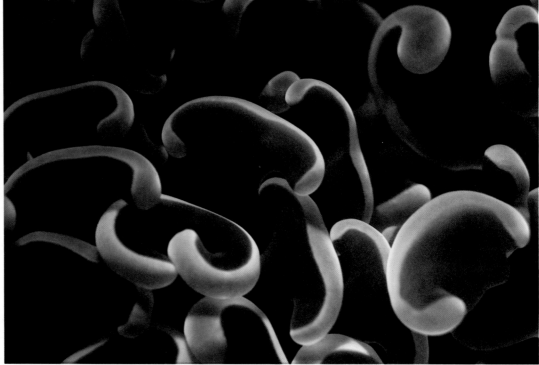

ANNE L. DOUBILET: *Sea Anemones from Japan*, 1979

The sinuous curves of sea anemones found clinging to a rock 80 feet below the surface at Japan's Izu National Park were captured by photographer Anne Doubilet with a hand-held strobe and an underwater camera that was equipped with a 35mm lens and a 1:1 framer and extension tube (left).

With the accessories shown here, an amateur can get dramatic deep-sea close-ups, with less interference from suspended particles in the water, by bringing the lens within inches of the subject. Extension tubes vary the magnifying power of the lens, yielding images that are one-third life size, one-half life size or life size. The wire framers — usually pressed lightly against the subject — indicate the area being photographed and automatically set the correct distance to the subject. Depending on how far underwater the scene is, the strobe should be placed from four to 12 inches from the subject.

JONATHAN NORTON LEONARD AND THE TIME-LIFE PHOTO LAB: *Contents of a Woman's Purse Photographed with Radioactive Material,* 1945

Beyond the Rainbow's Spectrum

Visible light is what we see by — but not necessarily what we take pictures with. Its waves, evoking the familiar colors from violet to red, make up only a tiny portion of the great spectrum of electromagnetic energy. All other parts of the spectrum are invisible, but some of them can be used in photography. Beyond the violet, short-wave end of the visible spectrum are ultraviolet X-rays and gamma rays. Beyond the red, long-wave end are infrared and radio waves, which have wavelengths as long as six miles.

All these waves have properties different from those of ordinary light and serve as invaluable tools for exploring the physical universe. The bulk of them are restricted to scientific, industrial and medical uses; amateurs, of course, should not attempt to make an X-ray or gamma-ray picture even if they have access to the equipment or to radioactive elements. But one section of the invisible spectrum, infrared, can be used by amateur photographers with little special apparatus. It can provide interesting and sometimes eerily beautiful pictures, in tones startlingly different from those perceived by the human eye and frequently revelatory of features hidden in natural light.

X-rays, while not the first part of the invisible spectrum to be discovered, were the first to be put to practical use. In 1895 Wilhelm Konrad Röntgen, a professor at the University of Würzburg in Germany, was experimenting with a Crookes tube, a then-mysterious device that produced a visible glow by passing electricity between two electrodes in a glass tube from which most of the air had been removed.

One of the experiments Professor Röntgen performed with his tube was to enclose it in thick, black cardboard and turn it on in total darkness. When he closed the switch that sent electricity through the tube, a dim glow appeared far across the room from the covered tube. The light came from a cardboard screen that had been coated with barium platinocyanide, a material that fluoresces when struck by ultraviolet light. But ultraviolet could not have passed through the cardboard encasing the Crookes tube. Some unknown ray apparently was issuing from the tube and activating the screen.

Professor Röntgen realized that he was in the presence of an important mystery. Working systematically, he explored the properties of the new radiation, which he named X-rays, X being the mathematical symbol for an unknown. It must have been an enormous thrill when he put his hand between the tube and the fluorescent screen and saw a shadow picture of his own bones. He also found that the rays, apparently penetrating solid wood, had fogged photographic plates that he kept carefully wrapped inside a desk drawer. This told him that he might be able to make X-ray shadow photographs. He tried it — and one of the first results was a picture of his wife's hand, clearly showing her bones as well as a ring on one of her fingers.

Not until 1912 was it proved that Röntgen's mysterious X-rays are electro-

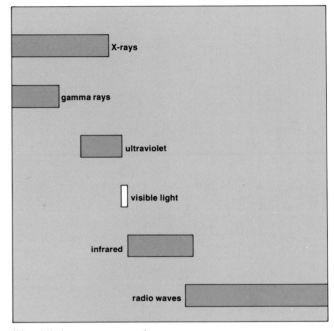

Although the human eye senses only electromagnetic wavelengths between 400 and 770 millimicrons, pictures may be taken with everything from short gamma rays to the long radio frequencies pulsing from deep space. Some of these pictures are true photographs, created by the action of electromagnetic radiation on chemical emulsions. Others use a nonphotographic medium to record the signals, which are then converted by computer into visual images — revealing such mysteries as quasars on the edge of the universe and chemical reactions inside the human brain.

magnetic waves, analogous to light but much shorter in wavelength, between .005 and 10 millimicrons (millionths of a millimeter). The shorter the waves of X-rays, the more energetic they are and the more material they can penetrate.

Seldom has the practical value of a discovery been exploited so promptly. Long before X-rays were understood they were put to use in medicine. Even primitive X-ray pictures could locate bullets embedded in human flesh, help surgeons set broken bones and find out whether Baby had really swallowed Mother's wedding ring. They also caused an enormous amount of popular excitement and misunderstanding. When it became known that most clothing is transparent to X-rays, some scandalized persons jumped to the conclusion that Röntgen's discovery was a threat to modesty.

Anyone who tried to use X-rays in this way was surely disappointed; a clothed person who is X-rayed of course looks like a skeleton surrounded by shadowy outlines of flesh. Far more serious than this misunderstanding was the long-continuing ignorance—even on the part of scientists—of the danger of X-rays. Because the rays cannot be seen, felt or otherwise sensed, they appear harmless, but they are not. When they penetrate human tissue, they can kill living cells or, worse, cause them to multiply unnaturally as deadly cancers. Many early X-ray workers suffered burns on their hands that refused to heal and became so severe that fingers, hands and even arms had to be amputated. Some died slowly of radiation-induced cancer. Modern apparatus and precautions make X-rays virtually harmless to the patient, but physicians and technicians who use them frequently tend to get careless. A disproportionate number of them still die of leukemia, a form of cancer often caused by the cumulative effects of radiation.

X-ray photography has many uses aside from medicine. Perhaps the most common is taking pictures of welds and metal castings to locate imperfections such as cracks, gas bubbles or slag inclusions. Before X-rays were available, many metal parts failed disastrously because of defects that were not revealed by normal inspection methods. It is now common practice in industry to X-ray all metal parts whose failure might cause a catastrophe.

A subtle use of X-ray photography is in studying paintings, for it reveals even more than infrared examination. When a painting is X-rayed, strange things often appear on the film. The surface paint vanishes while the thick layers of white lead with which many artists blocked in their main figures become prominent. Often figures appear that were wholly invisible to the eye, showing how the painter changed his concept as the work progressed. Sometimes these ghostly shapes prove that the artist used a second-hand canvas with a picture, by himself or another painter, already on it. When the films are examined in detail the artist's brushwork—the way he applied his paint—is often easy to see in the underlying layers. Many forgeries have

been exposed in this way. If the forger worked before the day of X-rays, he thought only of making the surface layers of paint conform to the brush style of the old master he was imitating. Having used his own style of brushwork on the underpainting, he is betrayed by the X-ray.

Some X-ray tests of paintings have unexpectedly happy endings, however. Many excellent paintings by old masters have been altered to fit changes of taste or even covered completely by a later work of low value. In such cases, X-rays show interesting ghosts invisible to the eye. When the surface paint is removed, the original painting is revealed in all its glory.

Gamma rays are another part of the electromagnetic spectrum that can be used to make photographs. First noticed by Henri Becquerel of France in 1896, only one year after Röntgen discovered X-rays, they are essentially the same kind of waves as X-rays, but are produced naturally by radioactive substances. It was quickly found that they could be used to take pictures, but the only available sources of them, radium and its derivatives, were much too rare and expensive to enable them to be widely employed. It was not until the development of nuclear energy during World War II that man-made radioactive materials became plentiful enough for this purpose.

Probably the first published picture taken with gamma rays from radioactive materials produced by a man-made nuclear reaction was taken, or at least instigated, by the author of this chapter. I was then science editor of TIME magazine and was invited in September 1945 to see the crater of the first atomic test bomb near Alamogordo, New Mexico. The Army Air Forces flew about 20 reporters to a base where we were joined by a party of physicists. We got into cars and drove toward the test site, which was in the center of a great, dry plain covered with low brush. In the distance we could see what looked like a smallish pond of green, scummy water. A dirt road led toward it, and beside the road ran a row of telephone poles, their crosspieces loaded with wires and cables. As we approached the test site, which still looked like a green pond, the wires disappeared, blown away by the bomb blast. A little farther on, the crosspieces disappeared. Then the poles themselves were snapped off at the ground.

The "pond" proved to be a shallow crater lined with fused soil that looked like green glass and crackled underfoot like ice. Because of radiation danger, we were allowed to stay only about 20 minutes, but in that time I collected a handkerchief full of the green fused soil. If I had known what I was to learn later, I would not have touched the stuff, but at least I had sense enough to ask a friendly looking physicist (he turned out to be Dr. J. Robert Oppenheimer, head of the Los Alamos laboratory that built the first atomic bombs) to test my souvenirs with a radiation counter that he was carrying.

He rejected some of the pieces as too radioactive, told me the rest were not too hot and advised me to wrap them in my coat and keep them well away from my body. At the first opportunity I wrapped them in sheet lead. Back in New York I took them to the TIME-LIFE darkroom where the technicians, some of whom were a bit skeptical, provided a wrapped sheet of photographic film. On it we put a woman's purse bought in the five-and-ten and filled with such things as coins and bobbypins. On top we laid a sheet of stiff cardboard with lumps of the fused soil from New Mexico arranged on it. The result was the picture on page 139 showing the contents of the purse.

Certain United States government officials had been claiming that the two bombs exploded over Japan at the end of World War II had no radioactive aftereffects. When TIME ran that picture, the article described the test site in New Mexico. It did not call anyone a liar, but it pointed out that "X-ray" pictures could be taken with the soil melted by the test bomb.

Radioactive isotopes, produced not by nuclear explosions but by controlled nuclear reactors, are now used widely for gamma-ray photography much more sophisticated than the picture of the purse. The most popular of these isotopes is cobalt 60, but others can be used. They are all extremely dangerous and must be handled with elaborate safeguards, but they have the advantage over X-ray machines of portability, independence of power supply and small size. A potent pellet of cobalt 60 can be placed, by remote control of course, inside a narrow-bored, thick-walled pipe or casting, where an X-ray tube would not fit. From this vantage point, it will take a picture of an entire welded joint, throwing telltale shadows of imperfections on a strip of film wound all around the pipe. Such a source can take many pictures at the same time. Since it radiates equally in all directions, it can be placed in the center of a shielded room while objects to be gamma-rayed are set all around it with filmholders behind them.

Gamma rays produced by much less potent radioactive isotopes are also providing dramatic insights into the workings of the human body. The feat is achieved with a device known as a PET (positron emission tomography) scanner, which produces vividly colored cross-sectional views of the head or torso, revealing not only how the part is structured but some of its workings *(pages 156-157)*. With a PET scan, a physician can examine the functioning of the brain after a stroke, for example, and decide whether surgery would be beneficial. The technique has also allowed researchers to study how the brain reacts biochemically to stimuli and has even enabled them to recognize differences in brain metabolism between normal and mentally disturbed individuals.

Modern nuclear physics has created another kind of radiation that can be used for photography: the neutron beam. Neutrons are not, however, electromagnetic waves; they are nuclear particles with zero electric charge. When

generated in a nuclear reactor and directed outward in a beam, they will pass through massive materials and yet register on a film. Pictures taken in this way—neutrographs—resemble X-ray pictures superficially, showing shadows of varying density, but in neutron pictures the shadows are cast by light materials rather than heavy ones. Neutrons are used for many kinds of inspection. They look for flaws in the uranium fuel for nuclear reactors; they detect the hydrogen in unwanted moisture; and they find cracks in plastic or aluminum parts that might elude X-ray inspection. Although they are dangerous, their use has probably saved a great many lives.

In the electromagnetic spectrum, the short waves of ultraviolet are just shorter than the visible spectrum of colors perceived by the human eye. Ultraviolet occupies the wavelengths between 10 millimicrons and 400 millimicrons, where blue visible light begins. For photographic purposes the most important of these waves is near ultraviolet, which is longer than 200 millimicrons. Only this part of the ultraviolet range can be used in a camera without extremely expensive special equipment.

Ultraviolet is reflected, as visible light is, when it hits most material. But it also has another interesting effect: Its energetic waves make many materials fluoresce—that is, give off visible light, usually blue or greenish yellow. As a result, there are two distinct ways to make ultraviolet pictures. In the first method, both the source and the camera lens are covered with filters that allow no visible light to pass. The only radiation that affects the film is the ultraviolet being reflected from the subject, just as visible light is the basic radiation affecting film in an ordinary photograph. In the second method, the camera lens is covered with a filter that excludes ultraviolet, and the resulting picture shows only the visible light that comes from the subject's fluorescing materials.

The two kinds of pictures can be quite different because of the varying ability of different materials to reflect ultraviolet or to fluoresce when struck by it. Both are widely employed in the study of suspicious documents, the principal use of ultraviolet photography. Erased printing or signatures on a document can often be revealed because invisible remnants of them either reflect ultraviolet differently from the paper or fluoresce brilliantly. Many a seemingly clever forgery has been detected in this way.

Ultraviolet is sometimes called "black light" because the lamps that generate it produce no radiation visible to the eye; but unlike infrared it is not much use for taking secret "surveillance pictures" (as detectives call them) of unsuspecting people in the dark. Projected in the dark, it makes human skin and teeth fluoresce with ghastly brilliance, so that persons under surveillance are apt to perceive that they have been photographed and can take appropriate action against the photographer or his hidden camera.

The long rays of infrared, which include those sensed as heat, are the opposite number of ultraviolet, being just longer than the eye can perceive. Anyone who has held his hand up to the sun knows that heat radiation is associated with visible light, but there was no clear thinking on this point until the spectrum of visible colors was studied carefully. In 1800 the British Royal Astronomer, Sir William Herschel, set up thermometers in sunlight that had been spread into a rainbow of colors by a prism. He found that the thermometers registered a higher temperature near the red end of the spectrum. Even beyond the red the thermometers remained hot—hotter than those in the visible spectrum. Herschel correctly concluded that sunlight contains something like light that is invisible to the eye and that carries a large amount of energy. He named it infrared, which means "below red."

The infrared begins with waves longer than deep red, 700 millimicrons. When its waves are not much longer than those of red light it is called near infrared and though invisible to the eye it behaves much like visible light. Infrared was not used photographically for more than a century because ordinary film was not sensitive to it, but about 1931 it was discovered that certain dyes added to the emulsion would make it record an image in some but not all kinds of infrared. Today infrared pictures can be taken in an ordinary camera with special infrared film. The longer the waves become, the more difficult they are to handle. Approximately 1,350 millimicrons is roughly the limit for practical photographic use. Far infrared—heat waves—longer than this can be detected only with special apparatus and are typically used to form vague "heat" pictures of warm objects such as the human body or a car whose engine has been running.

Photography with near infrared does not record the world in the same way as with visible light. Near infrared is reflected strongly by many common materials that absorb most visible wavelengths. Moreover, it passes through other things that absorb or reflect visible light. In some cases visible light makes objects give off infrared wavelengths, the infrared radiating outward as part payment for the incoming visible light.

Taking black-and-white pictures with near-infrared waves is not at all difficult. The only essential special equipment needed is infrared film, several kinds of which are available, and a filter to keep out most visible light, which would otherwise dominate the scene. It must also be remembered that the glass of a lens does not refract infrared as strongly as it does the shorter waves of visible light. Therefore the lens focuses an infrared image slightly behind the visible light image. This must be allowed for by focusing in visible light and then moving the lens a small additional distance away from the film, thus bringing the infrared image into focus on the film. The correction varies with different lenses and is usually marked on the lens. In any case it is good

policy to use the smallest practicable lens opening, because infrared be-
haves somewhat differently in passing through a lens, and aberrations are
not as completely allowed for. When a small lens opening is used, say f/11,
such failings of the lens do little damage to the quality of the picture. Depth
of field is also increased, reducing the effects of focusing errors.

The sun provides plenty of near infrared for landscapes and other scenes
taken outdoors, but ordinary light meters are not reliable guides for expo-
sure, for they are designed to measure only visible light. The easiest and
most startling black-and-white infrared photographs that amateurs can take
are of landscapes with mountains in the far distance. In visible light moun-
tains are usually obscured by haze and show little contrast against the pale
sky near the horizon. Infrared sees through the haze; the mountains stand
out sharply against a dark, almost black sky, and many distant details appear
that are invisible to ordinary photography or to the human eye.

The improvement is due to a combination of several different effects. The
ratio of brightness between many objects is usually greater in infrared than
in visible light, making them easier to distinguish from one another. Also, the
longer waves of infrared are not scattered as much by the atmosphere, and
this reduces two scattering-caused interferences with long-range clarity: the
brightness of the sky and the bluish haze that often intervenes between the
camera and the horizon. Probably most important is the fact that most ob-
jects on the ground reflect more infrared than they do visible light rays;
therefore they stand out against the sky.

Besides delineating distant landscapes, infrared provides some strange
— and useful— effects. Green foliage absorbs a large part of the visible light
that strikes it and therefore shows up fairly dark in ordinary black-and-white
photographs. By contrast, foliage strongly reflects infrared, so trees and
green fields appear almost white in pictures taken by its light. Clouds show
brilliant white against the dark sky because the comparatively large water
particles of which they are composed reflect infrared much as they do visible
light. Lakes and other bodies of water that take their color from the blue sky
appear dark also. This often makes small streams that would normally be
hidden by foliage show as prominent features.

Infrared pictures taken across water often achieve startling effects. The
water comes out ominously dark except where ripples reflect the full rays of
the sun, including its infrared, as if they were small mirrors. In these places
the water sparkles like diamonds strewn on black velvet. Leaves in the fore-
ground look like white paper cutouts. Trees on the far shore, which would be
dark in visible light, are flecked with lacy brightness. Above them float hills
and distant mountains wonderfully clear and sharp.

Architects often use infrared to enhance the drama of a building and its

surroundings. Tourist agencies occasionally use it to show to best effect spectacular mountains that are hard to photograph because of haze. Their cameras often see far more than trusting tourists do.

Close-up infrared pictures are not apt to be beautiful. Portraits look unhealthy because lips and skin appear unnaturally pale; other subjects show unusual contrasts and details that the eye interprets as ugly blemishes. But for just such reasons infrared photography has a long list of important uses, most of them based on the fact that it sees what the eye does not. In medicine it is used to judge the condition of the network of veins just under the skin — unhealthy veins may be filled with oxygen-poor blood that shows dark in infrared and therefore stands out clearly.

Infrared is extremely valuable for studying illegible or suspect documents. If writing or printing has been erased, either mechanically or chemically, the fact is often revealed by intrared, which is strongly absorbed by traces of ink that remain invisible in normal light. Forgers sometimes erase everything except the signature on a hand-written letter, and then type a will or other important document above it. No handwriting expert would question the genuine signature. Infrared, however, will reveal the erased writing and so prove the document false.

Many old objects, maps and documents have writing on them that is illegible because the ink has faded or is covered by dirt or darkened varnish. Infrared often shows the writing as clearly as if it were new and fresh. This technique was spectacularly used in deciphering the Dead Sea Scrolls, the 2,000-year-old Hebrew manuscripts that were found in caves near the Dead Sea in the 1950s. Some of the parchments had turned so dark with age that the writing on them could not be read. When photographed, however, the ink absorbed infrared, which was strongly reflected by the darkened parchment. The photographs consequently showed the writing clear and black against a light background.

Police and private detectives make extensive use of infrared. It shows up powder marks on the clothing of persons killed by short-range gunfire. It helps in the study of fingerprints, permits letters to be read inside sealed envelopes, detects some kinds of writing in invisible ink. Best of all, it permits pictures to be taken in the dark. Burglars can be photographed at work without their knowledge, by focusing a camera on a cash drawer or safe and arranging for its shutter and an infrared flashbulb to be tripped when an intruder approaches. Infrared is also used by blackmailers and by lawyers looking for evidence to use in divorce cases. Pictures taken by hidden infrared cameras may not be artistic, but they are sufficiently explicit to be extremely useful for such purposes.

Infrared can also be used to take pictures in color — but the color is what is

known as false color. Colors, of course, are merely sensations produced in the brain by certain wavelengths of visible light that have entered the eye. Infrared produces no sensation because the retina is not sensitive to it. But since it affects certain photographic emulsions, it can be considered a color and used to take pictures that show it as a color when they are developed. This is generally done by making invisible infrared reveal itself as red in the final photograph.

Like standard color film that takes pictures in true colors, infrared film has three superimposed emulsions, each emulsion sensitive to a different set of wavelengths—in this case infrared, green and red. These wavelengths form images on their respective layers, but when the film is developed, positive images in other colors appear. Green light produces an image on the middle emulsion in the negative stage. That is, objects that send a lot of green light through the camera lens appear as light-toned areas in the yellow positive. Red light produces a positive in magenta (a reddish purple), and infrared produces a positive in cyan (a bluish green).

Yellow, magenta and cyan are subtractive colors. When superimposed and viewed with white light passing through them, they yield the three primary colors familiar to the eye. Yellow and magenta combine to form red. Yellow and cyan form green. Cyan and magenta form blue. When they are present in unequal strengths, they yield an unlimited number of intermediate colors. Infrared, normally invisible, is rendered as red, and the visible colors are deliberately mixed. As a result most of the colors in the final picture are false. That is, they are different from what the eye sees in ordinary visible light.

Since foliage reflects a large amount of infrared, it makes light-toned areas on the cyan positive. This permits magenta and yellow in the other layers to predominate; they combine to form false red, making green leaves look like flaming autumn foliage. Any object that reflects a great deal of red but only a little of other wavelengths permits cyan and yellow to predominate, forming green. Where the yellow positive image is light-toned, magenta and cyan form blue. Since little red or infrared, which would wash out magenta and cyan, comes from the clear, cloudless sky, an infrared false-color picture usually shows the sky in a color close to the blue the eye would see. Human bodies show an unsightly network of deep blue veins.

False-color pictures are useful militarily because they make it even more difficult for an enemy to hide behind camouflage. False-color has its civilian uses too. When an orange grove is photographed in false color the healthy trees are a uniform red, while trees attacked by pests or fungi are purplish or blue. Often an aerial color picture of a landscape made in visible light shows little but slightly varying shades of green. Infrared enlivens the entire scene, making its components stand out in a full gamut of false but meaningful colors.

Amateurs have no great difficulty with false-color film, and sometimes they get surprising results that experts cannot fully explain. One reason why the colors are not fully predictable is that not all the infrared that affects the film comes from reflected sunlight. Some of it is infrared that is generated when ultraviolet waves from the sun hit certain materials. It is difficult to predict without trial what effects this will produce in the final picture.

While the false colors produced with the moderately long infrared wavelengths give us revealing overviews of our own planet, the very long radio wavelengths provide a unique means of peering into the distant reaches of space and observing phenomena invisible to optical telescopes. The existence of extraterrestrial radio sources was not known until 1931. In that year, a young Bell Laboratories engineer, Karl Jansky, rigged up a primitive directional antenna in order to find the source of static that plagued long distance telephone lines. After accounting for lightning and other obvious culprits, Jansky was left with a persistent hissing that he ultimately concluded could only be of celestial origin. Since then, an entire branch of astronomy has evolved around studying these emissions, using very large dish antennas *(page 174)* that collect and focus radio waves in the same way that reflecting optical telescopes focus light waves. A computer then converts the radio signals into an image—thus extending photography's vision out to the edge of the universe and back to the beginning of time. ☐

Jonathan Norton Leonard

Rays That See through Anything

Almost as soon as Wilhelm Röntgen, who was a professor of physics at the University of Würzburg in Germany, discovered in 1895 the strange emanations he called X-rays, he found out the two facts that would make them so useful to mankind: They affect photographic emulsions the way visible light does; but unlike light waves, X-rays are not reflected by most objects—they pass through them and penetrate some substances more easily than others. Thus "shadow pictures," or radiographs, made by placing a piece of film on one side of an object and an X-ray generating tube on the other, can show what is inside the object.

· It was many decades after Röntgen's discovery before other scientists were able to figure out what X-rays are—electromagnetic waves like visible light but of shorter wavelength—and why it is that X-rays "see" through opaque objects. In general it is the electrons contained in atoms that absorb X-rays; elements of high atomic weight have many electrons in a given amount of space, so they block X-rays more than do elements of low atomic weight, which have few electrons per unit volume. That is why iron and lead, which are heavy, block X-rays while such lighter elements as carbon, oxygen and hydrogen allow the rays to pass without as much obstruction.

Human bones, which contain calcium and phosphorous, both fairly heavy, appear as light markings on X-ray pictures. They have blocked the rays and kept them from darkening the film. Soft tissues, made mostly of carbon, oxygen and hydrogen, show darker on the film because they have permitted more X-rays to pass. The amount of absorbing material, as well as its composition, is also important. Hidden cavities in a metal casting or the air passages in a human lung appear darkest in the picture because they have not absorbed as many X-rays as the solid material around them.

How easily X-rays penetrate parts of an object depends also on the X-rays themselves, for the shorter the length of their waves the more energetic they are. The shorter X-rays, called "hard," show more of the finer details inside large, heavy objects such as ancient gold sculptures. But the longer ones, called "soft," are particularly useful for recording delicate nuances within easily penetrable materials—slight variations in the thickness or the composition then have a large effect on the amount of X-rays reaching the film, producing beautifully shaded pictures of things such as plants, as in the photograph opposite.

Other kinds of radiation are more energetic—and more penetrating—than X-rays. Gamma rays are basically the same as X-rays but can be of shorter wavelength, and are used to make detailed shadow pictures of less easily penetrable objects such as machinery. (The basic difference between X-rays and gamma rays is in their sources: X-rays are produced by electronic tubes and gamma rays are given off naturally by some radioactive materials.) Quite different are neutrons, which are not electromagnetic rays but, instead, particles from the interior of atoms. They are able to penetrate substances that X-rays and gamma rays cannot, giving the most detailed radiographs of all.

Dr. Paul Fries, a German physicist, used X-rays to create such haunting shadow images of plants as those in the picture at right. Here he radiographed bouvardia and foxglove against a background of ferns, using long-wavelength, or soft, X-rays to reveal differences in the inner structures of the plants.

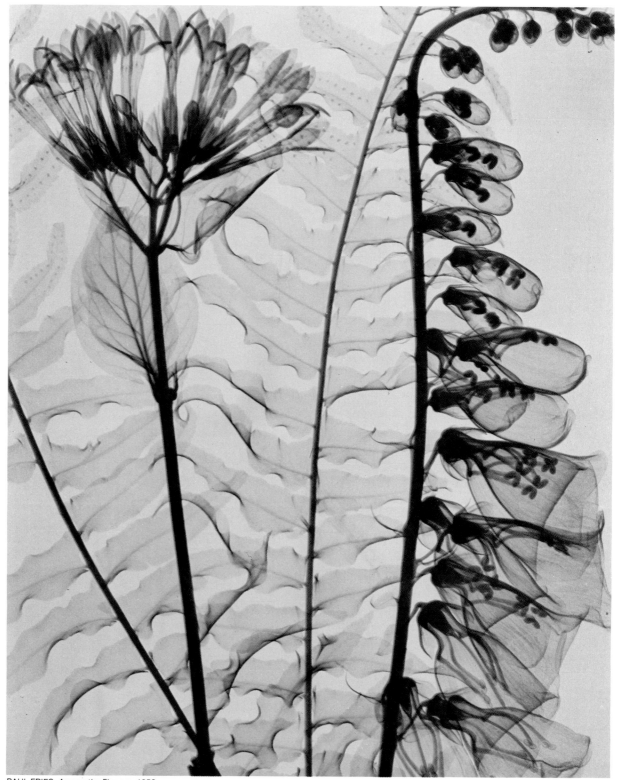

PAUL FRIES: *Among the Flowers*, 1956

Revealing Secrets within a Work of Art

Archeologists and art historians use the penetrating power of X-rays and gamma rays to probe opaque surfaces to study what is underneath the surface of the work without destroying it. Mummies are radiographed to investigate the medical histories and the physical characteristics of peoples who lived thousands of years ago. The craftsmanship of past civilizations is also revealed by radiography and often shown to be surprisingly sophisticated. Egyptologists, for example, long believed that the mask of Tutankhamen, Pharaoh of Egypt in the 14th Century B.C., had been constructed of two separate pieces of gold, although it appears to the eye to have been molded as a single piece. But since gold is extremely dense, impervious to even the hardest X-rays, the theory was not confirmed until 1967, when very hard gamma rays from iridium 192, a radioactive isotope that is produced by a nuclear reactor, were employed to make the clear radiographs at right.

Unmasking fraudulent works of art is another task for radiography. It immediately puts the finger on the forger who creates cracks on the surface of his painting to make it look old. Since he cannot make the cracks extend to the base of the canvas, the X-ray pictures show that they are superficial, revealing the fraud.

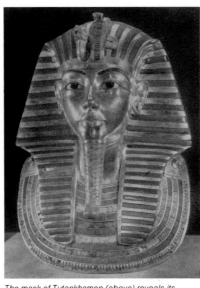

The mask of Tutankhamen (above) reveals its construction details in gamma-ray radiographs (right), confirming archeologists' suspicion that the mask was made from two pieces joined by a strip of gold, which appears as the light band running down behind the ear. The full-face view revealed an additional surprise: The pharaoh's beard was cleverly attached by a tapered cylinder pushed into the chin—visible in the bottom half of the picture at far right, opposite—and the beard was then fitted over it.

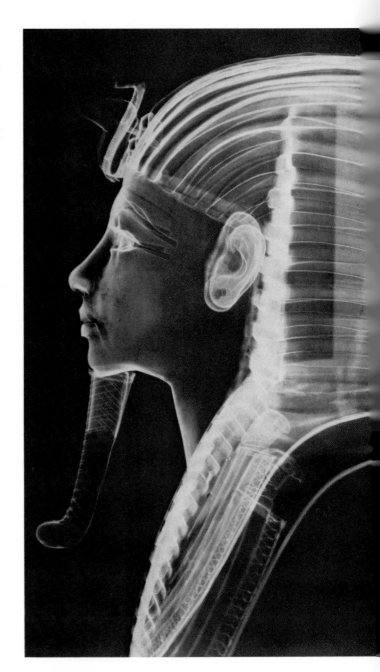

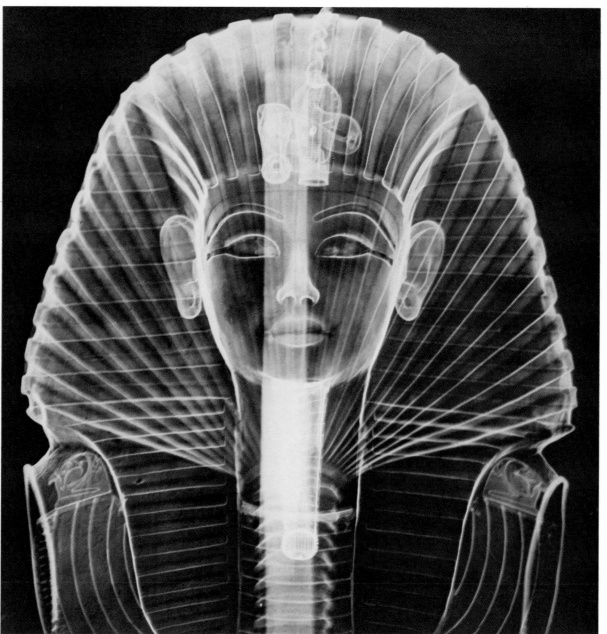

Details from a Radioactive Beam

Just as a dentist takes X-ray pictures of his patients' teeth to check for cavities, industries use the penetrating power of the rays to examine their products for weak spots or structural flaws. Dark spots on the film after exposure indicate cavities and flaws that have allowed the rays to pass through.

Radiographs are valuable for checking the consistency of raw materials as well as the quality and safety of finished products. If one part of a metal is thinner than another, it will show up darker on the radiograph. If the inconsistency is so great that it fails to meet specifications, the section is rejected.

Since their primary purpose is to check individual parts or samples of raw materials, industrial radiographs are usually quite small. The radiograph of the Mercedes-Benz 230SL sports car at right is an obvious exception. To make the picture, hard gamma rays from radioactive cobalt 60 were used. The cobalt was then suspended from a crane that was secured to eliminate vibrations, five large photographic plates were placed under the car, and after 50 hours' exposure a detailed record of the works of a car had been made.

Made to demonstrate how radiographs can reveal fine detail, this gamma-ray picture—at 17 feet overall the largest ever made—shows the smallest part of an automobile's structure with incredible accuracy. Even the filaments in the headlights, at left, can be seen clearly.

Pictures of the Brain in Action

Resembling electric-colored gumdrops, the images shown on these pages are computer-enhanced photographs of the human brain. They are products of a dramatic new medical technique called a PET scan (for positron-emission tomography) that enables doctors to view the functioning—or the malfunctioning—of the body's organs without the risk of exploratory surgery.

A patient to be diagnosed by PET scan is injected with either glucose or another biochemical that has been radioactively "tagged" with an isotope that emits positively charged electrons, or positrons, as it decays. A scanning device follows the progress of the tagged substance by detecting the gamma rays emitted when the positrons collide with negative electrons normally found in the body's cells.

As the injected substance is absorbed, a computer processes the data from the scanner to build up a color-coded picture of the organ's activity. The picture is displayed on a monitor and can be photographed for later examination. A PET scan will detect changes in the brain's absorption of glucose, for example, when a patient opens an eye, moves an arm—or even thinks about moving it.

By studying these metabolic patterns, doctors can determine the extent of the damage in victims of heart attacks and strokes, locate the areas of the brain most active during epileptic seizures—and someday may be able to diagnose and treat mental illness. PET scans are as yet too costly to be used for routine diagnosis. But early evidence from visual profiles, like those at right made at Brookhaven National Laboratory, suggests that there are distinctive brain patterns for such disorders as schizophrenia, senile dementia and manic depression.

Normal brain, two-dimensional view

Normal brain, three-dimensional view

Yellow predominates in these two- and three-dimensional PET-scan images of a normal brain, indicating average levels of glucose consumption. Shades of orange in the periphery of the visual cortex indicate that the patient's eyes were closed; if the eyes had been open, there would be a splotch of orange and red across the central portion of the brain. Areas of reduced metabolic activity are shown in green.

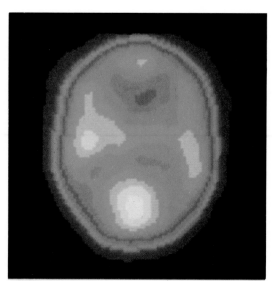

Schizophrenic brain, two-dimensional view

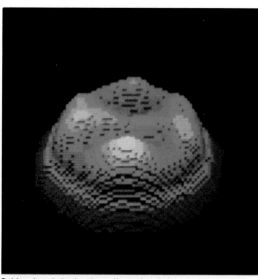

Schizophrenic brain, three-dimensional view

A characteristic feature of the schizophrenic brain (left) is the considerably reduced activity of the frontal lobe—believed to control the emotions—as indicated by the deep green of the top portion of the two PET scans. By providing a direct look into the brain's biochemistry, PET technology can help confirm or revise a diagnosis of schizophrenia, which often has external manifestations that are easily confused with those of manic depression.

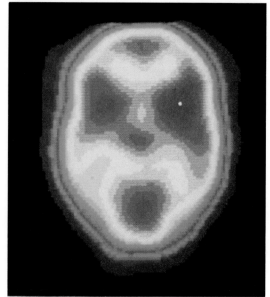

Manic depressive brain, two-dimensional view

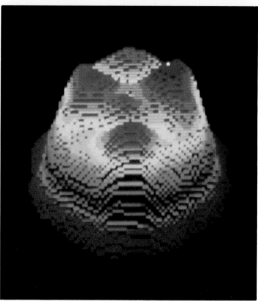

Manic depressive brain, three-dimensional view

PET scans of a manic depressive on the high side of that illness's boom-and-bust emotional cycle (left) are vastly different from those of the schizophrenic, underscoring the diagnostic usefulness of the technique. Splotches of red reveal the brain's greatly increased glucose consumption in this phase, especially on the right side, where a white spot shows an area of frantic activity. A pattern typical of the depressed phase of manic depression has not yet been found.

A Pinhole Portrait of Nuclear Fusion

X-ray pictures taken of microexplosions that burn for only a billionth of a second are bringing scientists closer to the goal of harnessing energy from nuclear fusion, a process that releases energy by fusing atoms together rather than—as in nuclear fission—splitting them apart. Fusion is one alternative to the costly and controversial system of creating nuclear power from fission reactors, but so far the break-even point for fusion reaction has eluded scientists: In the laboratory, the reactions do not release as much energy as it takes to induce them.

One field of research that may yield a solution to this problem is inertial confinement, which involves the use of multiple laser beams. A glass pellet containing gaseous deuterium and tritium, two isotopes of hydrogen commonly used as fusion fuel, is simultaneously heated by as many as 24 laser beams. Under this onslaught, the temperature of the pellet rises as high as 100,000,000° F., causing the skin of the pellet to explode outward. The recoil of the exploding skin crushes the hydrogen atoms within, compressing them to 100 times their liquid density.

During the tiny fraction of a second in which the implosion achieves its incredible temperature and pressure, the atoms emit X-rays, which can be captured on film and analyzed by computer; thus scientists are presented with a data-packed self-portrait of the fusion process.

In an early stage of a fusion experiment, researchers at the University of Rochester's Laboratory for Laser Energetics adjust the mirrors that focus 24 laser beams through portholes in a central spherical chamber (seen here with most of the portholes still covered). Another porthole in the chamber admits a special pinhole camera designed to record an X-ray image of the short-lived fusion flash. The laser beams are aimed at a very small target in the center of the chamber: a fuel pellet of hydrogen isotopes encased in a glass shell about .015 millimeter thick and .33 millimeter in diameter. The extreme heat and pressure of the resulting implosion is a scaled-down version of what takes place in the explosion of a hydrogen bomb.

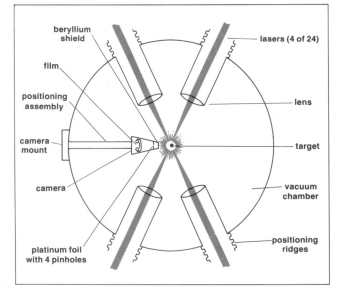

In this diagram of the nuclear fusion experimental apparatus seen in the photograph above, the conical camera tapers from four inches in diameter at the end holding the X-ray-sensitive film to approximately one-fifth inch at the end near the target. The platinum-foil lens, with four pinholes and no shutter, is positioned just 8/10 inch from the fuel pellet. Between the pellet and the lens, a beryllium shield blocks debris and filters out so-called soft X-rays—longer rays that otherwise would obscure the more significant details of the fusion reaction.

As the cooler "pusher" material of the glass ▶ pellet explodes outward, pairs of hot deuterium and tritium atoms are crushed together to form helium, and part of their mass converts to energy. Varying intensities of X-rays, seen here as computer-coded colors, enable scientists to observe temperature differences and electron behavior inside the powerful microexplosion.

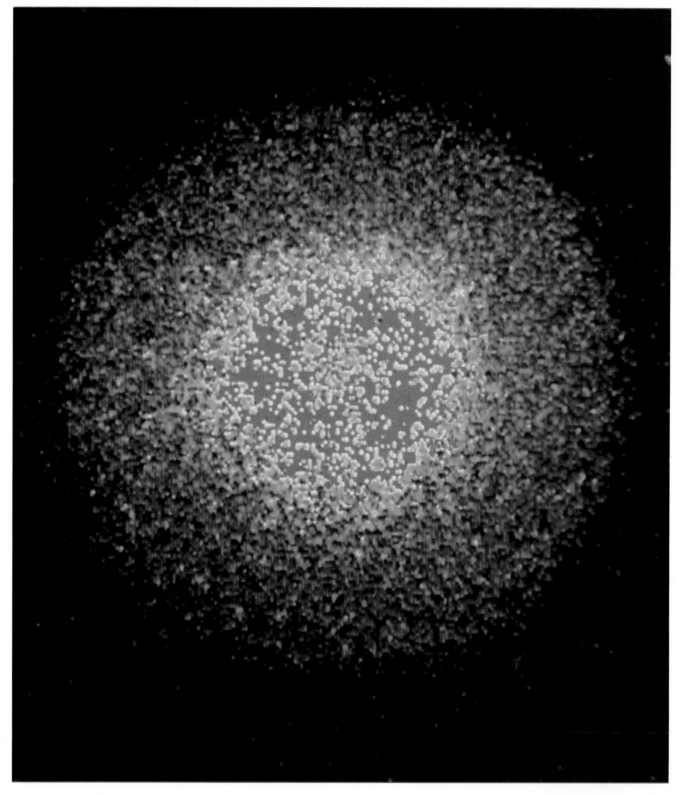

What X-rays Miss, Atomic Particles Catch

As X-rays and gamma rays penetrate material that is opaque to visible light, neutrons, particles that constitute part of the basic make-up of nearly all atomic nuclei, will pass through material that is opaque to X-rays—and will also produce their own distinctively different kind of shadow pictures. Because neutrons, unlike X-rays, gamma rays and visible light, are not electromagnetic waves, they are not affected by the electrons that orbit around the core of an atom. Only the nucleus itself influences their passage, some nuclei affecting them more than others do. Neutrons pass easily through the atoms of heavy elements, such as lead, that stop X-rays, but are stopped themselves by atoms like hydrogen and carbon, which pass X-rays.

The contrast between X-ray and neutron pictures can be seen in the two shadow photographs of a toy train. X-rays *(opposite, top)* show the outline of the train's metal structures and little else. The ghostly image in the lower picture, made by scientists at General Electric, who used a stream of neutrons from a nuclear reactor, reveals the engine's plastic structure and even the rubber traction rings on the wheels because the nuclei of the rubber and the plastic stopped passage of the neutrons.

Neutron pictures, or neutrographs, are expensive to make, largely because they require costly nuclear reactors. But they are used in a few critical areas where X-rays are inadequate, such as checking the quality of explosives and inspecting parts that are used by aerospace and other industries. □

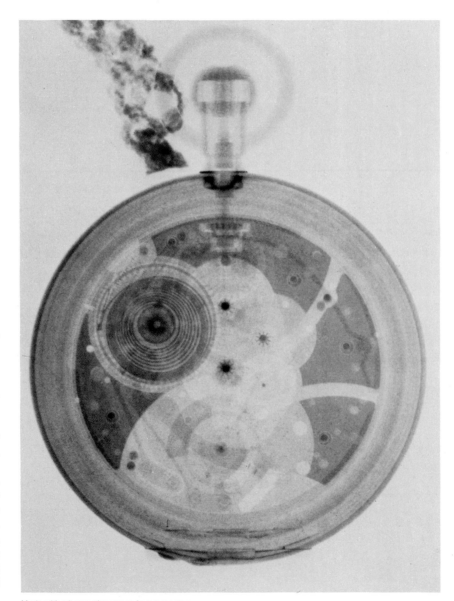

Made with a beam of neutrons from a reactor, this neutron picture of a stopwatch looks like an X-ray but is more detailed. The jewels can be counted easily, and the plastic fob, which is invisible to an X-ray, is clearly recorded.

Since neutrons penetrate objects that stop X-rays, this neutrograph of a toy train (above) does not show its metal rails, visible in the X-ray at top. The neutron beam is absorbed by the wood crossties, and shows them clearly.

Seeing as an Insect Sees

A butterfly may recognize members of the opposite sex by wing markings that the keenest lepidopterist cannot see at all. A honeybee will pick and choose among flowers in a field, gathering nectar from some while ignoring others that, to the human eye, look virtually identical. All around—but out of sight for humans and perhaps all vertebrates—is a world perceived only by certain insects whose vision is sensitive to near-ultraviolet, those wavelengths just shorter than the blue end of the visible spectrum. By means of ultraviolet photography, however, scientists are discovering more of this secret world. In the process, they are literally shedding new light on the solutions to the fundamental problems of sustenance, reproduction and self-defense that various plant and insect species have evolved.

Although laboratory work is vital to understanding the chemical and physical basis of ultraviolet coloration, many aspects of insect behavior must first be observed and recorded in the field. Sharply detailed photographs can be made outdoors using quartz lenses to transmit the sun's ultraviolet rays and filters to screen out the wavelengths of visible light. To naturalists interested in the relationship between insect vision and behavior, ultraviolet photography is an invaluable aid to seeing as the insect sees. □

Primrose willow in visible light

Primrose willow in ultraviolet light

THOMAS EISNER: *Insect's-Eye View*, 1975

Alfalfa butterflies in visible light

Alfalfa butterflies in ultraviolet light

◄ *The petals of the primrose willow (opposite) appear uniformly yellow in visible light (top). In ultraviolet (bottom) the same flower shows a vivid nectar guide—a distinctly marked area around the flower's center that offers pollinating insects a target when they come looking for food. By revealing this insect's-eye view of the world, ultraviolet photography provides clues to the evolution of plants and their pollinators. Flowers that must attract insects sensitive to ultraviolet have, near the base of each petal, ultraviolet-absorbing chemical compounds called flavonols. Yellow under visible light, the flavonols appear dark in ultraviolet photographs—and to the appropriate insects. By contrast, flowers that rely for pollination on birds and bats—whose eyes do not see in the ultraviolet range—have no such "hidden" markings.*

In a world where butterflies see ultraviolet while many of their predators are limited to the visible spectrum, this gaudy insect actually flaunts two sets of markings—one that it shows to potential attackers, the other for the eyes of its own kind. In visible light, the orange-and-black colorings of the male and female Alfalfa butterflies shown here appear roughly the same (above, left). But the wings of the larger female (above) absorb ultraviolet wavelengths uniformly, whereas the orange areas of the male's wings (top) reflect these wavelengths—a useful distinction during the mating season.

Photographing the Invisible
Infrared's Unnatural View of the World

Originally developed for the military to search for camouflaged enemy installations, films sensitive to the invisible waves of radiation called infrared help biologists take pictures in the dark, artists study paintings, ecologists detect water pollution—and ordinary photographers make extraordinary views of the world. Infrared films fit many standard cameras, and pictures are taken with them in the usual way (unlike X-ray photographs, which require special equipment). Infrared produces black and white or color—yet the pictures are anything but usual, for the tones are rendered in unnatural ways *(pages 168-169)*. This deliberate modification of nature is one of the attributes that makes infrared photographs so useful. The film records not simply the light the eye sees, but some of the invisible infrared waves provided by sunlight and artificial light. These are reflected by many things in ways different from the way visible light is reflected. Polluted water, for example, reflects visible light waves much like pure water. But it reflects infrared waves in a considerably different fashion; the pollution in a stream thus stands out noticeably in an infrared photograph.

The invisibility of infrared waves is their second great merit. Since good photographs—like the one at far right—can be taken in total darkness, many animal studies, for instance, are greatly simplified. The pictures of a gecko lizard shown here are part of a sequence made to investigate the action of the pupil of the eye as it opens and closes in response to changes in illumination. Catching the gecko with its pupil in various stages of contraction was simple with ordinary film and standard lights. But they would not do for a picture showing the pupil open to its largest aperture—it would begin closing as soon as the photographer started to take its picture. The solution was infrared illumination, to which the gecko is as insensitive as humans. The camera was loaded with infrared film and the light source was covered with filters that permitted the transmission of infrared waves—and the gecko's pupil was caught wide open in the dark.

Pictures can be indirectly made in the dark even without supplying the infrared illumination from filtered lamps, but only with very special equipment, for such pictures require electronic detection of very long infrared waves that do not affect films *(pages 170-173)*. With this apparatus, man has been provided with an extra sense that reveals the appearance of the world even without light

As a standard flashbulb fires, the pupil of a gecko lizard, a reptile native to Southeast Asia, contracts (above). But the picture at right shows the pupil fully dilated—a shot that could be made only because it was taken in total darkness with infrared film and a filtered flash that released only infrared waves. The flash of infrared, invisible to both lizard and photographer—but not to the infrared-sensitive film—is reflected in the cornea of the animal's eye.

Seeing through a Painting

Infrared photography is the next best thing to a short-range time machine for art historians. The history of a painting often lies just beneath the surface, unseen by even the most discerning eye. A restoration that covers part of the artist's original work, a painted-over signature, a change in the position of a subject, even a complete painting—all of these features may be hidden below the varnish of a finished painting. But infrared pictures can see through these uppermost layers to reveal what lies underneath. The pictures often reveal subtle artistic changes, as can be seen in the details at right from a painting by the Flemish master Jan van Eyck.

Infrared photography is particularly helpful for studying old paintings that are extremely fragile and must be handled with great care to prevent the paint from cracking. Infrared pictures can be made with the painting hanging in its position on the wall. There is thus little danger of damaging the work.

Infrared and X-ray photographs are usually made to study paintings before they are cleaned. Infrared is first used, and if further investigation is required X-ray pictures are taken.

As its title suggests, Jan van Eyck's 15th Century painting, "The Marriage of Giovanni Arnolfini and Giovanna Cenami," represents the wedding of a well-to-do Italian merchant. Because of its apparent symbolism—the candle signifies the presence of God—some imaginative art critics have suggested that the work is an allegorical marriage license. The impression that the bride is pregnant is simpler to explain—it is an illusion created by her costume, which was fashionable in that period.

This infrared photograph, taken at the London ▶ National Gallery before a cleaning, reveals that the artist reinforced the story he was telling just before he completed the painting. At the last moment Van Eyck changed the angle of the bridegroom's hand to indicate more clearly that he was taking his marriage vows, and also proceeded to place a wedding ring on his finger.

Photographing the Invisible: Infrared's Unnatural View

False Colors, Hidden Truths

Color infrared film is an invaluable tool for many disciplines because the colors it produces are so unlike the real colors of the world, making many natural features, invisible in standard pictures, stand out in "false" color. This transformation of the real world's hues was first used by the military. Trees and bushes cut down to camouflage equipment give themselves away because their foliage, still a fresh-looking green to the eye, shows brown in infrared, while healthy foliage registers as brilliant red.

This is in part a result of the fact that objects reflect infrared waves in different degrees. Healthy foliage contains a greater amount of chlorophyll, which reflects the infrared more strongly than dying foliage does. Similarly, polluted water shows in a color different from that of clear water because decomposing organisms or other foreign matter interfere with the normal reflections of infrared.

The advantages of being able to distinguish between healthy and dead or dying plants and to notice the presence of pollution in water by examining infrared color shots were quickly realized by ecologists, foresters and agricultural experts. Plant diseases, for example, can be sought and detected with aerial cameras before a widespread area is affected. Infrared photographs can be used to survey the entire plant resources of an area, since it is possible for experts to distinguish among varieties of trees and bushes in a forest by studying an infrared picture that has been made from the air—the foliage shows obvious variations in infrared color.

The standard-color photograph above, taken from Gemini V, clearly shows the Imperial Valley, which extends from the Salton Sea (left) in California south across the border into Mexico. The entire valley appears fertile. But in the false-color infrared photograph at right, taken during the flight of Apollo IX, the well-irrigated California section of the valley stands out in brilliant red, a sign of healthy vegetation. The Mexican part of the valley appears bluish, an indication of poor drainage and excessive salinity in the soil. The thin line between the two sections marks the American-Mexican border.

JAMES A. McDIVITT, RUSSELL L. SCHWEICKART, DAVID L. SCOTT FOR NASA: *Imperial Valley*, 1969

Pictures Made by Heat

Only infrared radiation of a relatively short wavelength—called near infrared because the waves are so close to those of visible red light—can be recorded on infrared film. Longer infrared waves, the far infrared rays of radiant energy that are generated in varying degrees by every physical object on earth, do not affect photographic emulsions. But they can be detected by electronic instruments—descendants of the World War II snooperscope, which spotted enemy soldiers at night—that show heat images, known as thermograms, in television-like patterns. These images can be photographed to provide permanent records.

Thermograms are literally heat maps that record differences in temperature in the subject. When made in color *(pages 172-173)*, the hottest areas are reproduced as white, with red, yellow, green, blue and magenta forming a descending scale that spans about 15° F., all lower temperatures appear black. (If a black-and-white picture is made, cooler areas are dark, while warmer areas are light.)

Deviations of a fraction of a degree in the operating temperature of parts of machinery can be recorded on a thermogram to give advance warning that the part is functioning improperly. And cancer specialists have found that malignant tumors are slightly warmer than healthy tissue, permitting early, life-saving detection of malignancy.

Dark patches on a thermogram, or heat picture, show cool skin on the right side of a patient's head; normally warm skin appears lighter. The unnatural coolness indicates impaired blood circulation and suggests that an artery carrying blood to the brain is partially blocked.

The body is gone, but the image of a "murder victim" remains in this thermogram made to show the power of infrared to peer into the immediate past. The policeman sees only a rug; the thermogram reconstructs a "corpse" from the heat the body left on the rug.

In this thermogram of a row of houses in Michigan, the windows of the best-insulated home (second from right) appear blue, indicating that little of the interior heat is escaping. White, red and yellow areas of each house show where most of the heat loss is. The thermogram was made with a van-mounted infrared scanner for an energy conservation program. A computer translated the intensities of radiation into a color-coded image.

Photographing the Invisible
Radio Whispers from Space

On the high plains outside Socorro, New Mexico, a cluster of radio antennas known simply as the VLA, or Very Large Array, stands poised to receive the faintest signal from outer space. Linked to a central computer by underground microwave channels, the 27 dish antennas have a combined receiving ability equivalent to that of a single dish 21 miles in diameter. The $78 million installation includes 38 miles of railroad track, laid out in a sprawling Y shape, to allow the antennas to be shuttled to and from 72 separate observation posts.

A gaseous ghost is all that remains of a star that ▶ exploded some 350 years ago in the constellation Cassiopeia, more than 10,000 light years away. Only the vaguest threads of light would be visible through an optical telescope; but radio waves emanating from the gas cloud are so powerful (surpassed only by those of the sun) that the VLA's antennas readily pick them up. A computer turns the incoming signals into numbers and then, through a cathode tube, into points of light of varying colors and intensities. By exposing a 4 x 5 sheet of Ektachrome 64 color film to the cathode tube, scientists created this color-coded map of the cloud's otherwise invisible anatomy.

The heavens abound with newly discovered bodies whose qualities we are only beginning to understand. Among them are neutron stars called pulsars, strangely shaped galaxies that may be a million light years across, and enormously distant bodies called quasars, which seem to be racing away from earth at nearly the speed of light. All were discovered by astronomers using telescopes that detect and amplify not light but faint radio waves from outer space.

Measured in units of intensity called "janskys," after the American researcher who built the first primitive radio telescope in 1931, these invisible signals are helping scientists construct astronomical images that are as detailed as photographs taken with the most powerful optical telescopes. However, because radio waves are so much longer than the wavelengths of light—about six miles for the longest radio waves, compared with only .000028 inch for visible light waves—the equipment required to detect them is far larger than the largest optical telescope.

In 1981 the reigning giant among radio telescopes was completed at Socorro, New Mexico (above). This listening post, known as the VLA (for Very Large Array), consists of 27 huge dish antennas, each 82 feet in diameter and weighing 210 tons. The dishes are linked to a central computer, which aligns them to receive radio signals from a given part of the sky and then translates the data into color-coded visual "maps."

The Socorro complex has produced spectacular results: Scientists now can investigate, through pictures of unprecedented sharpness and detail, events as far away in time and space as the explosion of a supernova (opposite) more than three centuries ago.

Based on data gathered by a network of radio
telescopes in the United States, these computer-
generated images document the theoretically
impossible behavior of quasar 3C 273.
Measurements taken several times between mid-
1977 and mid-1980 show that the quasar expanded
some 25 light years, a rate of movement almost 10
times the speed of light —and in apparent violation of
Einstein's theory of relativity.

July 1977

March 1978

June 1979

July 1980

IBM: *Memory Chip in the Eye of a Needle*, 1979

New Eyes for Factory and Laboratory

The more science builds complex machines to extend the muscles and mind, and the more medicine attempts to repair that most sophisticated of machines, the human body, the less adequate seems human eyesight. No eye can see what happens in the howling flame of a rocket, perceive the strains and stresses within a building, or watch a baby growing inside its mother's womb. But photography can. To keep pace with the ambitions of a modern technological society, photography has had to develop all sorts of complex and specialized powers. Its basic image-making ingredients of light and film have proved amazingly adaptable and versatile.

Images are formed by an uneven distribution of light that creates brighter and darker regions in a picture. In ordinary photography, inequities of distribution are caused when objects reflect and absorb light in varying amounts; the pattern is faithfully conveyed to film by a lens. The phenomena of refraction, diffraction and polarization also alter the motion and distribution of light, and they play an important role in technological photography as well. All of these aspects of light have long been known. The ancient Greeks understood that light is bent — refracted — as it passes through mediums of differing densities. In the 13th Century, the English scientist Roger Bacon explored the behavior of convex lenses; he was, in fact, imprisoned for inventing spectacles, held to be an instrument of the devil. Religious conservatism notwithstanding, monks were soon wearing eyeglasses, and in the middle of the 17th Century an Italian Jesuit named Grimaldi went on to discover diffraction — the bending of light waves as they pass a sharp edge or go through a slit. Only a few years later, the great Dutch scientist Christiaan Huygens investigated polarized light waves, whose vibrations are restricted to a single narrow plane — unlike ordinary light, which vibrates in all directions perpendicular to its line of travel.

The men who unveiled the complex behavior of light would undoubtedly marvel at today's technological applications of their discoveries. Refraction, for example, is exploited by techniques called schlieren photography and shadowgraphy, which are used to capture and investigate such elusive subjects as a shock wave from an explosion, the turbulence in a flame or the air currents generated by a speeding aircraft. Compressed or heated gas refracts light, and the bent rays can be recorded by photographic emulsions if the illumination is sufficiently brief and intense.

Refraction can also produce drastic magnifications or reductions of the size of the image recorded on film. The electronics industry, for example, uses the technique of microphotography to reduce enormous drawings of electrical circuits, up to 40 square feet in size, to tiny chips like the one on page 179: a memory chip small enough to fit through the eye of a needle.

Polarized light also has become a technological boon. Most photographers regard it as something to be avoided, and they employ filters to cut off the

polarized reflections from windows or water. But a technique called photoelastic stress analysis uses a pair of polarizing filters to see the stresses inside plastic materials. By making small plastic models of buildings and photographing them in polarized light, structural engineers are able instantly to identify complicated inner forces that would defy mathematical analysis.

Another ingenious method of recording images is called holography. As its name implies (holos is the Greek word for entire), holography captures all the visual information about a subject, yielding three-dimensional images that can be viewed from many angles. The technique makes use of the laser—the technological wonderchild of the 1960s that produces a brilliant beam of light with its waves all in perfect step. Holography is also based on the long-known principle of diffraction—and thus melds a new discovery and an old one. Holographic instruments can scan the distribution of dust and pollution particles in the air, detect imperfections in machine parts or store enormous amounts of data for computers.

Computers themselves form one half of an even more recent photographic partnership that has resulted in a technique called biostereometrics. Coupled with a computer, the camera can chart the subtle contours of the body, producing what are, in effect, topographical maps of the human form. These have proved invaluable to auto safety engineers, for example, in designing dummy models for car-crash experiments.

Perhaps the most avant-garde use of the camera in the laboratory has been as a detector of clues to the character and behavior of subatomic particles. The very existence of such particles as kaons, muons and quarks is predicated on photographs of the tracks they leave in a so-called bubble chamber—a tank of pressurized liquid hydrogen subjected to a high-energy beam.

Ingenious as these applications of photography may be, they pale beside the uses to which camera, light and film have been put in penetrating the innermost workings of human physiology. Sweden's famed medical photographer Lennart Nilsson, for instance, uses tiny, high-magnification lenses to reveal such arcane scenes as the inside of an artery or the image that registers on the retina of the eye. Linked to a cathode-ray-tube monitor and a device called a transducer, which emits and receives sound waves beyond human hearing, the camera can record "sonograms"—portraits in sound waves that depict the condition of soft tissues deep inside the body. And connected to medical viewing devices called endoscopes, the camera can peer into the body to record processes as fragile and as subtly complex as the human reproductive cycle, from ovulation to the development and birth of a baby.

Eerie Visions of Heated Gas

Light rays are bent when they pass from one transparent medium to another of different density—from air to water, from one gas to another, or among currents of the same gas at different temperatures. An ingenious technique called schlieren photography *(schlieren* means streaks in German) exploits very slight amounts of bending—or refraction—to make visible the most ephemeral motions of gas and to tell scientists what happens in such unapproachable regions as the fiery exhaust of a jet engine. For the remarkable pictures on these pages, William T. Reid, a fuels specialist of the Battelle Memorial Institute in Columbus, Ohio, employed the schlieren method to show heated air rising from his own fingers *(right)* and to reveal the turbulence in a Bunsen burner flame *(opposite).*

A high-speed flash of light is needed to stop the motion, but the heart of the technique is the use of two sharp knife-edges that partially intercept the light beam before and after it strikes the gaseous subject *(diagram below, right).* The second knife-edge causes the various degrees of refraction, resulting from temperature differences in the gas, to be recorded on film. As shown in the diagram on the opposite page, it cuts off some bent rays of light and allows other bent rays to pass on to the camera.

If color is introduced by means of filters at the initial knife-edge, the degree and the direction of refraction become more dramatic, making the schlieren image a powerful and vivid tool for teaching and research. By revealing thermal currents, schlieren photographs are of assistance to clothing designers and environmental engineers, and to scientists in their determining optimum designs for spacecraft and airplanes.

WILLIAM T. REID: *Warm Air Currents Rising from Fingers,* 1950

Warm air currents—around 98° F.—rising from William Reid's fingers (left), are distinguished from the 75° laboratory air by the adding and subtracting of refracted light by the schlieren knife-edge. The picture was made with a 5 x 7 Corona view camera. The light source was an electric pulse in a high-pressure mercury lamp, which produced a flash of 3/1,000,000 second.

As shown in the diagram at left, schlieren photography uses a focused light beam passing over two knife-edges—before and after it illuminates the gas currents being recorded. After the first knife-edge has given the beam a sharp edge, the light is directed to the subject by a concave mirror. A second mirror simultaneously refocuses the light at the other knife-edge and directs it into the camera.

A turbulent Bunsen burner flame (right) is frozen into a flowing sculpture in this schlieren shot made by Reid at 3/1,000,000 second. This extraordinarily fast speed was needed to freeze the extremely rapid turbulence in the primary burning zone at the base of the flame.

The diagram below schematically shows how the second knife-edge affects light refracted by the Bunsen burner flame. The edge normally cuts off half of the focused beam. However, temperature differences within the gas bend some rays in the beam—which would otherwise pass over the blade—downward, where they are intercepted. This leaves some dark sections in the part of the beam passing over the blade edge. Other rays, which would have been intercepted by the edge, are bent upward and add their brightness to the bright sections already in the part of the beam passing over the edge. A coruscating image of light and dark areas is thus recorded on the film, revealing the roiling currents that are present in the gas.

knife-edge

film plane

bunsen burner

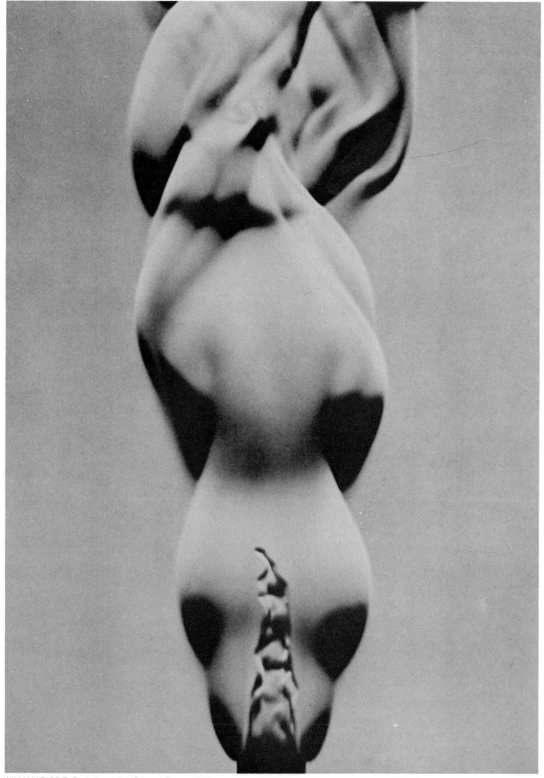

WILLIAM T. REID: *Turbulence in a Bunsen Flame,* 1950

Shadows of Shock Waves

In designing an internal-combustion engine or a gun, engineers must find a means of reducing the impact of the shock wave that is produced by the explosion and causes its noise. One way is to direct the shock wave—a region of compression in air moving at the speed of sound—through baffles. A car muffler works on this principle. Through a technique called shadowgraphy, engineers can actually photograph the effect of the baffles on the wave. Compressed air bends light to a greater degree than air at normal pressure because it is denser—and the bent waves of light can draw shadow-like lines directly on film without the intercession of a camera lens.

To get the shadowgraphs on these pages, a team of scientists at the Ernst-Mach-Institut in Germany used a spark device that emits bursts of light at the rate of 50,000 per second—fast enough to catch a shock wave, emitted by a laboratory device called a "shock tube," making its way through four baffles at 1,100 miles an hour.

In a sequence of eight shadowgraphs, a shock wave can be seen (left to right across these pages) passing through apertures in four baffles (dark areas) in a pipe. Part of the wave is deflected by each baffle in turn, and the rest surges into the next chamber with its pressure lessened. A series of bright electrical sparks cast the shadows directly on the film.

Tiny Chips Printed from Large Negatives

Microphotography is just the opposite of photomicrography: Instead of magnifying a tiny object, it drastically reduces a large one. In industry, its most spectacular application is the integrated circuit, or microchip. Using microphotography, minuscule electronic components can be made to operate any number of modern marvels, from microwave ovens to the latest video games.

To mass produce these minute building blocks of the space age, a master pattern of one layer of the chip's circuitry *(right, top)* is reduced photographically to a 1/200-sized image and is repeated hundreds of times side by side on a glass negative or photomask. Next, the mask is placed over a silicon wafer that has been given two coatings: a thin layer of silicon dioxide to prevent short circuiting, and a layer of a photographic type of emulsion called the resist, which is sensitive only to ultraviolet (UV) light.

The wafer is then exposed to UV; areas not shielded by the mask harden to form an outline of the circuit, while shielded areas remain soft and are etched away in an acid bath. The wafers are baked in an atmosphere of gases loaded with selected impurities, or "dopants," that alter the electrical properties of the silicon. The process may be repeated as many as 10 times to create more layers of circuitry before the wafers are cut into chips.

At top right, a master circuit pattern, 200 times the size of the silicon chip upon which it will be imprinted, is inspected for flaws before being photographically reduced and replicated to make a glass negative, or photomask. At right, a technician, working in a dust-free room bathed in yellow, ultraviolet-less safelight, aligns a photomask upon a UV-sensitive silicon wafer and exposes it to the blue glow of UV light. After more layers of circuitry are added, the four-inch-wide wafer will be separated by a diamond cutter or a laser beam into 200 identical chips.

Part of a large-scale integrated circuit, whose full size is 6 x 7mm, glows like a miniature metropolis in this photomicrograph by Manfred Kage. He took the picture through a microscope with polarized lighting and a special interference prism (pages 10, 86-95). The prism imparts brightly variegated hues that enhance differences in the surface of the chip for microscopic analysis.

MANFRED KAGE: *Impressions of LSI,* 1981

Analyzing Stresses with Polarized Light

Engineers have often wondered whether the beautiful spires and arches of Europe's Gothic cathedrals served a structural purpose — or whether they sometimes were used as mere decoration. To find out, Professor Robert Mark of Princeton University photographed Amiens Cathedral in France, using a technique known as photoelastic stress analysis. He built a cross-sectional plastic model of the cathedral and hung it with steel weights *(above)* to simulate a 60-mile-per-hour wind from the right.

When the model was photographed between two crossed polarizing filters, psychedelic swirls of color appeared — produced by the effect that stressed regions of plastic have on polarized light. After studying the stress pattern, Professor Mark concluded that most structural features of Amiens Cathedral were fully functional. A similar study of a church in Rouen indicated stresses high enough to have caused cracks — and when he checked, the cracks were indeed there.

A number of steel nuts, pulling from one side against a plastic model of a cross section of Amiens Cathedral, duplicate the pressures of a 60-mile-per-hour gale on the original. The model has been heated and made less rigid so that the stresses will actually reshape the plastic. Next, it will be cooled down again in order to "fix" the effect of the stresses permanently.

FRITZ GORO: *Gothic Arch under Stress*, 1969

Professor Mark puts the cathedral model, its stress patterns fixed in place, between two sets of filters. The rear filter polarizes the light falling on the model, so that only light waves vibrating in restricted directions reach it. Normally, this light would not pass through the foreground filter, which is oriented to block waves vibrating in the direction given by the first filter (and, in fact, the left side of the light source is dark in the picture above). But the stressed areas in the plastic alter the direction of polarization of some light waves passing through the model and they can get through the second filter.

In addition to altering the polarization of light, the stressed areas of the plastic slow down light waves of some wavelengths — or colors. Some of the slowed light waves will be out of step with the others, and they tend to cancel each other. However, other wavelengths will remain in step. When viewed through the second polarizing filter, the noncancelling wavelengths show up as swirls of color. Stress is greatest in the plastic model where the color-pattern is most crowded.

189

Creating Polarized Colors at Home

ERICH HARTMANN: *Colors of Stresses,* 1964

The same technique that engineers and scientists use to study structural stresses in buildings has been exploited by some photographers for esthetic reasons alone. Even ordinary transparent plastic materials—things like hangers, wrappings, and so on—can put on a peacock display of colors, because they contain stresses built into them when they were manufactured, and the stress areas selectively reinforce certain wavelengths, or hues, of polarized light that are passing through them. The only special equipment needed is two filters to produce cross-polarization. One, in front of the light source, polarizes the illumination falling on the plastic subject; the other polarizing fil-

ter, in front of the camera, makes the colors apparent.

For the pictures above, Erich Hartmann used clear sheet acetate as his subject. The pastel colors reveal the stresses formed when the acetate was extruded during its manufacture. Nina Leen chose household items for her composition *(opposite).* Both photographers turned their filters to cross the angle of polarization of the light waves. Although scientific studies usually require large polarizing screens, pictures such as these can be made with small filters. One can be a polarizer used as a sky-darkening or reflection-reducing filter on a camera; the other can even be a lens from Polaroid sunglasses.

Erich Hartmann arranged strips of sheet acetate in a one-inch-wide rosette design for the picture at left and tied another strip into a knot for the picture above. To get close to the subjects, he used extension tubes (page 52) on his Pentax.

Plastic hangers, a small plastic box and ▶ cigarette-package wrappings glow with intricate colors in Nina Leen's picture at right. The light came from small spotlamps and passed through polarizing filters that were placed under and on the table on which the objects were arranged.

NINA LEEN: *Plastic Hangers in Polarized Light*, 1963

The Laser's 3-D Pictures

Holography—the technique of producing three-dimensional pictures with laser light—is such a radical departure from conventional photography that it seems to have sprung full-blown from science fiction. A hologram *(right, below)* is a photographic transparency—in this instance, a glass plate rather than film—exhibiting misty, swirling lines that were registered without the aid of a lens. And yet this apparently inchoate picture contains not just one but thousands of different views of the scene it recorded.

When laser light is beamed through the front of the transparency, a vision of the scene in three dimensions can be perceived by the naked eye, floating in midair behind the transparency, as though seen through a window. Laser beams can also project the scene onto a screen *(opposite),* and a different perspective will appear each time if the spot where the projecting beam passes through the transparency is changed.

The theory of holography has been known since 1947, but it could not be put to work until lasers began to supply the world with an entirely new kind of light in the 1960s. The crucial characteristic of a laser beam is its orderliness: All the wavelengths are in step, like a flawless marching band. To make a hologram, a single laser beam is split into two (or sometimes more). One part of the beam is bounced off mirrors and then spread to illuminate the subject. The other—the reference beam—is reflected by mirrors onto a photographic plate without being directed to the subject. When the light reflected from the subject reaches the film, it interferes with the reference beam. That is, some of the perfectly regular waves from the two beams reinforce each other,

and some of them cancel each other out. The result is what appears to be a garbled photographic recording of tiny lines. These lines, however, can help re-create the shapes of the light waves that made them. If the laser beam is sent through the lines at the same angle as the reference beam was, the lines will bend the light waves so that they cancel and reinforce in a manner exactly matching the relationship between the original beams. An absolutely lifelike, three-dimensional image is the result.

Such a three-dimensional view cannot, of course, be duplicated on a printed page of two dimensions. So for the demonstration pictured here, photographer Fritz Goro designed an arrangement of solid shapes and letters that would reveal the variety of viewing angles packed into the one hologram. The hologram was made with laser equipment at the laboratory *(right, top)* of research engineer Juris Upatnieks and Professor Emmett Leith, who pioneered in the technique at the University of Michigan.

Because recording requires extremely fine separations between the lines on a hologram, almost no vibration was permissible. All the equipment—the mirrors, lenses, beam-splitters and photographic plate—was positioned on a seven-ton granite slab set on inflated inner tubes. The subject figures were cemented to a wooden plate, since the slightest movement would have made them not merely fuzzy but totally invisible. Even the most minute sound vibrations—such as those that are made by voices—would have spoiled the experiment. Goro and the scientists therefore sat silent in the dark during the five-minute exposure needed to make the hologram.

The main laser beam—made visible by smoke that Fritz Goro had blown into the laboratory—passes Upatnieks' right elbow and, controlled by a series of lenses and pinholes, illuminates the subject. Its companion reference beam has been temporarily switched off.

Professor Leith scans the final hologram—an 11 x 14-inch photographic transparency crammed with microscopic lines produced by a meeting of the reference beam and light waves that reflected off the subject. The pattern bears no visible resemblance to the subject.

Two perspectives of Goro's specially designed subject are projected on the screens shown above when laser beams pass through the hologram at different places. Every part of the hologram contains a complete view of the entire scene holographed.

Topographical Maps of the Human Form

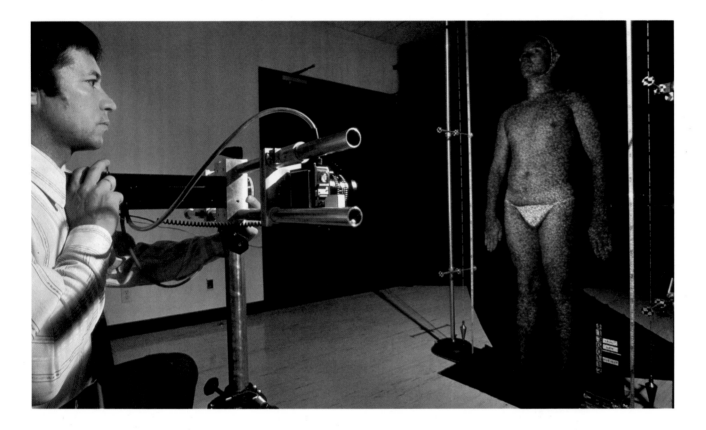

The mummy-like picture on the opposite page is the product of a sophisticated imaging technique now being used in such diverse fields as automotive safety, space medicine, anthropology, dentistry and the design of sports equipment and protective clothing. Called biostereometrics—three-dimensional measurement of living things—it puts together photography, aerial mapping and computerization to give scientists a more precise, detailed understanding of human structure than was ever before possible.

As in the old-fashioned stereopticon, biostereometrics works by looking at a subject from two angles at once. While a random pattern of speckles is projected upon a subject *(above),* two pairs of cameras make simultaneous and overlapping images of the front and back of the subject. The speckles supply reference points that are common to each photograph; from these points, a machine plots as many as 40,000 coordinates, which are then fed into a computer. The computer can make simulated three-dimensional portraits—and readily changes the data hidden in the portraits into charts and graphs that reveal such things as body volume and body density.

The technique is extremely accurate and remarkably convenient, supplanting tedious measurements with a tape measure and calipers or the making of cumbersome plaster casts. All the data needed for building artificial limbs, dummy models for auto-accident studies or dental prosthetic materials can be gathered in the time it takes to make a photograph. If further analysis is desired, the photograph already contains the necessary information: Simply by increasing the number of coordinates plotted, more detailed measurements can be made without requiring the presence of the subject.

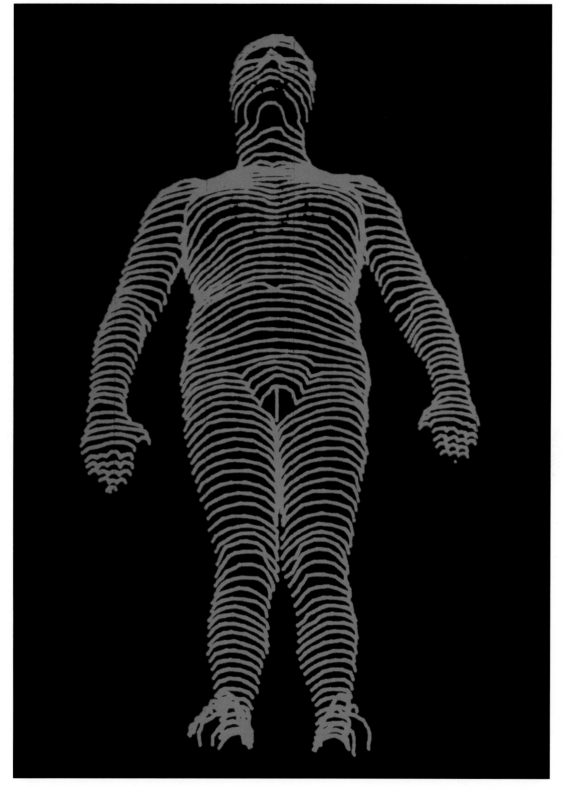

At The Institute for Rehabilitation and Research in Houston, Texas, where much of the pioneering work in biostereometrics has been done, two stroboscopic projectors cast a speckled pattern on the subject (left) while two pairs of cameras snap simultaneous fore and aft photographs. (Only the front pair of cameras is shown.) The speckles create an artificial texture to make it easier to plot coordinates on skin surfaces that would otherwise lack sufficient visual contrast.

From coordinates plotted in much the same way as latitude and longitude are, a computer produces contour maps such as this one of the body's rolling terrain. Master models used in auto-safety studies can be measured in this way and the data stored in digital form, making possible the precise replication of the standard models for comparative research.

In Pursuit of Subatomic "Charm"

The quarry is elusive: ephemeral subatomic particles with names like kaons, pions, muons and quarks; nuclear forces called "beauty," "charm," "flavor" and "truth." Invisible as the wind, their existence can be inferred and their behavior studied only from their tracks as they pass through the special environment. The bubble chamber, an apparatus that offers the appropriate environment, acts as a custom-built photo studio to record that passage. Physicists hope bubble-chamber pictures will help explain how the universe is held together and what its tiny building blocks are made of.

Six cameras are mounted in the roof of the bubble chamber shown at right, each with a 108° wide-angle lens and a xenon flash ring (diagram, below right). In order to direct light back to the camera, the interior of the chamber is lined with Scotchlite, the same coating of tiny reflective beads that is painted on traffic signs. The cameras are shutterless; exposures are made when the flash units fire bursts of light that last 15/100,000 second. Each camera is shielded by three layers of hemispherical windows built to withstand the –250° C. temperature of the liquid hydrogen in the chamber and keep outside heat from warming the interior.

The liquid hydrogen is kept at conditions so controlled that the most minute disturbance can be recorded on film. When the particles called neutrinos are beamed through the chamber at nearly the speed of light, a collision will cause a roiling track of bubbles (opposite). But getting such an interaction is not easy. "We aim a billion neutrinos into the chamber for each picture," says one scientist, "and are happy to see just one event." □

An operator at Fermi National Accelerator Laboratory (Fermilab) in Batavia, Illinois, adjusts one of six cameras atop the lab's bubble chamber (above). Arrayed so the entire chamber is covered, the cameras record simultaneous images on motor-driven 70mm film, giving scientists several views of each shot for better depth perception.

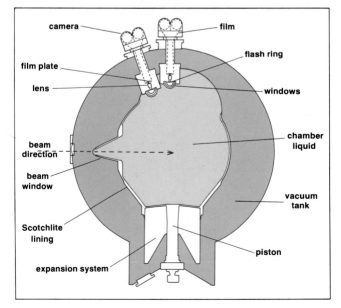

In the diagram at left of the Fermilab bubble chamber, high-energy neutrinos are beamed into the chamber through the beam window, and their tracks are recorded by the cameras mounted in the roof (only two of the six are shown). Three hemispherical windows act as heat and vacuum shields between the chamber and the camera lenses. The piston and the expansion system control the chamber pressure that keeps the liquid hydrogen just below its boiling point of –250° C.

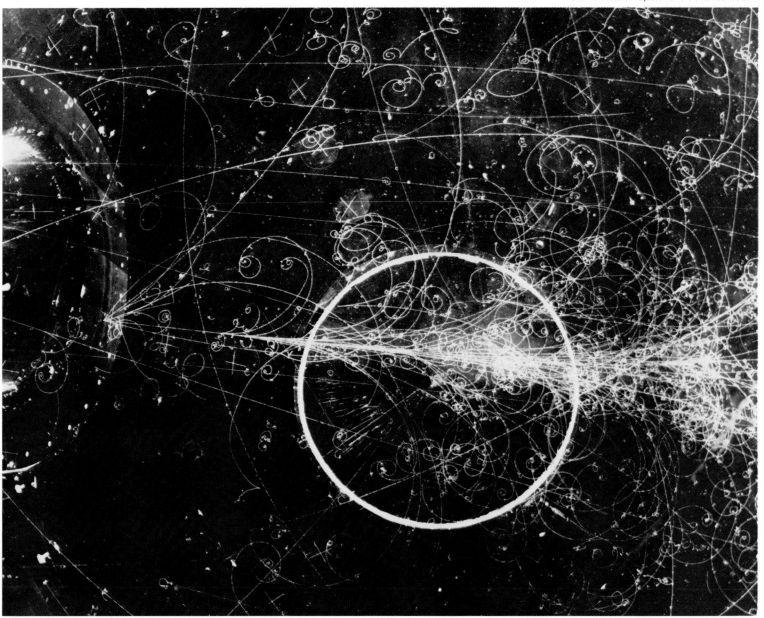

197

An Aid to Technology and Medicine
Witness to the Mysteries of the Body

No photographer has done more to reveal the innermost secrets of the human body than Swedish photojournalist Lennart Nilsson. With highly sophisticated equipment specially built for him by lens manufacturers, and using techniques he has devised over patient years of trial and error, Nilsson has produced pictures that are unrivaled for their medical accuracy and beauty.

During his self-assigned and lifelong quest to "make the invisible visible," Nilsson has put together a virtual armory of special gear including super-wide-angle lenses with focal lengths ranging from 4mm down to .5mm. These are fitted onto surgical scopes that enable him to peer photographically into chambers of the body where hitherto only surgeons had dared to venture. If need be, he can turn to any one of three conventional light microscopes, or to either of two electron microscopes that yield magnifications as great as 200,000 times life size. In spite of all this exotic technology, Nilsson remains a photographer first and last. "All this is photography like any other photography," he has said, "except that it also ends up being basic research because of the technology involved."

Of all the hidden sagas Nilsson has captured on film, none is more moving than his photo essay on the creation of human life. The audacious notion of attempting such a story came to him in the mid-1950s. He happened to pass by a roomful of medical exhibits in the Karolinska Institutet in Stockholm, where he spotted an embryo preserved in a bottle. The fetus was tiny, barely half an inch long, but its effect on Nilsson was powerful. He reasoned that pictures of a living fetus would be even more arresting — if he could only find a way to take them. Nilsson devoted 10 years to this pursuit, working with doctors at several cooperative hospitals who allowed him to set up his elaborate equipment wherever and whenever a fetus had to be removed suddenly from its mother's body.

It was a painstaking, complicated project, but ultimately successful. In 1965, *Life* magazine published Nilsson's photographic story of the beginnings of life, from conception to the first squall of the newborn, including a historic first: a portrait of a living embryo in its mother's womb *(opposite)*. Only 15 weeks old, this tiny being measures about five and a half inches from crown to hips. Yet the features are already recognizably human. Seeing the picture, a leading Swedish gynecologist said, "This is like the first look at the back side of the moon."

Using a super-wide-angle lens that covers 110° of view, and a tiny light bulb at the end of a surgical viewing scope, Nilsson shot his picture of a living 15-week-old embryo (right) from only one inch away. The embryo skin is so thin the blood vessels seem to be on the surface. In 25 weeks, the baby will be born, having developed from two cells into a creature of 200 million cells.

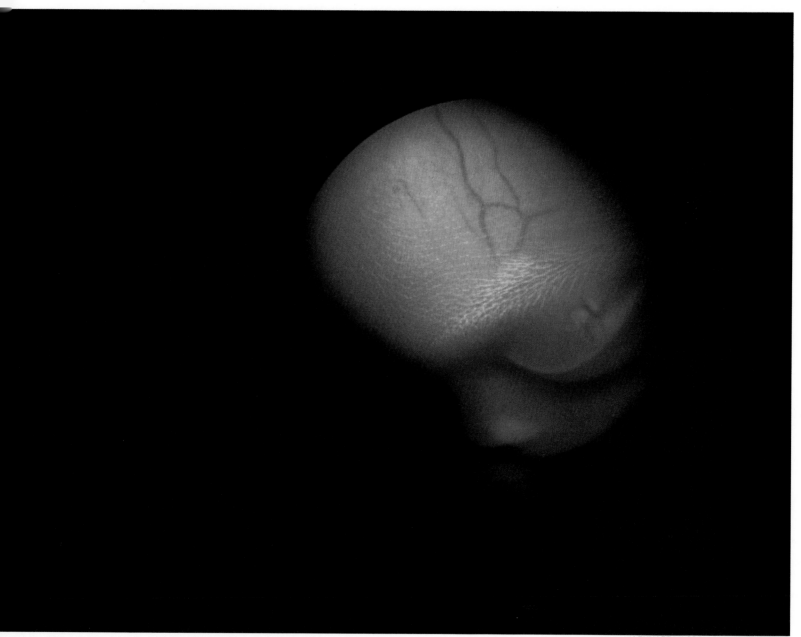

LENNART NILSSON: *Living Embryo*, 1965

The Retina's Upside-Down View

Nothing is more essential to photography than that oldest and most elemental of cameras, the eye itself. What do we see when we see? Challenged by that intriguing question, Lennart Nilsson set out to document the eye's inner imaging system, devising a remarkable answer. In one of his most ingenious probes, shown at right, Nilsson was able to use the lens of a human eye in photographing the image it cast on the retina. Shimmering on the back of a young man's eye is an upside-down vision of a young woman holding a telephone.

Nilsson took this extraordinary picture with a special type of camera that ophthalmologists use to check on the health of the eye. The instrument is an intricate collection of mirrors and lenses that reflects a beam of light through a series of zigs and zags into the eye and back out to the camera. Nilsson adapted the device so that he could insert a color transparency of the woman into the beam of light, which was supplied by an electronic flash. When the flash was triggered, the young man actually saw the woman—and the camera was able to share in the marvel of human eyesight.

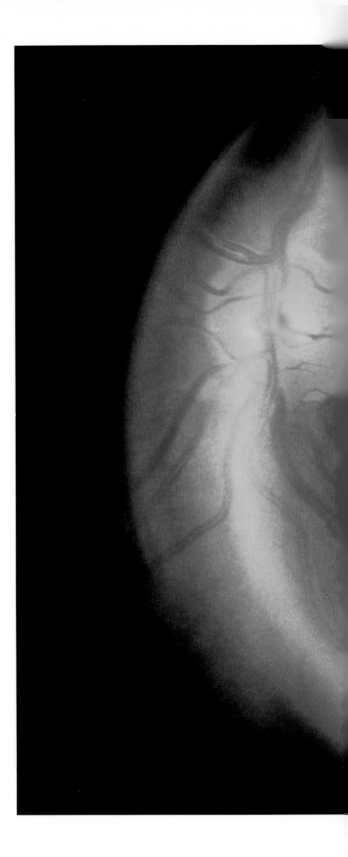

Inverted by the lens of the eye, the image of a young woman on a color transparency floods the retina—a layer of light-sensitive cells that sense visual images. The picture discloses the network of blood vessels in and around the cells and the optic nerve—the bright spot to the left of the woman—which sends the image to the brain, where it is turned right side up.

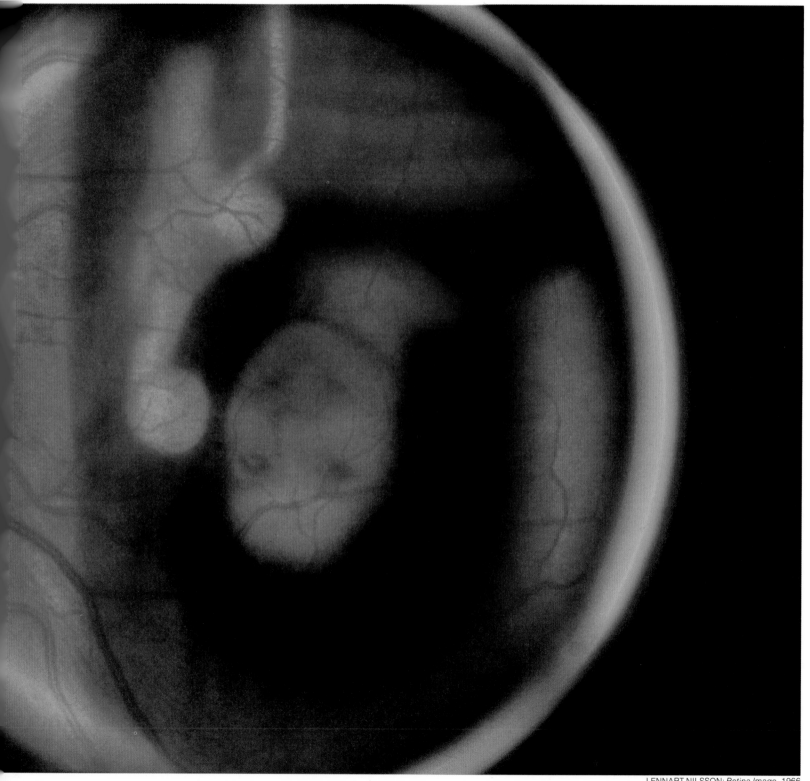

LENNART NILSSON: *Retina Image*, 1966

Anatomy Seen from the Inside

LENNART NILSSON: *Heart Surgery,* 1968

For the eerie shot above, Nilsson placed a super-wide-angle lens about five inches behind the crest of the bared, beating heart of a man whose chest had been opened for surgery. The tiny lens, only 1.5 millimeters in diameter, was attached to a Leica. Two electronic flash units provided the illumination in the operating room.

Besides sending light into the body from the outside, Lennart Nilsson has taken his lenses and light sources into the most restricted recesses of the human anatomy. By using such achievements of miniaturization as a wide-angle lens no larger than a rice grain, Nilsson was able to make a heart's-eye view of doctors about to commence cardiac surgery *(left).*

The picture at right reveals the inside of a fat-choked aorta, surgically removed after death, with an enormous blood clot hanging like a stalactite. Even the pathologists in the Stockholm hospital where Nilsson was working, veterans of daily study of the anatomy of life and death, had never seen such a sight until they looked through the viewfinder of Nilsson's camera.

To enter the previously unseen interior of a fat-constricted aorta (right), Nilsson employed the same tiny lens he had used for the heart picture, plus a cable of twisted glass fibers to carry light inside. Two holes can be seen where the aorta, the body's main blood vessel, divides into smaller arteries carrying blood to the legs. In the foreground dangles a huge blood clot — a coagulated mass of blood cells and protein that measures a quarter of an inch in width.

203

Re-creating a Fatal Stroke

At the onset of a stroke, a cerebral artery, distorted by the pressure within, quivers to one last heartbeat and then bursts. Taking that sequence of pictures *in situ* is, of course, impossible. However, Lennart Nilsson found a way to illustrate the deadly threat posed by cerebral hemorrhage: He reenacted the event down to the last detail.

On this project, Nilsson proceeded as he always does, planning the images in his mind's eye long before taking them. "You have to ask yourself, 'What is the most powerful thing here?'" he says. "It's a matter of finding the strongest detail and enlarging it, emphasizing it. Even if it only lasts a few seconds. You have to know what you're looking for. If you don't, no fancy instruments will help."

In his studio next to the autopsy room of a Stockholm hospital, Nilsson worked swiftly after a post-mortem had pinpointed the location of an aneurysm, a bubble, that ruptured and killed a 46-year-old man. With the help of his long-time partner, Dr. Jan Lindberg, he set up a segment of the diseased artery, connected it to a pressurized container of the dead man's blood, and positioned two strobes to provide lighting. Then, as the blood pressure mounted, straining another aneurysm in the disease-weakened wall, Nilsson made his shots, stopping the action just as the artery began to burst. The resulting photographs are not only striking medical documents, but haunting, eerily beautiful pictures of the always-present specter of death. □

An aneurysm, a weakened section in the wall of a cerebral artery, swells close to the bursting point in Lennart Nilsson's re-creation of a fatal stroke. After an autopsy on a stroke victim, Nilsson rushed the flawed section of artery to his studio, along with a supply of the man's blood, which was pumped through the artery at the fatal pressure.

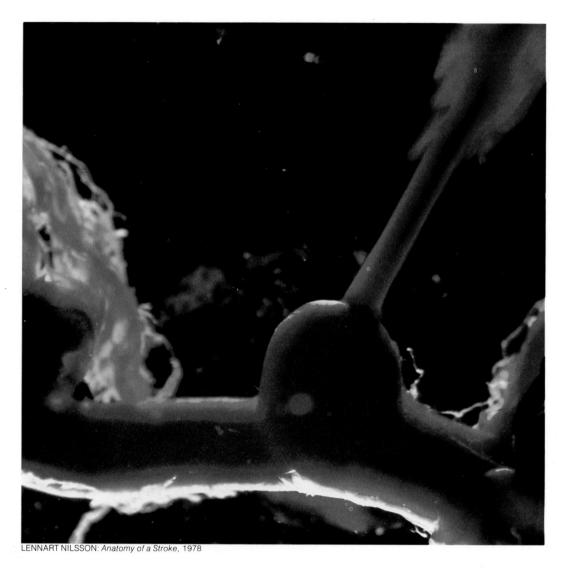

After two and a half minutes of dangerously high pressure, blood bursts through the swollen wall of the artery less than an inch away from the rupture that had taken the victim's life. Nilsson used a Hasselblad with a 120mm lens and an extension tube, making the shot at a 1/1500-second exposure.

LENNART NILSSON: *Anatomy of a Stroke,* 1978

Present at the Dawn of Life

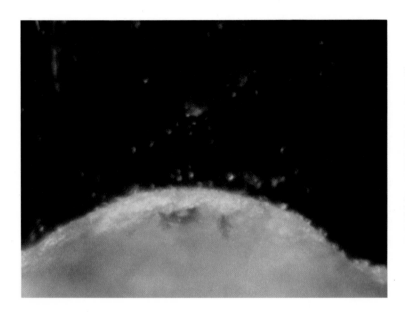

A blister-like formation called a Graafian follicle appears on a human ovary; inside it, an ovum, or egg, is developing. This and the following pictures were made with an endoscope fitted with a 6mm-wide lens whose focus varied from 3mm to 1cm.

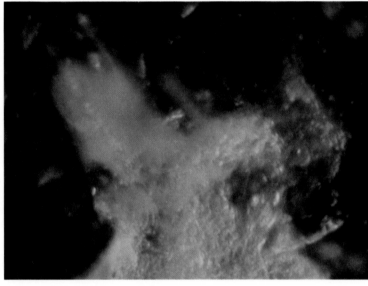

Twelve to 16 days after the follicle begins to swell, the surface of the ovary bursts in a volcano-like explosion. Takeda illuminated the action with two microscopic lights that were attached to glass-fiber rods about 15cm long and 5cm in diameter.

The process of conception is a suspense story that is fraught with peril every millimeter of the way. Like a microscopic spacecraft, an unfertilized human egg is launched explosively from the ovary into the dark reaches of the female body cavity. Then—as it has for all of mammalian history—the egg, or ovum, voyages to the oviduct and a possible encounter with a sperm cell. If all goes well, fertilization, development and birth will follow.

The photographs that are shown on these pages are stills taken from a prize-winning Japanese documentary film entitled "The Beginning of Life: The Mammalian Story." Six years in the making, the film is intended for frame-by-frame study, and stills such as these are now used in

Japanese high-school biology textbooks.

The cinematographer, Junichiro Takeda, used specially constructed photographic equipment that included microscopic lights fitted to glass-fiber rods, and miniature lenses 3mm and 6mm in diameter mounted on the ends of endoscopes. These devices enabled Takeda to pipe light deep into the body where the action was—and then to relay the images back out to the film.

Takeda used human subjects except when to do so might have endangered life; in such cases, animals were used or a special environment was created. His most imposing challenge was to capture the instant of fertilization. He managed it by combining the ovum and sperm in a

bath of saline solutions and blood serums that provided a hospitable setting.

Portraying the development of the fertilized egg was almost as difficult. Normally, the egg must divide many times, in a process called cleavage, for an embryo to form—but in Takeda's studio, cleavage halted after only four divisions. Hormone stimulation was tried, but failed. Then the film-maker, working with medical researchers, implanted the egg in a segment of uterus, and placed the segment in fluid similar to the one used for the fertilization sequences. At last, an egg cell continued the cleavage process and the cinematographer could proceed to record its subsequent development into an embryo.

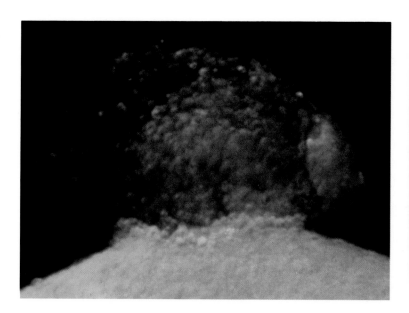

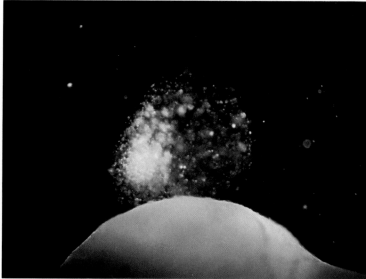

JUNICHIRO TAKEDA: *Ovulation,* 1970

Venting from the ovary's surface is a viscous cloud—the "cumulus oophorus." The cloud contains a mixture of follicular liquid rich in estrogen, the female sex hormone, and cells that surround the ovum, which is still hidden within.

The ovum is lofted free of the ovary. It contains 23 chromosomes, the mother's genetic contribution, and is surrounded by cumulus oophorus, which will nourish it during a three-day journey through the four-inch-long oviduct and into the uterus.

The Creative Encounter

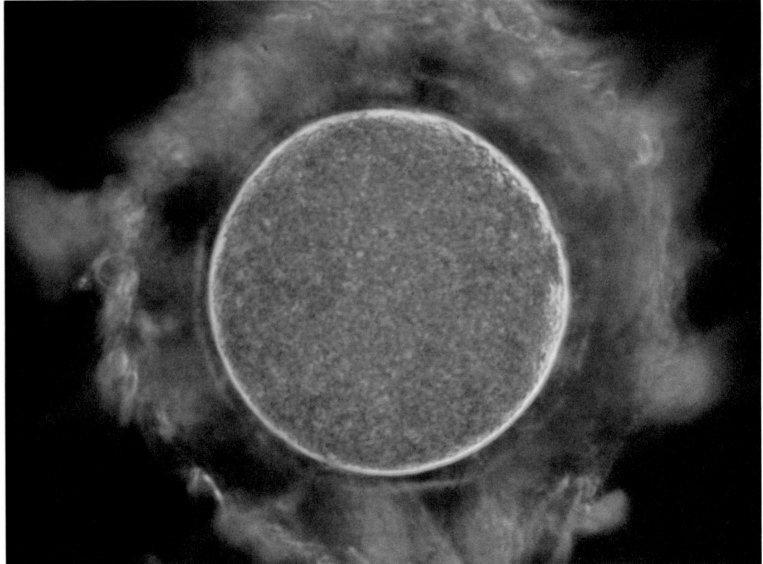

JUNICHIRO TAKEDA: *Fertilization and Development*, 1970

In their race against time, sperm cells – which can survive only 48 hours – form a bluish halo around the egg in an attempt to penetrate it on the first day of its journey in the oviduct. The encounter was photographed with a special lens 3mm wide.

About 30 hours after a sperm has entered and
fertilized the ovum, adding its 23 chromosomes to
the nucleus of the egg cell, the egg begins
the process of cleavage by dividing into two cells.

Forty hours after fertilization, the egg contains
four cells. In this picture, the egg is shown nestled
against one of the ridges of the muscular oviduct.
With no motive power of its own, the egg is propelled
along by hairlike projections of the oviduct.

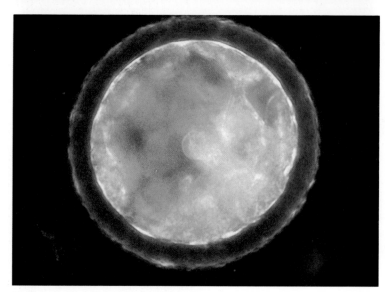

Continuing to subdivide, the ovum is now a layer
of cells enclosing a fluid-filled cavity. Called
the blastula, it is still no larger than when it left
the ovary. At this point, three days after fertilization,
the egg has reached the uterus.

At the blastocyst stage—in which a mass of inner
cells called the embryoblast is formed—the egg
attaches itself to the uterus wall. Here it will
develop the placenta, through which the embryo will
obtain nutrition and eliminate waste material.

209

Revelations through a Glass Ball

These extraordinary color portraits of living embryos in the womb, nine and 11 weeks old, were the first ever made of human life at such an early stage. The photographs were taken by a team of three German obstetricians who were attempting to develop the technique of embryoscopy as an aid to the investigation of early fetal development.

Embryoscopy employs a modified version of the endoscope, a medical viewing device used to examine organs and tissue that can be reached by way of the body's natural openings and channels. The embryoscope, which is inserted into the uterus through the cervix, has a very small optical-glass ball at its end, instead of the flat optical glass that serves in an endoscope. The ball is used because its curved surface will not puncture the delicate amniotic sac that surrounds the embryo; it also allows a clear view through the membrane of the sac, since it displaces body fluids that would otherwise obscure the glass.

To illuminate their tiny subject, the doctors pipe light through a fiberglass cable into the optic system of the embryoscope and thence into the womb. The image thus revealed is conveyed through the embryoscope to a 35mm camera fitted with a special 70-120mm zoom lens.

Although this kind of direct observation could offer doctors richly detailed diagnostic information that would help to determine the health of the unborn child, it nevertheless is dangerous. The embryoscope could precipitate a miscarriage, and the fetus could suffer optical damage from the intensity of the light. For these reasons, embryoscopy is not practiced in the United States, and in Germany it is used only in cases in which an abortion is planned.

DR. A. GALLINAT, DR. H. LINDEMANN AND DR. A. LUEKEN: *Living Human Embryo*, 1978

In this embryoscopic portrait, taken in the 11th week, the well-formed left hand is seen resting on the embryo's chest. Like the picture opposite, this photograph shows only part of the embryo because of the embryoscope's optic angle and the subject's closeness to the optical glass.

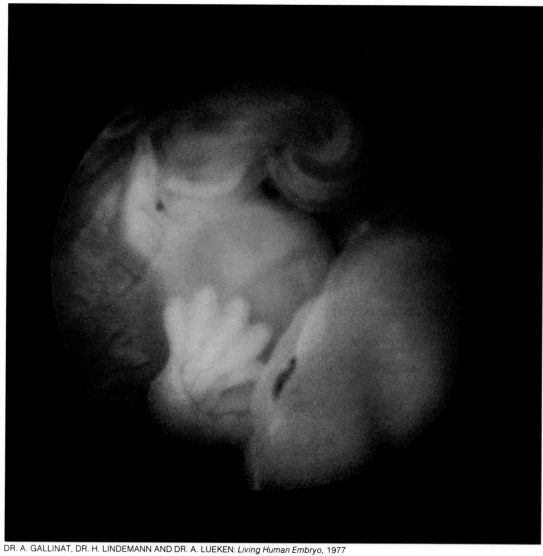

A human embryo lies in its mother's womb nine weeks after it was conceived, its fingernails and the darkly-pigmented area of the eye clearly visible. The embryoscopic photograph was made through the fragile membrane of the amniotic sac.

DR. A. GALLINAT, DR. H. LINDEMANN AND DR. A. LUEKEN: *Living Human Embryo*, 1977

Sounding Out the Secrets of the Unborn

Sonar—the echo-tracking system used by bats and dolphins to navigate and by the Navy to detect enemy submarines—can also yield photographic images that enable doctors and medical researchers to "see" into the body with far less risk to the patient than with other diagnostic techniques such as X-rays and nuclear scans. The medical technique, known as ultrasound scanning, uses no radiation and thus is especially suitable for screening pregnant women to detect fetal abnormalities, such as spina bifida or hydrocephalus, and defects or obstructions in tiny fetal organs like the heart and kidney. The scans are valuable even in uncomplicated pregnancies, providing obstetricians with such helpful information as the unborn baby's age, sex and position within the uterus.

The technique uses sound waves of a much higher frequency than those perceptible to the human ear. The sound waves are beamed into the body by a transducer, a device that converts electrical energy to sound and vice versa. As the transducer is swept over the body, the waves pass from one kind of tissue to another, sending back weak or strong echoes, depending on the density of the tissue. After being converted back into electronic impulses, the echoes are fed into a cathode-ray-tube monitor and appear on the screen as a cross-sectional image of the area being examined.

Usually cameras are connected to the cathode-ray tube to make still pictures for detailed study. Sonar portraits—or sonograms—like the one shown on the opposite page make deliveries safer for both mother and baby. They enable doctors to diagnose and treat birth defects early—and give prospective parents an exciting view of their unborn child.

Using a transducer that emits ultrasonic waves and picks up their echoes, a technician examines the fetus in a womb. The woman's abdomen has been lubricated with mineral oil to enhance sound transmission. The transducer—which emits sound waves from 2.5 to 10 megahertz (1,000,000 cycles per second)—converts the echoes to electrical impulses, which are translated into an image on the monitor (above, right).

A sonogram portrait of an unborn child ▶ (opposite) is etched in thousands of glowing pinpoints of light, each one representing an echo picked up by the transducer. Images accurate to within 1.5 millimeters can be obtained from as deep as 20 centimeters inside the body and can show the fetus blinking or sucking its thumb.

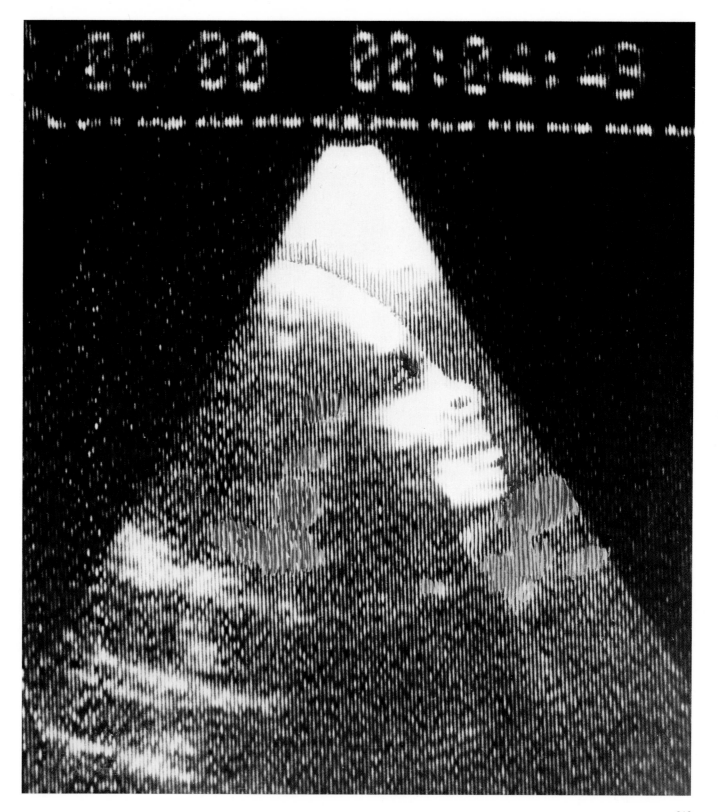

The Magic Moment of Birth

While few photographers can hope to duplicate Lennart Nilsson's intricately managed medical picture taking, some amateurs can now move into the once-restricted precincts of the hospital to record the birth of their own children. In some hospitals, fathers are encouraged to accompany their wives through labor and delivery—with cameras, if they choose. John Graham, an NBC art director, availed himself of this opportunity. Both he and Mrs. Graham had taken a course in a natural-childbirth method in which the mother controls her breathing to eliminate the pain of labor. In hospital garb, Graham stood in a Hunterdon, New Jersey, labor room and posed for the shot above—calmly taken by his wife, early in her labor. The rest of the pictures document the drama thereafter from a father's view.

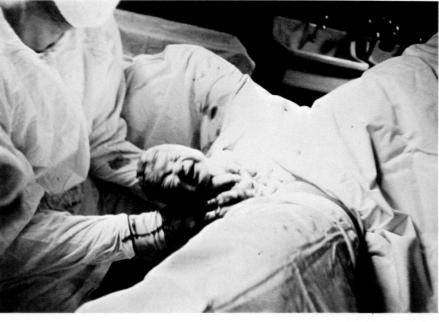

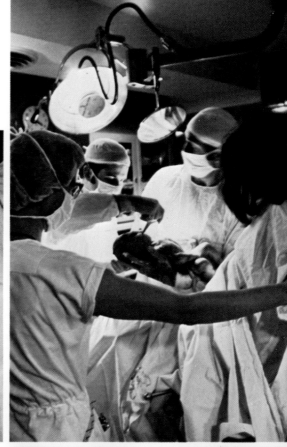

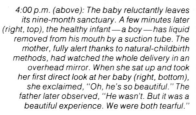

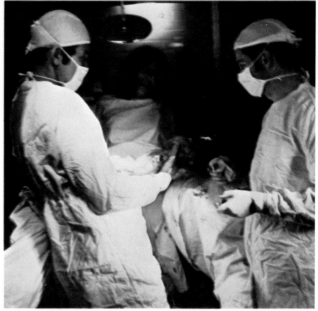

◄ 3:55 p.m. (opposite, top right): As she has done since labor began at 8:00 a.m., Mrs. Graham works at breathing exercises to counter the tendency of pelvic and abdominal muscles to tense up painfully during contractions. Her husband, free to move about shooting pictures with his Nikon F, timed the procedure with a stopwatch to help in the exercises.

4:00 p.m. (opposite, bottom): At delivery's start, Mrs. Graham sits up to watch the baby starting to emerge as her husband continues his photographic record. The delivery room's bright illumination and shadows lightened by reflections from white surfaces eliminated the need for special lighting equipment. Exposures of 1/50 second at f/11 on ASA 400 film gave good negatives. The photographer's only problem was the excitement that comes with involvement. In Graham's case this was heightened by the fact that he and his wife had tried for four years to have a child and had pretty much given up on their chances.

4:00 p.m. (above): The baby reluctantly leaves its nine-month sanctuary. A few minutes later (right, top), the healthy infant—a boy—has liquid removed from his mouth by a suction tube. The mother, fully alert thanks to natural-childbirth methods, had watched the whole delivery in an overhead mirror. When she sat up and took her first direct look at her baby (right, bottom), she exclaimed, "Oh, he's so beautiful." The father later observed, "He wasn't. But it was a beautiful experience. We were both tearful."

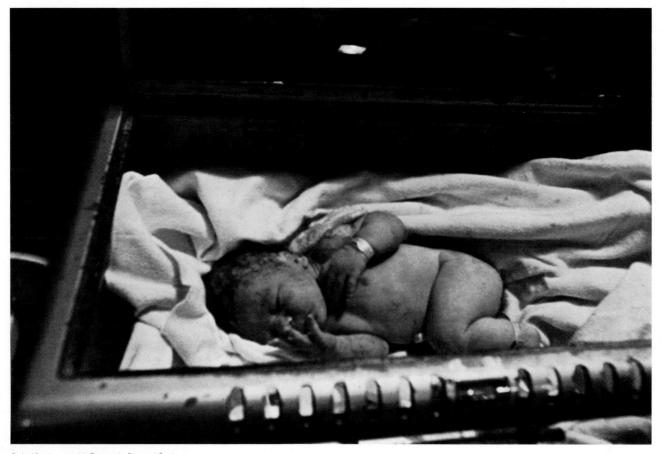

*Only 10 minutes old, Benjamin Samuel Graham
—a robust infant weighing eight pounds
and 14 ounces—sleepily poses for his father's
camera in the hospital delivery room.*

Bibliography

General

Attenborough, David, *Focus on Nature*. Oxford Scientific Films, 1981.
Muybridge, Eadweard:
 Animals in Motion. Dover, 1957.
 The Human Figure in Motion. Dover, 1955.
Nuridsany, Claude and Marie Pérennou, *Photographing Nature*. Oxford University Press, New York, 1976.
*Ruechardt, Eduard, *Light, Visible and Invisible*. University of Michigan Press, 1958.
†Tolansky, Samuel, *Revolution in Optics*. Penguin, 1968.

Electronic Flash and High-Speed Photography

Edgerton, Harold E., *Electronic Flash, Strobe*. McGraw-Hill, 1970.
Edgerton, Harold E., and James R. Killian Jr., *Flash!* Charles T. Branford, 1954.
Karsten, Kenneth, *Science of Electronic Flash Photography*. Amphoto, 1968.
Lefkowitz, Lester, *Electronic Flash*. Eastman Kodak, 1981.
Luray, Howard, *Strobe—the Lively Light*. A. S. Barnes, 1963.
Nilsson, N. Robert, and Lars Högberg, eds., *High-Speed Photography*. John Wiley & Sons, 1968.
†Van Veen, Frederick, *Handbook of Stroboscopy*. General Radio Company, 1966.

Photomacrography and Photomicrography

Bennett, Alva H., Helen Jupnik, Harold Osterberg and Oscar W. Richards, *Phase Contrast, Phase Microscopy—Principles and Applications*. John Wiley & Sons, 1951.
†Cosslett, Vernon E., *Modern Microscopy, or Seeing the Very Small*. Cornell University Press, 1966.
Eastman Kodak:
 Basic Scientific Photography for the Hobbyist, Naturalist and Student. Eastman Kodak, 1977.

Biomedical Photography, A Kodak Seminar in Print. Eastman Kodak, 1976.
†*Photography Through the Microscope*. Eastman Kodak, 1980.
Francon, M., *Phase Contrast and Jamin-Lebedeff—Progress in Microscopy*. Row Peterson, 1961.
*Lefkowitz, Lester, *The Manual of Close-Up Photography*. American Photographic Book Publishing Co., 1979.
†Möllring, F. K., *Microscopy from the Very Beginning*. Carl Zeiss.
Rochow, Theodore G., and Eugene G. Rochow, *Hoffman Modulation Contrast—An Introduction to Microscopy by Means of Light, Electrons, X-Rays, or Ultrasound*. Plenum Press, 1978.
*Scharf, David, *Magnifications, Photography with the Scanning Electron Microscope*. Schocken Books, 1977.
Wilson, Michael B., *The Science and Art of Basic Microscopy*. American Society for Medical Technology, 1976.

Aerial and Astronomical Photography

Deuel, Leo, *Flights Into Yesterday: The Story of Aerial Archeology*. St. Martin's Press, 1969.
Eastman Kodak:
 †*Astrophotography with your Camera*. Eastman Kodak, 1968.
 †*Kodak Data for Aerial Photography*. Eastman Kodak, 1969.
*Hapgood, Fred, *Space Shots—An Album of the Universe*. Times Books 1979.
Newhall, Beaumont, *Airborne Camera: The World from the Air and Outer Space*. Hastings House, 1969.
Owings, Nathaniel A., *The American Aesthetic*. Harper & Row, 1969.
Vaucouleurs, Gérard de, *Astronomical Photography: From the Daguerreotype to the Electron Camera*. Macmillan, 1961.

Underwater Photography

Frey, Hank, and Paul Tzimoulis, *Camera Below: The Complete Guide to the Art and Science of Underwater Photography*. Association Press, 1968.
Schulke, Flip, *Underwater Photography for Everyone*. Prentice-Hall, 1978.

X-Ray, Ultraviolet and Infrared Photography

†Bleich, Alan Ralph, *The Story of X-Rays*. Dover, 1960.
Eastman Kodak:
 †*Applied Infrared Photography*. Eastman Kodak, 1968.
 †*Infrared and Ultraviolet Photography*. Eastman Kodak, 1963.
 Radiography in Modern Industry. Eastman Kodak, 1970.
 †*Ultraviolet and Fluorescence Photography*. Eastman Kodak, 1968.
Matthews, Sydney K., *Photography in Archaeology and Art*. Humanities Press, 1968.
†Simon, Ivan, *Infrared Radiation*. D. Van Nostrand, 1966.

Magazine Articles

"Anatomy of a Stroke." *Life*, May 1979.
Bloom, Mark, "The Ultrasonic Boom." *Medical World News*, December 26, 1977.
Gore, Rick:
 "Eyes of Science." *National Geographic*, March, 1978.
Nilson, Lisbet, "Lennart Nilsson." *American Photographer*, August, 1980.
Smith, Alex G., "New Trends in Celestial Photography." *Sky and Telescope*, January, 1977.

*Also available in paperback.
†Available only in paperback.

Acknowledgments

The index for this book was prepared by Karla J. Knight. For their help in the preparation of this volume, the editors would like to thank the following: Mortimer Abramowitz, Superintendent of Schools, Great Neck Public Schools, Great Neck, N.Y.; James Albus, National Bureau of Standards, Washington, D.C.; Norbert S. Baer, Institute of Fine Arts, New York University, N.Y.C.; Don Bane, Jet Propulsion Laboratory, Pasedena; Lloyd M. Beidler, Dept. of Biological Science, The Florida State University, Tallahassee; Richard J. Boyle, Curator of Painting, Cincinnati Art Museum, Ohio; Marguerita Braymer, President, Questar Corp., New Hope, Pa.; Thomasine C. Brooks, Phillips Library, Harvard College Observatory, Cambridge, Mass.; Sylvia Bruce, Ikelite Underwater Systems, Indianapolis, Ind.; Larry Bruder, Olympus Corporation of America, New Hyde Park, N.Y.; Mary-Nelson Campbell, News Bureau, Stanford University Medical Center, Cal.; Central Skindivers, N.Y.C.; Dennis di Cicco, *Sky and Telescope*, Cambridge, Mass.; Copal Corporation of America, Woodside, N.Y.; William J. Daly, Kanematsu-Gosho, Inc., N.Y.C.; Anne L. Doubilet, N.Y.C.; Harold E. Edgerton, Institute Professor Emeritus, Massachusetts Institute of Technology, Cambridge, Mass.; Professor Thomas Eisner, Langmuir Laboratory, Ithaca, N.Y.; Edward Ralph Emmett, Speedotron Corporation, Stratford, Conn.; Rhodes Fairbridge, Department of Geology, Columbia University, New York City; Douglas Faulkner, Summit, N.J.; Pasquale Ferazzoli, Olympus Camera Corporation, Woodbury, N.Y.; Harold Forgosh, Scientific Instrument Division, Bausch & Lomb, Inc., N.Y.C.; George Frye, Willoughby-Peerless Camera Stores, N.Y.C.; H. Lou Gibson, Biological Photographical Association, Rochester, N.Y.; Fritz Goro, Time Inc., N.Y.C.; Kenneth Goss, Lockwood, Kessler & Bartlett, Syosset, N.Y.; Joseph L. Gossner, N.Y.C.; Graphic Services Department, The Rockefeller University, N.Y.C.; Crawford H. Greenewalt, Wilmington, Del.; Professor L. Fritz Gruber, Cologne, West Germany; Sarah J. Hill, Whitin Observatory, Wellesley College, Massachusetts; Caroline K. Keck, State University College, Oneonta, N.Y., and New York Historical Association, Cooperstown, N.Y.; Gyorgy Kepes, Director, Center for Advanced Visual Studies, Massachusetts Institute of Technology, Cambridge, Mass.; Erich Kleinwaechter, Boehringer, Ingelheim, West Germany; Lewis W. Koster, Media Medical Production Service, V.A. Medical Center, Tucson, Ariz.; David Kostizak, Rochester Laboratory for Laser Energetics, Rochester, N.Y.; John Krewalk, Criterion Manufacturing Company, West Hartford, Conn.; Shelly Lauzon, Woods Hole Oceanographic Institution, Woods Hole, Mass.; Henry M. Lester, N.Y.C.; Sam Letcring, Rochester Laboratory for Laser Energetics, Rochester, N.Y.; Dr. Jan Lindberg, Stockholm, Sweden; Betty Lobit, Karl Heitz, N.Y.C.; Richard LoPinto, Nikon Inc., Garden City, N.Y.; David

F. Malin, Anglo-Australian Observatory, New South Wales, Australia; Robert Mark, Department of Civil Engineering, Princeton University, Princeton, N.J.; Robert E. Mayer, Bell & Howell, Chicago, Ill.; Irving Mehler, Honeywell, Inc., N.Y.C.; A. Eugene Miller, Insurance Institute for Highway Safety, Washington, D.C.; Dr. George T. Mulholland, Fermi National Accelerator Laboratory, Batavia, Ill.; Erwin W. Müller, Evan-Pugh Research Professor of Physics, The Pennsylvania State University, University Park, Pa.; Lisbet Nilson, New York City; Al Nordheden, New York Horticultural Society, N.Y.C.; Robert G. Norwick, Nikon Inc., Garden City, N.Y.; Charles Olin, Great Falls, Va.; Elwood Ott, Aero Service Corporation, Philadelphia, Pa.; Agnes Paulsen, Kitt Peak National Observatory, Tucson, Ariz.; Dr. Keith

R. Porter, Boulder, Col.; William T. Reid, Battelle Memorial Institute, Columbus, Ohio; Richard's Sporting Goods, Inc., N.Y.C.; Kevin F. Ritschel, Celestron International, Torrence, Cal.; Larry Salvo, Subsea Products, Riviera Beach, Fla.; Dan Santora, Edmund Scientific, Barrington, N.J.; David Scharf, Los Angeles, Calif.; Neil Sheeley, The Naval Research Laboratory, Washington, D.C.; Daniel B. Sheffer, Ph.D., Biostereometrics Laboratory, University of Akron, Ohio; Walter J. Seidl, Olympus Corporation of America, New Hyde Park, N.Y.; Wesley M. Smart, Fermi National Accelerator Laboratory, Batavia, Ill.; Mary G. Smith, National Geographic Magazine, Washington, D.C.; Robert F. Smith, New York State College of Veterinary Medicine, Cornell University, Ithaca, N.Y.; Klaus

Spiegel, Carl Zeiss, Oberkochen, West Germany; Sam Sugarman, Bulova Systems and Instruments Corp., Valley Stream, N.Y.; Dr. Stephen Tim, Brooklyn Botanic Garden, N.Y.; Rea Tyler, Insurance Institute for Highway Safety, Washington, D.C.; Erna B. Vasco, Carl Zeiss, Inc., N.Y.C.; Kathy Vereb, Edmund Scientific, Barrington, N.J.; Henry Weber, Carl Zeiss, Inc., N.Y.C.; Margaret Weems, National Radio Astronomy Observatory, Charlottesville, Va.; Murray Weinberg, Allied Impex Corporation, Carle Place, N.Y.; Ralph Weiss, N.Y.C.; Charles Woodward, Lockwood, Kessler & Bartlett, Syosset, N.Y.; Jurrie van der Woude, Jet Propulsion Laboratory, Pasedena, Calif.; Charles Wyckoff, Applied Photo Sciences, Needham, Mass.

Picture Credits *Credits from left to right are separated by semicolons, from top to bottom by dashes.*

Index
Numerals in italics indicate a photograph, painting or drawing of the subject mentioned.